TIJUANA BIBLES

Art and Wit in America's Forbidden Funnies, 1930s–1950s

Bob Adelman

Introductory Essay by Art Spiegelman
Commentary by Richard Merkin
Essay by Madeline Kripke

SIMON & SCHUSTER EDITIONS

For the unknown artists whose work this book celebrates.

A Bob Adelman Book

Design: David Kaestle and Rick DeMonico
Design and Production Assistant: Heather Barber

Research: Madeline Kripke, Robert Gluckson, Jae Ann Adelman, Andy Norman, the staff of the Kinsey Institute, Robert Phelan, Al Goldstein, David Aaron Clark, Mitchell Shuman

Consultant: Mary Beth Brewer

Photography: Bob Adelman and Michael Macioce

Computer Production: Lorenz Skeeter, Matthew Anacleto, Tamara Vassilieva

Props: Eons of Pittsburgh, Props for Today, Jae Ann Adelman

Production: Ken Coburn, Bernie Sendor, Michael van Zandt

SIMON & SCHUSTER EDITIONS
Rockefeller Center
1230 Avenue of the Americas
New York, NY 10020

10 9 8 7 6 5 4 3 2

Second Printing

Library of Congress Cataloging-in-Publication Data is available.

ISBN 0-684-83461-8

Manufactured in Hong Kong

ACKNOWLEDGMENTS

The original Tijuana Bibles were produced by a shadowy criminal underground in the 1930s. Very little hard information is available about how the Bibles were created, where they were manufactured, and how they were distributed. One certain fact, confirmed by numerous anecdotes, is that these comic books were for many young men their first peek into the forbidden world of erotic intimacy.

A diverse group of extraordinary people intensely researched these Bibles. I have dubbed them the Bible Study Group. I would like to express my gratitude for their contributions to our understanding and appreciation of the Tijuana Bibles:

To the artist Art Spiegelman, for sharing his brilliant insights, edgy humor, unique erudition, and love of cartoons with us; to the artist Richard Merkin, who delighted us with his wit and high spirits, and lavished upon us the fruits of his lifelong study of art style and cultural lore; to Madeline Kripke, who alerted us to the linguistic riches in the racy language of the Bibles; to David Kaestle, whose sensitivity to design and whose cartoon smarts tastefully brought order out of comic confusion; to Professor Robert K. Gluckson, who genially shared with us his hard-won and innovative scholarship.

Tijuana Bibles are no longer readily available, but they were very popular in their day. The vast majority of the books reproduced here are from Madeline Kripke's rich treasure trove, supplemented by Richard Merkin's unique and distinguished collection. The Kinsey Institute for Research in Sex, Gender, and Reproduction has kindly granted us permission to reproduce *Kate Smitz, L'il Abner, Lou Gehrig, Mutt and Jeff, Joe E. Brown,* and *The 4 Marx Brothers.* Additional material came from the collections of Art Spiegelman and Robert Gluckson.

A book requires the collaboration of many skilled people. We are very lucky to have had the text scrutinized and emended with diligence and care by the master copy editor David Frederickson. Early on, Kenneth Norwick was crucial in clearing up legal confusions surrounding the Bibles. As always, my attorney and friend John Horan was extremely helpful with his wise counsel. Michael Gross, dean of art directors, helped design the right cover. Rick DeMonico solved problem after problem of design and production patiently, elegantly, and seemingly without effort. My friend Lorenz Skeeter once again amazed me with his feats of computer magic. Though hard data was not easily found, both Madeline Kripke and Jae Ann Adelman industriously followed every lead in their researches.

At Simon & Schuster Editions, I would like especially to thank Bill Rosen for making a publishing decision that could not have been easy, and for staying the course in a time when all clocks race backwards. Our patient editor, Constance Herndon, has helped immeasurably by employing her formidable editorial and diplomatic skills to impose order on a most unwieldy beast.

Bob Adelman

TABLE OF CONTENTS

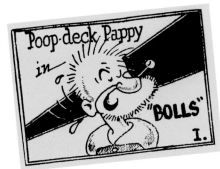
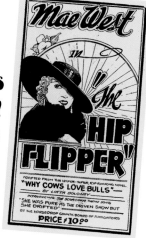
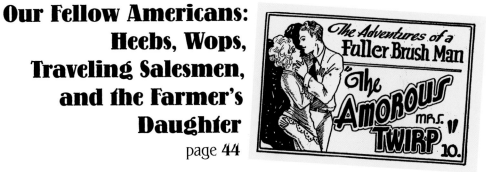

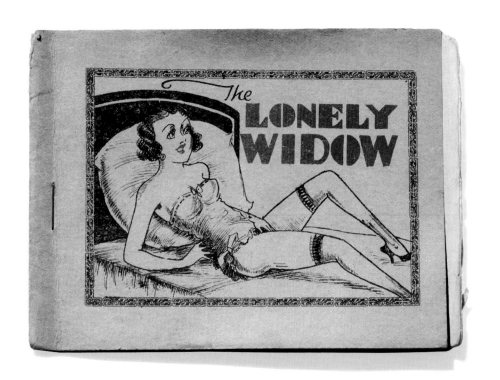

Those Dirty Little Comics

art spiegelman

Cartoons have a way of crawling past our critical radar and getting right into the id. It may be that their reductive diagrammatic qualities echo the way the brain sorts information. This subversive knack for lodging memorably in the deepest crevices of the psyche has never been more clearly demonstrated than by the genre of comic-book pamphlets sometimes known as Tijuana Bibles that first flourished in the thirties. They were cheerfully pornographic and downright illegal.

From today's perspective, part of the early Tijuana Bibles' appeal lies in their peculiar combination of debauchery and innocence. Perhaps because the blue-collar sexual environment they were hatched in was so oppressive, they didn't usually venture into the truly outré and kinky sado-masochistic domains that pervade much of today's popular culture, let alone contemporary hard-core pornography. They seem to marvel at the very *idea* of sex. A passage in Philip Roth's *Portnoy's Complaint* captures their adolescent tone perfectly:

> *Amazing! Astonishing! Still can't get over the fantastic idea that when you are looking at a girl, you are looking at somebody who is guaranteed to have on her — a cunt!* They all have cunts! *Right under their dresses! Cunts — for fucking!*

It was during the Psychedelic Wonder Years of my late teens, when I began working as an underground cartoonist, that I was first exposed to the *genuinely* underground sex comics of the past — but thanks to the aforementioned psychedelics I can't recall the exact circumstances. I know that some of my slightly older and wiser underground-comix cohorts like Robert Crumb and S. Clay Wilson had been exposed to these booklets in childhood, but for most of them it wasn't a watershed moment in their development as artists — more an *outhouse* moment in their

development as adolescents. The Tijuana Bibles weren't a direct inspiration for most of us; they were a *precondition*. That is, the comics that galvanized my generation — the early *Mad*, the horror and science-fiction comics of the fifties — were mostly done by guys who had been in their turn warped by those little books.

As a matter of fact, though nobody has been eager to bring it up before, the Tijuana Bibles were the very first real comic books in America to do more than merely reprint old newspaper strips, predating by five or ten years the format we've now come to think of as comics. In any case, without the Tijuana Bibles there would never have been a *Mad* magazine — which brought a new ironic attitude into the world of media that has since become pervasive — and without *Mad* there would never have been any iconoclastic underground comix in the sixties. Looking back from the present, a time simultaneously more liberated and more repressed than the decades that came before, it's difficult to conjure up the anarchic depth-charge of the Forbidden that those little dirty comics once carried.

Because of their genuinely underground existence there is surprisingly little — you should pardon the expression — hard data available about the Tijuana Bibles. Much of my information comes from talking with people who remember them from their misspent youths, from a swell master's thesis for the University of Washington written by Robert Gluckson in 1992, and from a number of more or less sleazy reprint collections from marginally reputable publishers that I found in porno shops in the early seventies. These came complete with speculative introductions by sociologists, sexologists, psychologists, or possibly podiatrists — anyone who could muster a string of letters like BA or better after his name to add "socially redeeming value" to what other-

wise might appear to be mere gatherings of hot stroke books. I never dreamed that I would someday mature into being a fellow producer of that species of prefatory prose, the least-read this side of small-appliance warranty notices.

In boning up to write this essay I read about 300 of the 700 to 1000 different Tijuana Bibles that are estimated to have been published, and I must confess that, like the clap, these comics are better in small doses. It may be due to their, let's say, undeviating devotion to one theme, but that recognized newspaper strip masterpiece, *Krazy Kat,* was no less single-minded in its repetitive variations on a kat getting konked with a brick. Nevertheless, be advised that this is an anthology better to dip into than swallow whole.

The Tijuana Bibles probably weren't produced in Tijuana (or in Havana, Paris, or London, as some of the covers imply), and they obviously weren't Bibles. They were clandestinely produced and distributed small booklets that chronicled the explicit sexual adventures of America's beloved comic-strip characters, celebrities, and folk heroes. The standard format consisted of eight poorly printed 4"-wide by 3"-high black (or blue) and white pages with one panel per page and covers of a heavier colored stock. There were occasional deviant sizes and formats, most notably a number of especially rare epic-length sixteen-page and even thirty-two-page pamphlets that are among the reprints that follow.

These books might have been called Tijuana Bibles as a gleefully sacrilegious pre-NAFTA slur

against Mexicans, to throw G-men off the trail, or because the West Coast border towns were an important supplier of all sorts of sin. In other regions of America they were also known as Eight-Pagers, Two-by-Fours, Gray-Backs, Bluesies, Jo-Jo Books, Tillie-and-Mac Books, Jiggs-and-Maggie Books, or simply as Fuck Books. They began appearing in the late twenties, flourished throughout the Depression years, and began to (I can't resist) *peter* out after World War II.

The books were apparently ubiquitous in their heyday, a true mass medium, passed from hairy-palmed hand to hairy-palmed hand. According to one of Al Capp's assistants, when Capp had first created *Li'l Abner* and was fretting about whether or not it was destined for success, he breathed an enormous sigh of relief on hearing that his characters had been pirated into a Tijuana Bible—he'd *arrived!*

Distribution was strictly under the counter, out of the backs of station wagons, or from outsized overcoat pockets, and they were sold in schoolyards, garages, and barber shops. A new Bluesie would reportedly set you back between a hefty two bits (enough for a shave and a haircut or five loaves of bread) to as much as five bucks—whatever the local traffic might bear. No one, of course, can say with certitude what the print runs were, but estimates range into the millions, since these illicit items could be bootlegged by anyone with access to a small printing press (or even, for some editions, mimeograph or rubber-stamp equipment). There don't seem to be records of publishers or artists being prosecuted, though shipments and salesmen were occasionally seized. It's not clear whether these publications were Mom-and-Pop operations or actually controlled by organized crime.

When Will Eisner, the doyen of American comic-book artists, was still an innocent young teen working in a New York City printing shop, he recalls being solicited to draw Tijuana Bibles at $3.00 a page by "a Mob type straight out of Damon Runyon, complete

with pinkie ring, broken nose, black shirt, and white tie, who claimed to have 'exclusive distribution rights for alla Brooklyn.'" The cartoonists were anonymous, and their ranks did not include Will Eisner (who described turning down the lucrative job offer as "one of the most difficult moral decisions of my life") or any of the actual creators of the original newspaper strips.

The artist who *single-handedly* set the standard for all the rest, generating many more works than the dozen or so other practitioners in the field, was known until recently only as "Mr. Prolific" (so tagged in the four volume *Sex in Comics* by Donald H. Gilmore, PhD) or to some aficionados as "Square Knob." He has recently been identified as one "Doc" Rankin by sexologist Gershon Legman, who claims to have met him in a cheap Scranton bookstore in the mid-thirties. Rankin, a World War I veteran, drew girlie cartoons for magazines aimed at cheering up ex-soldiers back from the liberated shores of Europe. His publisher, Larch Publications, produced off-color joke books for novelty and magic shops and might conceivably have branched out into producing hardcore under-the-counter material for this class of trade; certainly the aesthetic of the whoopee cushion and the ceramic dog turd permeates the Tijuana Bibles.

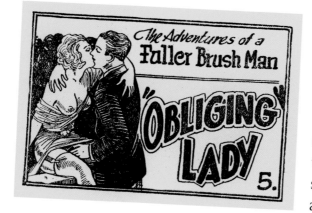

"Doc" Rankin's manic classic, *The Love Guide*, with Mae West and an all-star Toon cast, appears on the following pages, as do several of his *Adventures of a Fuller Brush Man* and many others. He was not only the seminal influence on the genre, he was by far its most competent draftsman, drawing credible likenesses in complex entangled poses with graceful steel-pen strokes. This guy was good enough to earn an honest living had he so desired. Visibly enjoying his work, he offered good value, often adding extra gags and caricatures in frames inside the frames.

The only other creator of Eight-Pagers I can put a name to is the one who produced a series of booklets immortalizing the 1939 World's Fair. (See for example *She Saw the World's Fair—and How,* on page 68.) Although dubiously identified by Donald H. Gilmore, PhD, as the work of three lesbian friends from Chicago, I clearly recognize the hand of Wesley Morse, an artist I briefly met years ago when I first began working for the Topps Chewing Gum Company. Though his Eight-Pagers are often hurried and perfunctory, drawn by someone more interested in making the rent than making whoopee, they have a calligraphic, free-flowing charm. Earlier in his career Morse had drawn cartoon features for the *New York Graphic,* and achieved some success as a gag cartoonist, but apparently had fallen on hard times by the thirties. In the fifties he reached the zenith of his career, drawing the *Bazooka Joe* comics that came wrapped around Bazooka bubble gum.

The names of the rest of the artists involved have slipped into the forgotten cracks of history; they are known now only by their stylistic quirks and idiosyncrasies. I've dubbed one of the post–World War II artists (from the decadent later period of the genre) "Mister Dyslexic." He has no sense of left-to-right narrative progression and is constantly placing his figures or his balloons (and sometimes both) out of sequence. By negative example he teaches the hidden difficulties of the cartoonist's craft. He can't draw even rudimentarily well, certainly can't spell, and holds for me as a working cartoonist the same fascination a really nasty car accident might hold for a bus driver. (Actually, Mr. Dyslexic's indifference to craft strikes me as typical of a general decline in craftsmanship that has marked this century's progress, but I'll shelve that discussion for some other occasion.)

Mr. Prolific probably never won any spelling bees and occasionally stumbled over difficult words like *feud* and *their,* but only the loutish Mr. Dyslexic could write, when Rita Hayworth first meets Prince Aly Khan (in *We Could Make a Million,* page 107): "Rita come appon this seene and decieds she must have some of this lovely prick." In the same short narrative he has Aly admire Rita's "loushes cunt," saying "It feel like I could get my hole hand in." Miraculously the artist spells the word *weight* with absolute precision in panel 1, but reverts to the more creative *wieght* in the last panel. His virulent, know-nothing anti-Communism, and his visualization of rumors about Whittaker Chambers and Alger Hiss's homosexual affair are significant primary sources for understanding America's Zeitgeist at mid-century; but I sheepishly admit that his work makes me want to reach for a red pencil rather than a Kleenex.

There's a mean-spirited malignance to Mr. Dyslexic's misogyny, xenophobia, and racism that compares unfavorably to the rather sweet misogyny, xenophobia, and racism in many of the earlier Tijuana Bibles. I use the word "sweet" advisedly, since most of the Eight-Pagers exude the wide-eyed innocence of, say, Guy Lombardo's hot and sweet college jazz band of the twenties or the bawdy thirties lyrics of "Ukulele Ike," who ended his career as the voice of Jiminy Cricket crooning "When You Wish Upon a Star."

Though the Eight-Pagers did traffic heavily in nasty stereotypes, they were primarily carriers of a virus that infected all strata of our popular culture, certainly including the movies, radio shows, and comic strips they parodied. In fact, since cartoons are a visual sign language, the stereotype is the basic building block of all cartoon art.

Cartoonists can overcome this apparent limitation and often achieve complexity of thought, but it's useful to look at the Tijuana Bibles as laboratory models of the comic-strip form at its most basic. There's a good marriage of form and content in these books: pornography and cartoons are both about the stripping-away of dignity; both depend on exaggeration; and both deploy what Susan Sontag, in *The Pornographic Imagination,* calls "a theater of types, never of individuals."

Granted, due to the monomaniacal focus of the scenarios, there is an even more limited palette of types in the Tijuana Bibles than in the actual newspaper comics. The women may be bright or dumb, innocent or seasoned, but all are horny to the point of insatiability. The main issue is whether they play "hide the weenie" solely for pleasure or for fun *and* profit. The men, handsome or (more often) not, are limited to old-and-horny or young-and-horny. Yet, at their most effective, the characters in the Eight-Pagers remain true to their legit media counterparts. Harpo Marx is as blithely unaware of appropriate behavior in these comics as he is in the movies; it's just that here Groucho scolds him for somehow using "a ladies ass for a harp. It's for jazzing only." Major Hoople was always a blowhard in the funny papers, it's more literal in these books. The colonialist wish-fulfillment implicit in Tarzan is only made more clear by having him k.o. a minstrel-lipped savage about to rape a white goddess who then admires and uses "the most stupendous (*white!*) joy prong in all Africa."

The Fuck Books were not overtly political but were by their nature anti-authoritarian, a protest against what Freud called Civilization And Its Discontents. Here was a populist way to rebel against the mass media and advertising designed to titillate

and manipulate, but never satisfy. Betty Boop, Greta Garbo, and Clara Bow all radiated sex appeal on screen, but they were *cock-teasers*, never quite delivering what they promised—especially after 1934, when the Hollywood Hays office went into high gear.

A related impulse expresses itself on the Internet today, with newsgroups posting digitized JPEG images of Walt Disney's Beauty and the Beast making what Shakespeare called "the beast with two backs," trading extended and explicit chain stories of the sex lives of the *Star Trek* crew, and—thanks to the wizardry of Photoshop—swapping naked pictures of the cast of *Gilligan's Island*. The *frisson* in this high-tech version of Tijuana Bibles seems to have at least as much to do with the thrill of violating copyright and licensing law as with sexual need. In the thirties it was simply a tremendous relief to find out *exactly* what Blondie and Dagwood did between their daily stints in the newspaper that led to the birth of their Baby Dumpling.

After all, comics are a *gutter* medium; that is, it's what takes place in the gutters between the panels that activates the medium. Of course comics have been seen as a gutter medium in the more obvious sense of the term ever since the Yellow Kid ushered in the first Sunday comics supplements at the turn of the century. The genteel classes have long expressed outrage at their vulgarity and tried to have them squelched as a threat to literacy and a corrupting influence on children. The funnies were certainly read by kids, but a 1938 Gallup poll showed that about 70% of all American adults followed them faithfully too. It's difficult to overestimate how central comics were to our mass culture in the days before cathode rays beamed images into every home.

Perhaps it's their primal and direct visual appeal that has given them a bum rap as a kid's medium and made them so very vulnerable to the censor's wrath. In 1994, Michael Diana, a Florida cartoonist whose self-published small-press comic book, *Boiled Owl*, is clearly aimed at adults, became the first cartoonist in America to be convicted of obscenity. One of the draconian

terms of his probation actually enjoined him from having *any* contact with minors! It's a dangerous business, cartooning.

The essential magic of comics is that a few simple words and marks can conjure up an entire world for a reader to enter and believe in. Presumably, this is true of erotic comics as well; how else can one explain the willingness to spend hard Depression-era currency to be aroused by a very primitively drawn Donald Duck *schtupping* an ineptly drawn Minnie Mouse? It's precisely this miraculous ability to suspend disbelief and temporarily blur Image and Reality that arouses the ire of those puritanical censors of the Left and Right who can confuse depictions of rape with actual rape. It's a profound confusion of *categories* as well as a scrambling of symptom and cause.

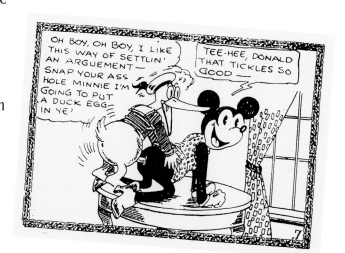

Though there are bound to be those who will loudly declaim that the Tijuana Bibles demean women, I think it important to note that they demean *everyone*, regardless of gender, ethnic origin, or even species. It's what cartoons do best, in fact. It's also crucial to point out that there actually are no women in these books. This is a genre drawn primarily, if not entirely, by men for an audience of men, depicting women with omnivorous male libidos. In *Dear Elsie*, a Sixteen-Pager by O. Whattacan, Tillie writes, "I couldn't hold my wad any longer so I let it fly—did I flood him. It gushed out like a volcano eruption," and goes on to call the mustachioed guy who tickled her "pussey" with his tongue a "*cocksucker*." In *When Mother Was a Girl*, a Rankin production on page 59, women are described as having "overheated

nuts." Yes, I've heard of female ejaculation and I know that slang words often shift in meaning through time, but I'm sure it's actually a clue: these are all guys with *cunts,* ready and eager to physically glom onto any creature or object anywhere near their reproductive organs.

Depression-Era Man had a hard time adjusting to the threat of the newly liberated and recently enfranchised Modern Woman, who had just entered the work force, and these comics all show signs of that stress. There's a big wad of anxiety squirting through these slim little books. It's rarely displayed as overtly as in the atypically vicious Bonnie Parker booklet on page 115, *Amputated,* where our cigar-chomping heroine severs an enormous (even by a Tijuana Bible's generous standards) penis and preserves it in alcohol as a souvenir of some really hot bellywhacking. The malaise in the Eight-Pagers is more often expressed in the form of the totally drained male (drained of come or money, depending on which of the two basic humor templates is being applied).

This sort of psycho-sociological analysis is important, but inevitably sounds like a defensive ploy to inject some Socially Redeeming Value into the concupiscent stew. Paul Krassner, editor of *The Realist* and, briefly, *Hustler,* aptly insisted that "appealing to the prurient interest *is* a socially redeeming value." The Tijuana Bibles were the sex-education manuals of their time. In entertaining and easy-to-read cartoon diagrams, the Beavises and Buttheads of an earlier age could painlessly learn what to put where, and how to move it once they put it there. Significantly, these books spread the hot news that women actually enjoyed

sex and that even fat people like Oliver Hardy and Kate Smith could be sexy. They taught that, despite the mortifying shame of it all, cunnilingus (in these books called "pearl fishing," "whistling in the whiskers," or "yodeling in the canyon") was fun. To understand how shameful oral sex was believed to be, class, you need only to turn to *Mussolini in Ethiopia* on page 124, a giddily primitive Eight-Pager drawn by Mr. Dyslexic's dad, with its memorable punch line: "You-like-to-have-your-pussy-sucked-I-get-Hitler-for-you."

These old Jo-Jo Books do have a liberating "any-port-in-a-storm" polymorphous perversity, but most of them seem far more wholesome than your typical Calvin Klein billboard. They portray a buoyant, priapic world in which lust overcomes everything, even bad drawing, bad grammar, bad jokes, and bad printing. So, to quote from the one Sixteen-Pager: "Now for some exciting moments—all set—keep your hands still."

—art spiegelman, PhD
NYC, 1997

The Lingo of the Tijuana Bibles

<div align="right">Madeline Kripke</div>

The Tijuana Bibles form a rich repository of the vernacular of the 1930s and 1940s, whose lively sexual humor they capture with a wide-eyed, buoyant exuberance. Though the cartoon artists have been much praised for their achievement, too little attention has been paid to the inventiveness and wit of the mostly anonymous writers. Without a trace of inhibition, they run through American slang's whole bag of tricks.

Interjections of amazement, encouragement, and enthusiasm inflate the comics' dialogue balloons: *Attaboy! Hot dawg! Hot ziggety damn! Hot-cha! Holy cats! Sufferin' cats! Jumpin' catfish! Ooh, daddy! Ride 'em, cowboy! Zowie!* At the supreme moment, the lovers lose themselves in cries of *blub, blub; glub; gobble; slurp, slurp.*

The cartoons are sprinkled with elaborate and playful bursts of alliteration, such as "hotter than a fresh-fucked fox in a forest fire," "pierced by the penetrating prong of police protection," and "ram that rotten round rod up that rusty rump." And they display a wealth of gritty, colorful figurative imagery in such expressions as "throbbing like a steam engine," "as hot as a red wagon," "any hotter and I could shit hot rivets," "grinning in the gap," "up the manure chute to clean out your flue," and the oddly tender "I want the head of it to touch my heart."

Puns are commonplace, many of them embedded in the names of authors like I. Letta Fart, O. Whatacum, E. Nawder Titsoff, and Iva Clapp, or in more elaborate fictitious title-author combos such as "*The Ruptured Chinaman* by Wun Hung Low" and "*Tom Cat's Revenge* by Claud Balls."

The jokes of traditional folklore also make an appearance. Some are vulgar: "What's the skin for that separates your cunt from your asshole?—That's a chin rest for cocksuckers." Some are witty: "She was pure as the driven snow, but she drifted."

Popping up in the pages of the Tijuana Bibles are limericks and bits of doggerel. Some reveal pure old-boyish misogynism:

Here's to the cunt that never heals,
the more you rub it the better it feels;
you can rub it and scrub it and pound it like hell,
but you can never get rid of that codfishy smell.

Lighter and less offensive is the succinct rhymed description of Hollywood as a land where everyone "fucks, sucks, screws, or chews." And there are little Ogden Nash–like snippets of verse:

Even poultry
commit adoultry.

When the Bible writers attempt to reproduce national or regional speech patterns, they usually achieve only crude and stereotyped approximations. French characters, for example, sub-stitute *ze* for *the* and make liberal use of *ee* sounds: "Wee-wee—zis is ze service I give Monsieur all ze time" and "Monsieur, you are so beeg!" Italians tack an *a* onto the end of almost every other word, and use *da* in place of *the*: "You gotta da nice ass" and "you got-a…big-a mouth." Germans simply appear fatuous; a typical character asks his partner to "viggle der ass, please," and another says *ach* repeatedly, especially when his beer belly precludes full penetration. The rare Englishman is equally dim and self-involved; one remarks, "I say, mothah—this is beastly clevah of me to fuck from the reah end."

Southerners—aside from the occasional highfalutin', blustering, inanely foolish gentleman (a colonel, perhaps)—speak and act like hillbillies, using such stock terms as *Ah* for *I*, *ain't, cain't, hain't, air* (for *are*), *this yar* (for *this here*), *daggone, hit* (for *it*), *dangdest, sho* (for *sure*), *suthin'* (for *something*), *onliest, who'd a thunk it,* and constructions prefixed with *a* (*agoin', acomin', adoin'*).

Racial and cultural stereotypes are just as common through-out the comics. Chinese characters bear demeaning names as Mr. Flung Shit Hi and Hoo Flung Dung, and almost all say *allee samee,* add *ee* endings to their words, and confound *r* and *l* and other sounds: "Dlagon Lady wish see Mist' Pat light aray," "Ooh, evly thing topsy tumble," "Wazza malla?" "Allee samee to you me tellee you plivate business—Miss Ma she make whole lot *jiggy-jiggy.*" Black characters fare no better: while mouthing *dis* and *dat, sho' nuf* and *ain't dat sumpin',* they bear the brunt of pointed and per-vasive racist humor. Typical bits of dialogue portraying Jews include "Vot's up, Abie? Are the cops after you again?" and "Oy-oy-oy! I'm commink!"

Often ordinary characters in these books are demeaning stereotypes. Though a man may be flattered as *his nibs,* he is more likely to be a *bird, bozo, chump, egg,* or *dumb egg, dumb kluck, pug,* or *sap;* an older gentleman coupling with a young chippie is *grandpop, old buzzard, old fart, old fogey,* or *old fossil,* while she addresses him in baby-talk as *lillums* or *mans* ("You nasty *mans!*"). A woman may be a *piece of ass* (or *tail* or *nookie*), or sometimes just a *piece;* she may be a *babe,* a *bimbo* (or *bimb* or *bim*), a *bitch, broad, cockteaser, dame, dish, femme, girlie, hip-flipper,* or *lay;* she may be a *jade,* a *whore,* or a *high-class keptee;* a

sexually experienced woman—one who *dishes it out* and *knows her strokes*—may even be a *three-way girl.*

Jargon, or occupational vocabulary, pervades these comics. The lingo of the crook, the prizefighter, the sailor, the cowboy, the farmer, the radio technician, the jazz musician, the traveling salesman, the cooch dancer, the starlet—all of these find their way into the comics. The realistic lingo helps make the totally surreal sexual hijinks seem a bit more plausible.

Underworld lingo appears almost everywhere: "It's a pushover…but lay off de rough stuff." "I gotcha, boss." "I tink dat wuz a flatfoot in de lobby when we got de kip." In several comics, guys get "knocked off." "Hot damn—I plugged one of them cops but [the] posse is right behind 'em…." "I'll blow you to pieces, you little rat!!"

The lingo of the prizefighter goes several rounds. One wager-ing character says he's "got a lotta kale riding on dis guy." And one "champeen" brags that he "let the bastard have a left" and "cold-cocked that mug."

The language of other professions provides extended metaphors that help to carry the story line. For example, a sailor, the "captain of his ship," goes "deep-sea diving" with his lady friend. When their amorous adventures "rock the boat" and "the ship is sinking," they decide to "go down with the ship." And a cook offers to "warm up some lunch," to "fry your meat" for you, to serve up some "hot cakes and syrup" turned "on a hot griddle," and, generally speaking, to provide "food for what ails you." You'd better believe that it "sure tastes good."

A baseball player tells his lover to "keep her eyes on the ball" while he attempts to pitch "strike one" to her. She lets him know that "the longest way round is the shortest one home." He says that in a minute his "bat" will be "up again and we'll play another inning." She advises him to hurry up or she'll "put in a pinch hit-ter." Apparently he scores, and she tells him, "Keep it up and you'll win the pennant"—to which he replies, "All I want is a season tick-et to your gate."

This kind of wordplay also appears in a comic featuring a radio repairman. He arrives on the scene and offers to "get my tool out." When the lady of the house complains that he's "tapping on a live wire," he replies that her "socket is a little too tight." Before long, she warns him that she's "going to broadcast in a second" and he echoes that his "tube is getting red hot." She gloats that there's "no static in my reception," and he agrees "there's nothing wrong with your cabinet, either." He says that in conclusion they can "call [it] a short circuit" and she tells him to "sign off." As he leaves, he remarks, "I'm glad you liked my wave-length."

See You in the Funny Pages!

Though the eight-pager cartoonist was to find inspiration in any number of sources, the primary fount was surely the good old Sunday funnies, then the richest and most consistent mirror of the American profile. From our current position, awash in the Internet and drowning in television, it may be difficult to sense the warm urgency of this now all-but-bygone phenomenon; but to much of our country, particularly in the period between the two world wars, the funnies were an assumed companion and more. Intimate, knowing, and usually accurate, they were a prism through which we could see who we were and a way, too, of gently commenting upon what we saw. They ranged from ocean to ocean, from the teeming metropolis, incorporating both penthouse and slum basement, to the meanest hinterland of the republic. The comics left us with indelible types and with phrases that enriched our language. (Tad Dorgan, the great sports cartoonist, must have created a mini-dictionary of such phrases by himself. *Hot dog!* for one was his.)

Though thoroughly working-class in origin, the Tijuana Bible encompassed the full spectrum of the Sunday funnies, lampooning everyone from fireman (Smokey Stover) to doctor (Rex Morgan, M.D.), from ballplayer (Ozark Ike) to sailor (Popeye), and even from caveman, for that matter (Alley Oop) to those forebears of NASA and Star Wars, Buck Rogers, Flash Gordon, and Brick Bradford. And, especially in the socially imbalanced Depression, they ranged from the swanky digs of the filthy rich, as in the highly decorated home of Jiggs and Maggie, to the pad of the congenitally unemployed and derby-hatted lout Moon Mullins, a middle-American dump where his equally derby-hatted kid brother Kayo, slept—not unhappily, mind you—in a top dresser drawer.

Given this amazing cast to work with, the eight-pager cartoonist was surely not wanting for material to transform. His aim was to create an alternative reality and to describe, in a manner that left no questions, precisely what couldn't be shown in the Sunday funnies, nor even in ten-cent comic books when they finally arrived, late in the thirties. It has been said that if the cartoonist is anything, he is direct—and

nothing could be more direct than these gadflies of the comic realm, stripping off all inhibitions, defying any and all accepted niceties: letting it all hang out, as it were, decades before the coming of Larry Flynt and Robert Mapplethorpe.

These cartoonists had their favorites, to be sure. One of them was Popeye, the virile and philosophic sailor man ("I yam what I yam and thass all I yam!" the seaman warned us). He had originally come into being as a minor character in the Thimble Theatre, created by E. C. Segar, but his quaint masculinity and thirst for action endeared him to any number of eight-pager cartoonists, some far more talented than others. Besides, he had that super ménage to accompany him: Olive Oyl, Wimpy, Sweet Pea, Poop-Deck Pappy, et al. Popeye was even teamed with Mae West (a sort of female Popeye) in several erotic adventures, a mating that rather presages the cinematic splice of sultry Seka and the late John Holmes in pornographic film some forty years later.

Moon Mullins, now largely forgotten, was perhaps the quintessential comic strip of the Great Depression, with its mélange of social types. The household included Uncle Willie and Aunt Emmy, who were broke; Lord and Lady Plushbottom, who still had titles; Moon, who took a job only if someone lay down next to him with it; the black chauffeur Mushmouth; Moon's girlfriend Little Egypt, a burlesque queen; and Kayo, the child who thought like a man. *Moon Mullins* was the ultimate stew of the American moment, and thus an utterly grand set for the pornographic shenanigans that took place in umpteen eight-pagers.

The comic pages provided endless variety for plots that, essentially, varied very little; but the form was particularly fond of husband-wife strips like *Toots and Casper* or girlfriend-boyfriend strips like *Tillie the Toiler* and her Mac. This was so much the case that the little books were often called Tillie-and-Mac books or Toots-and-Casper books. Both couples are now, alas, at one with the distant pulp past. Blondie and Dagwood, though, are still with us, having outlived endless artists not one of whom has depicted the suburban duo with the *joie de vivre* they enjoyed in this taboo milieu.

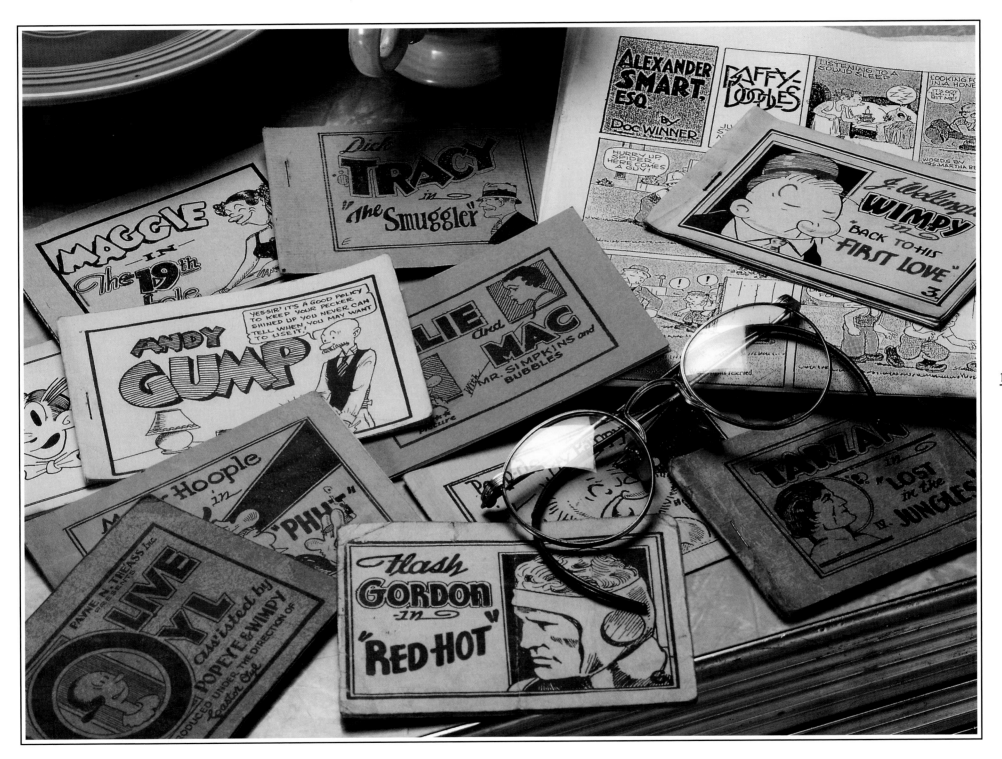

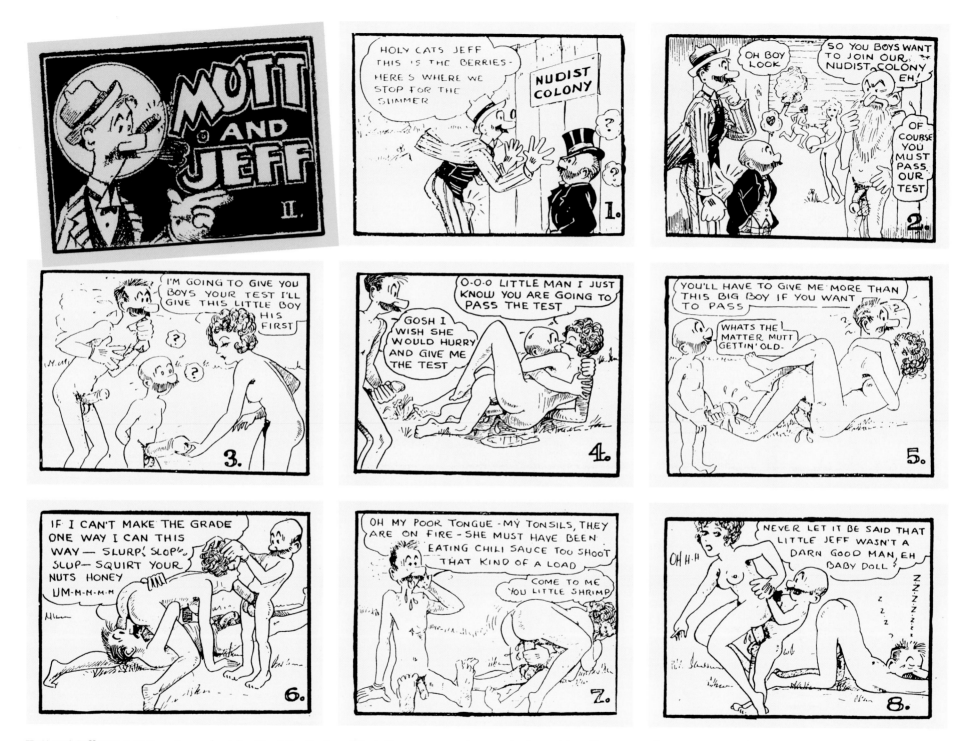

14

Mutt and Jeff was a very early comic strip, if not the first, and its influence was vast and long-lasting. It was created by a genius named Bud Fisher in 1907. Mutt, the tall one, had already existed in a single-panel racing cartoon, but in that fateful year, he paired up with Jeff, who got his name from the heavyweight champion of the time, Jim Jeffries. The long and the short of it is that Mutt and Jeff have become a part of our language, and the strip itself continued long after Fisher's passing.

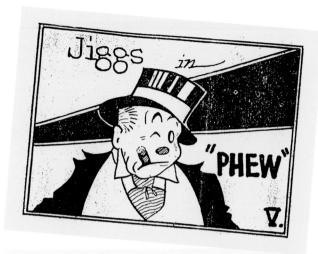

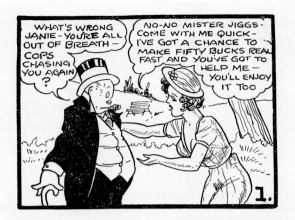

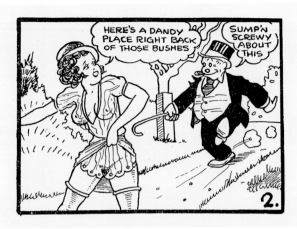

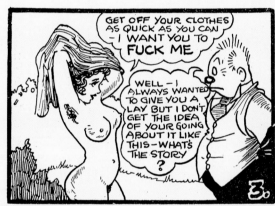

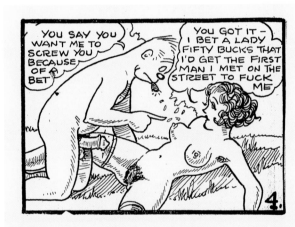

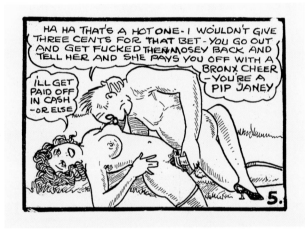

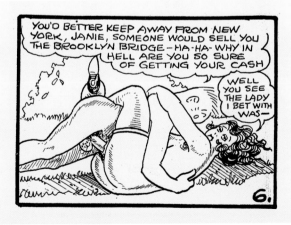

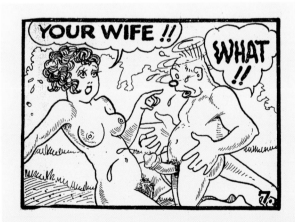

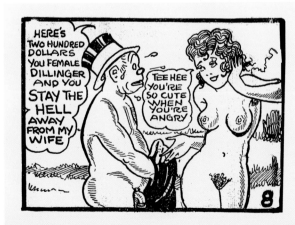

15

The graphic style of George McManus's Bringing Up Father *perfectly suited the manner of the cartoonist, Mr. Prolific. The elegance of line, the attention to detail, and the willingness to attend to the decorative made this union a happy marriage, as it were. Dating the booklet is easy due to the Dillinger reference; it is that banner year for the Tijuana Bible, 1934.*

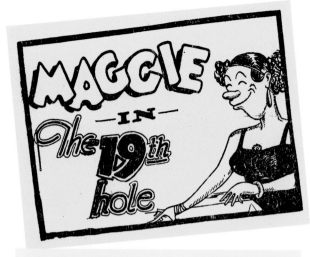

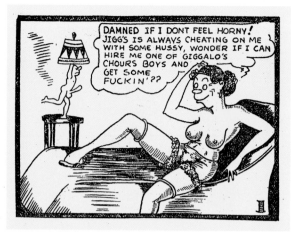

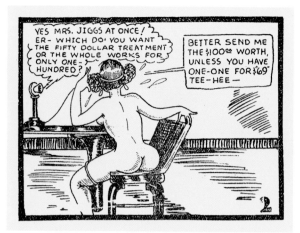

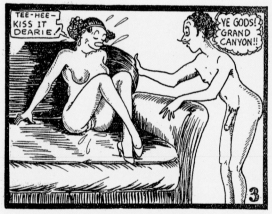

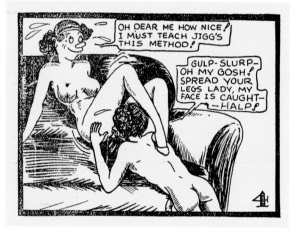

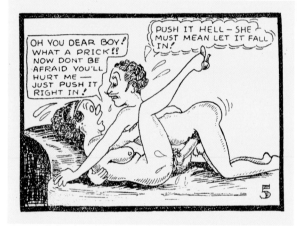

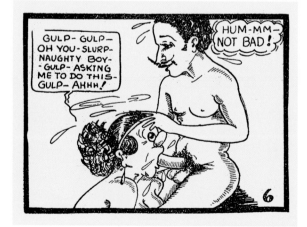

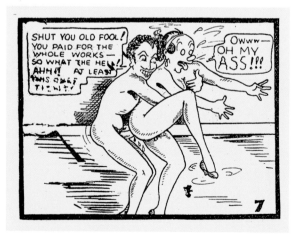

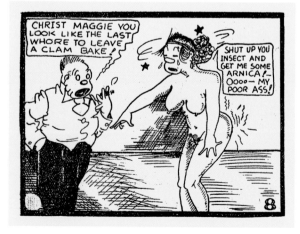

16

This adventure finds Maggie, from Bringing Up Father, employing the erotic services of a gigolo, obviously French. It was a time when all things erotically unusual were said to have been done best by a Frenchman or a Frenchwoman.

This was due partially to the experiences of the American soldiers during the First World War, and due as well to the fact that photography, which showed all, developed, early on, in France.

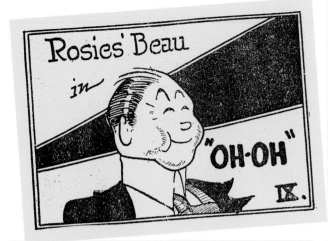

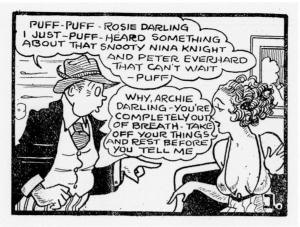

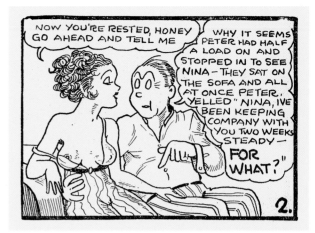

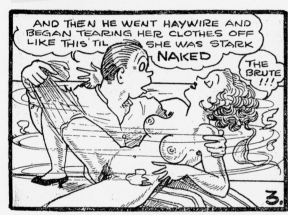

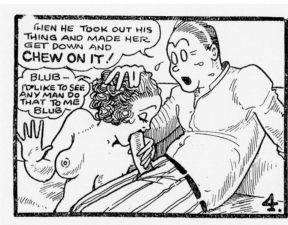

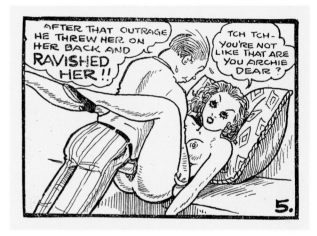

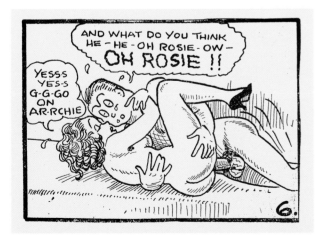

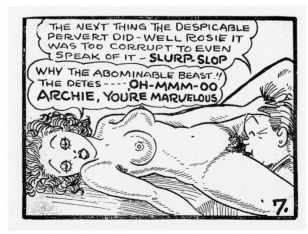

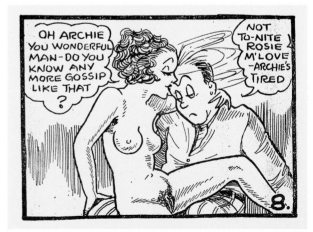

Rosie's Beau was an abbreviated strip that appeared over the masthead of Bringing Up Father, the far better known and utterly classic comic strip by George McManus. Jiggs, the father, is built like a balding fireplug, and mother Maggie, though statuesque, is distinctly homely; but daughter Rosie is to die for—one-third Gibson Girl, one-third John Held Jr. flapper, and one-third goddess. The little strip was a staple of the thirties and forties.

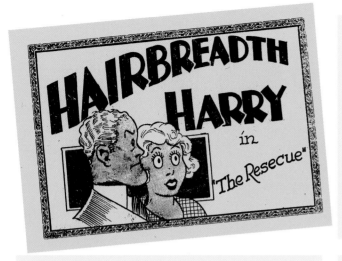

18

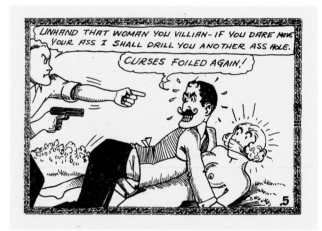

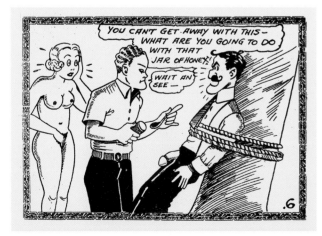

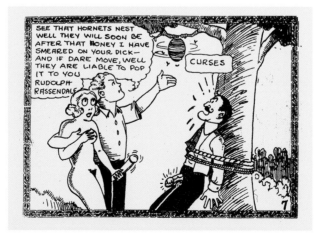

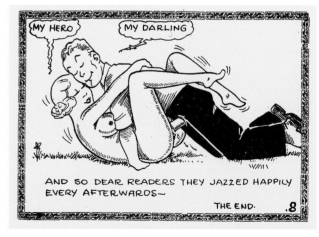

Though it was a popular strip of the thirties, Hairbreadth Harry was a holdover from late-nineteenth-century melodrama. Last-minute rescues could be found on the stage, in early cinema, or in proliferating publications like the Police Gazette—which, by the way, was as close to the Tijuana Bible as one got at the turn of the century.

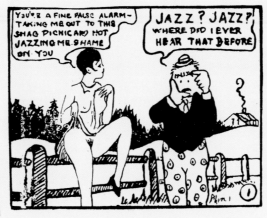

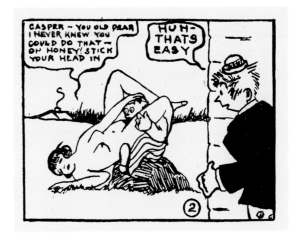

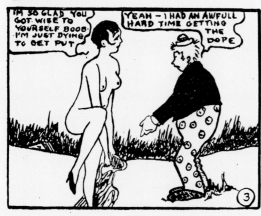

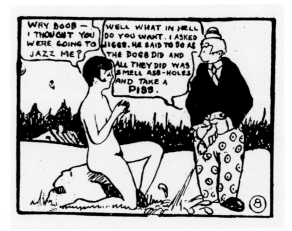

Rube Goldberg, best known for his lunatic inventions, drew the strip Boob McNutt in the twenties. This eight-pager is noteworthy for several reasons. First, there are cameo appearances by Casper and, incredibly, by Krazy Kat (her one appearance in this form, to anyone's knowledge). Second, amazingly, there is no standard intercourse in any of the panels. Last, the use of the word jazz would suggest that the book is very early, possibly from the late twenties; the lady's coiffure would seem to confirm this date.

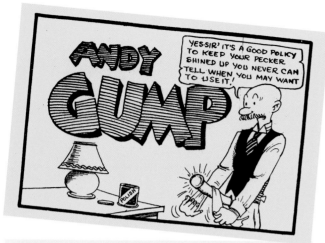

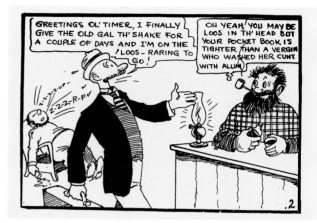

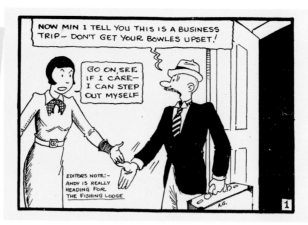

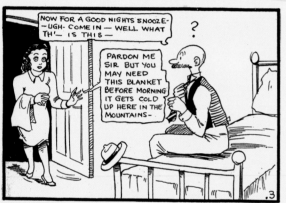

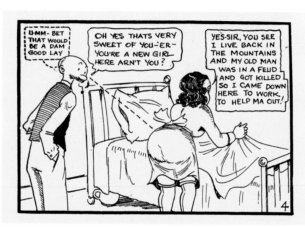

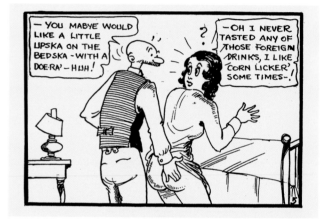

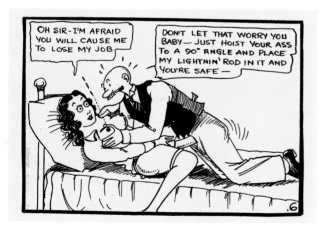

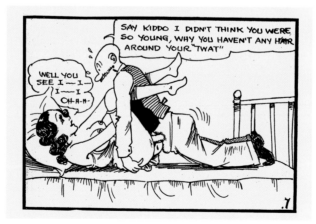

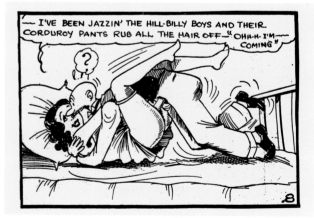

20

Andy Gump, *the chinless wonder, was the hero of a strip that seemed to last a lifetime. It was begun by Sidney Smith back in 1917, but was continued by several artists long after Smith's death (this was standard practice with many successful strips). Now* *largely forgotten, the comic strip was adored in the twenties and thirties, so much so that Andy Gump once ran for president—though he didn't win.*

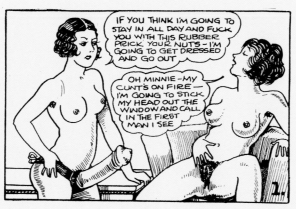

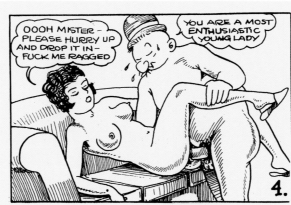

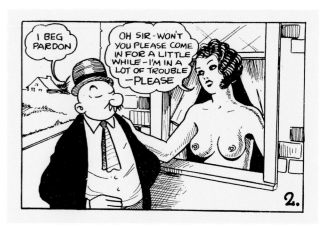

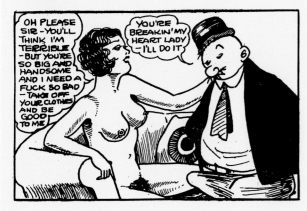

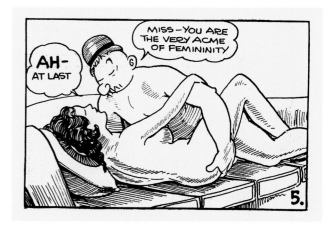

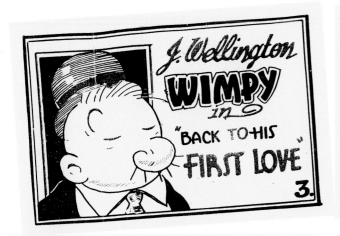

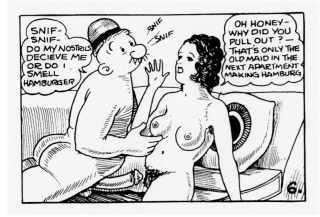

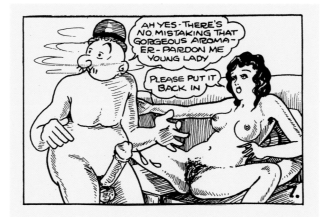

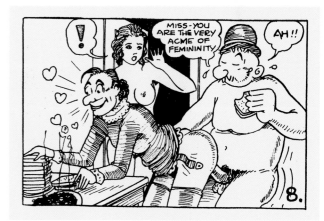

J. Wellington Wimpy—just Wimpy to his pals—was one of the repertory company known as the Thimble Theatre, created by E. C. Segar for King Features in 1917. The renowned hamburger enthusiast was actually preceded by a number of other Thimble denizens, *including Olive Oyl, her brother Castor, and a quaint seaman called Popeye. Though he arrived late, Wimpy quickly established his presence, and in time donated the word wimp to our vernacular, much to the dismay of George Bush.*

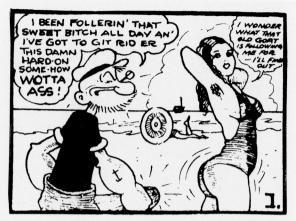

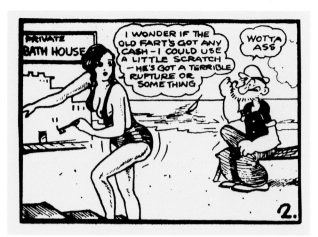

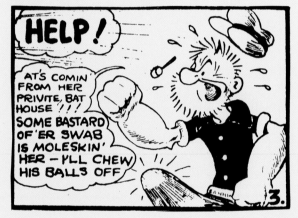

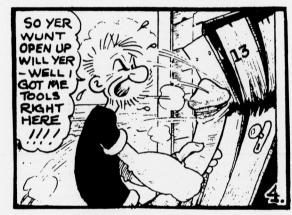

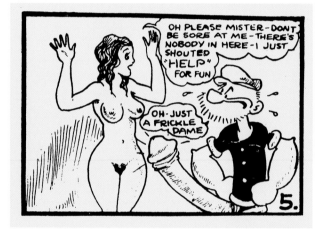

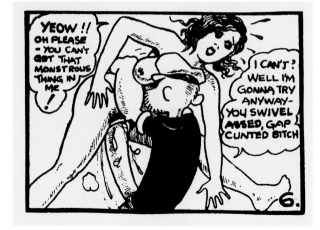

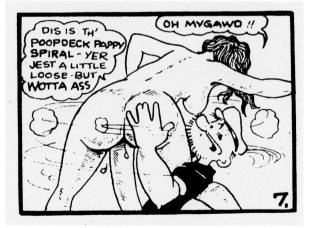

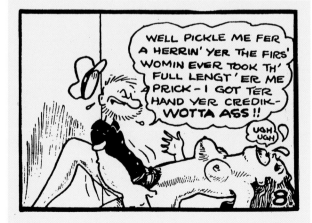

22

Poop-Deck Pappy was the father of Popeye in the Thimble Theatre classic. Better endowed, apparently, than even his spinach-eating son, he remained a part of the adventures (legitimate and otherwise) for years. Aside from Pappy's beard (and equipment), father and son were physically dead-ringers, right down to the corncob pipes and the anchors on their bulging forearms.

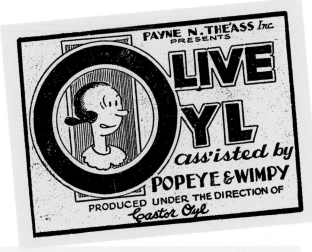
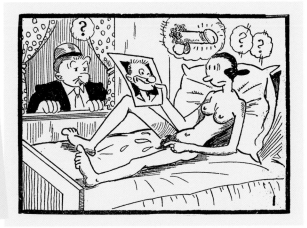
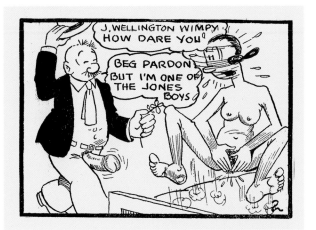
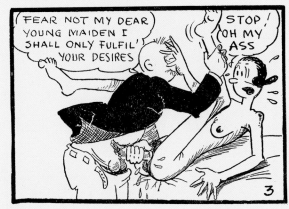
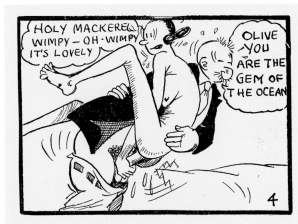
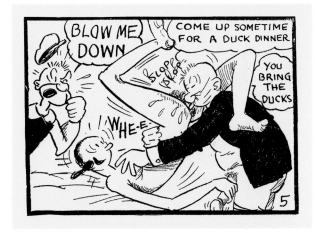
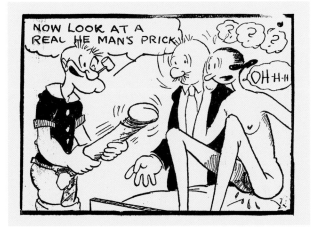
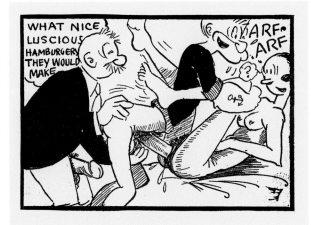
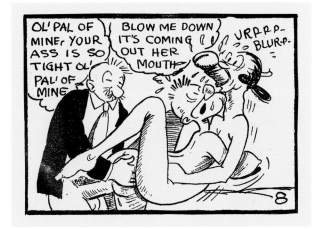

Olive Oyl was tall and gaunt, and she wore her hair in a kind of bun—all the time. Like all the Popeye characters, she was distorted, but pleasantly so. Olive Oyl was very popular, and she took well to the animated cartoons that Max Fleischer created for Paramount in the thirties and forties.

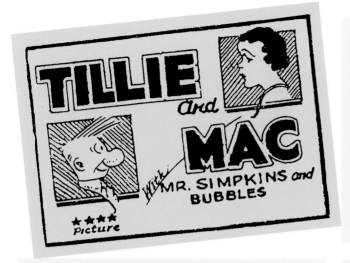

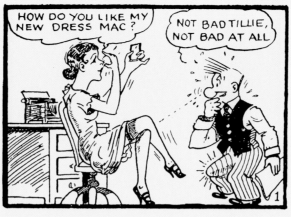

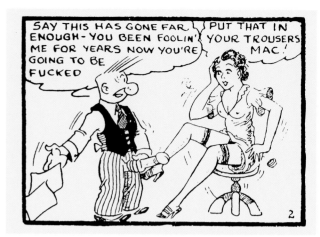

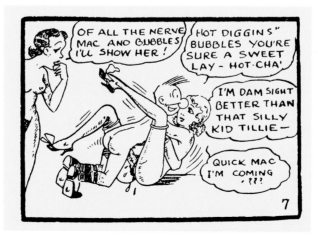

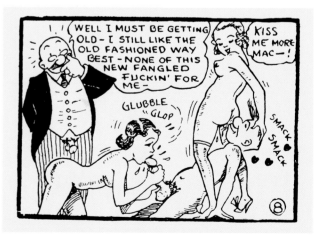

24

When a certain degree of propriety (or obscurity) was called for, Tijuana Bibles were often called Tillie-and-Mac Books, after the pair who starred in many of them. The "real" Tillie was the quintessential working girl, heroine of the long-running strip Tillie the Toiler. (There were others: Winnie Winkle, Dixie Dugan, Fritzi Ritz, and even Ella Cinders.) Mac was Tillie's rather vacant swain. The pair were popular with the eight-pager artists— she was pretty, he was funny-looking, and both were presumably horny.

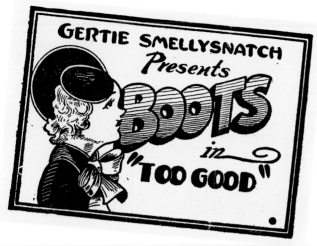
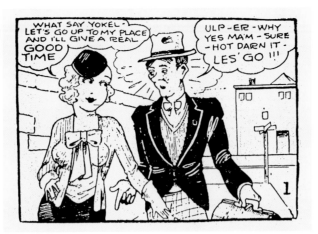
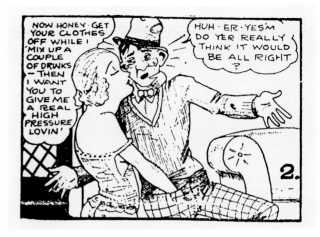

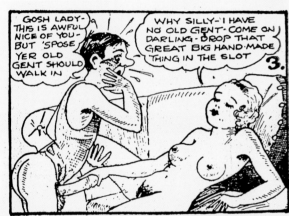
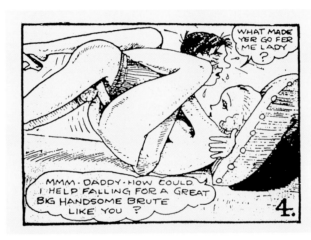
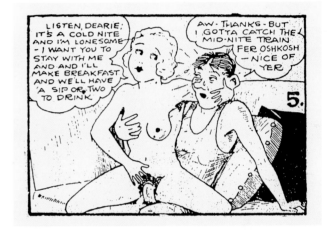

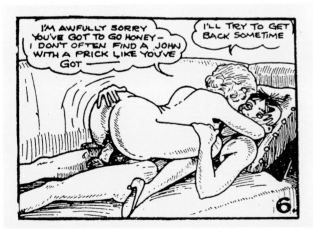
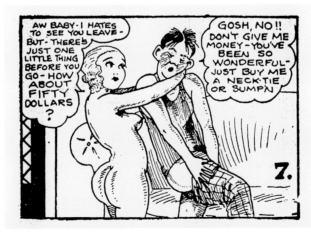
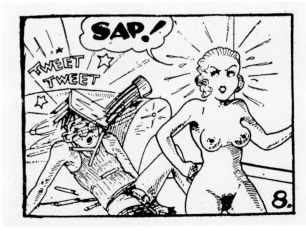

25

The twenties were the decade of the classic girl strip, surely brought on by the social vibrations of the New Woman. It was the era of the flapper, the It Girl, and Hemingway's Lady Brett Ashley, to name just a few "new" types. Gay and flirtatious, Boots came from this same heady cauldron. She was created in 1924 by Edgar Martin. Boots and Her Buddies was also one of the first strips to include occasional cut-out clothes, obviously (I think) for the little-girl audience.

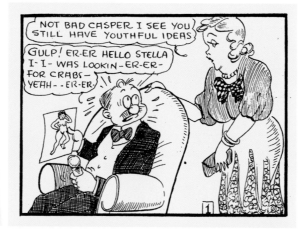

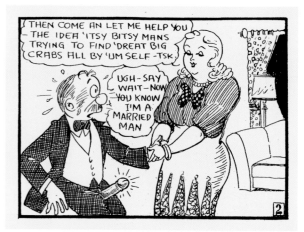

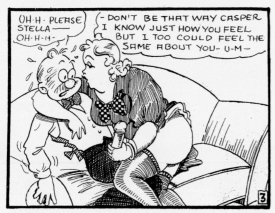

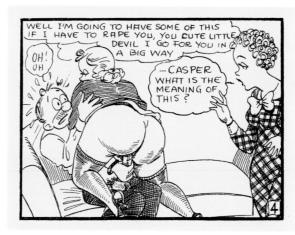

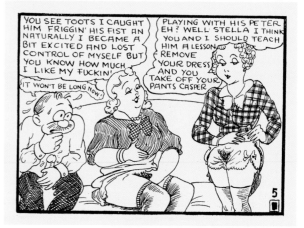

26

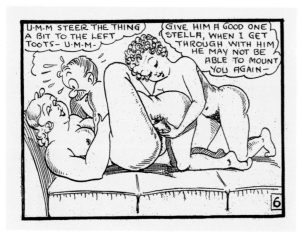

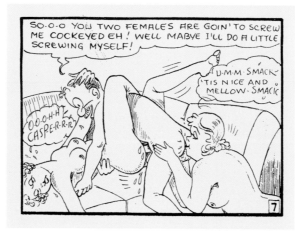

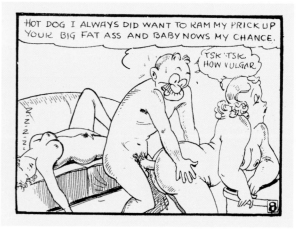

Toots and Casper were first drawn by Jimmy Murphy in 1920. They were the quintessential married couple, the proud parents of Buttercup, their beloved baby. The eight-pager artists adored married-couple strips (and almost-married-couple strips), and produced, over the years, more than a few booklets depicting their domestic adventures.

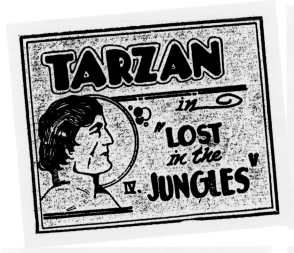

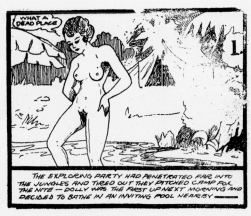

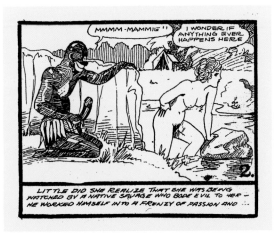

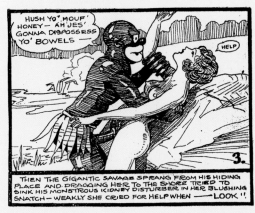

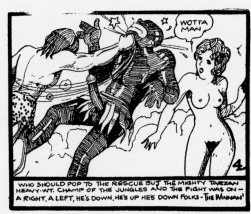

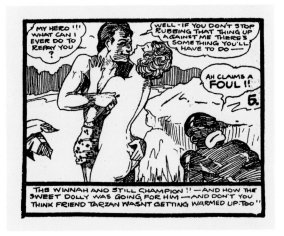

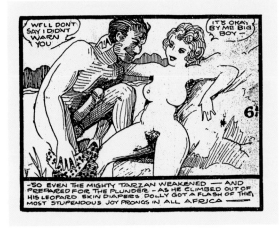

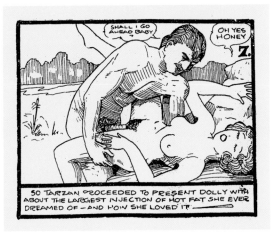

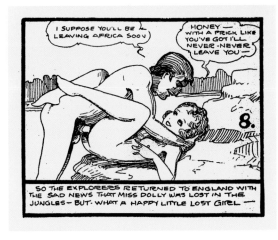

Edgar Rice Burroughs wrote the book Tarzan in 1914. Soon it became a film—or rather an endless series of films—and, in 1929, a comic strip (the direct basis for the Tijuana Bible version). Like Superman, Tarzan has evolved into a cultural monolith worth billions over the long run. Not bad, considering that Burroughs, the creator, had never been to Africa when he wrote his classic!

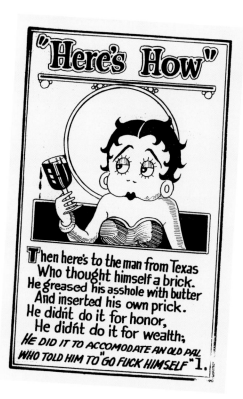

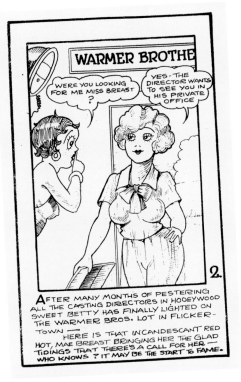

Sixteen-Pagers

The far lesser-known version of the Tijuana Bibles was the sixteen-pager. Produced when the form was at its zenith during the mid-1930s, the true Golden Age of the Bibles, it was vertical in format, usually had better cover stock, and was more expensive than its flimsy cousin. And it was always done by an artist of significant expertise. Owing to its extended continuity and much longer text, it was altogether a more literary venture than the eight-pager, which usually depended solely upon the set-up–punch-line formula.

The sixteen-pager is also far scarcer. Whereas thousands of eight-pagers (some say over a thousand) were printed in a period that ran from the late 1920s to the mid-1950s, only fifty or sixty genuine sixteen-pagers have been accounted for, and are much coveted by collectors of such ephemera. Of these, at least six star Mae West. Unlike her sister luminaries, she surely relished the gross adulation.

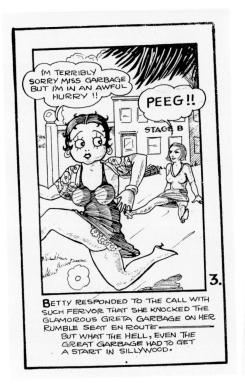

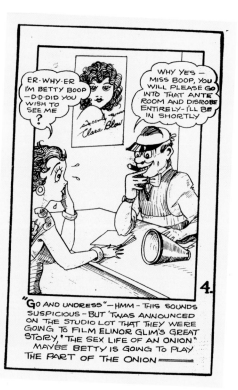

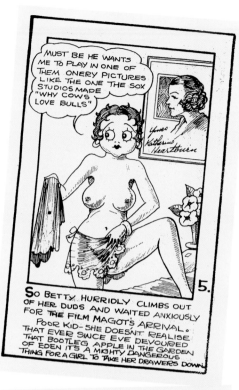

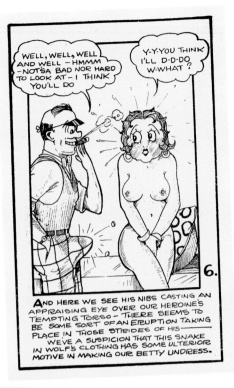

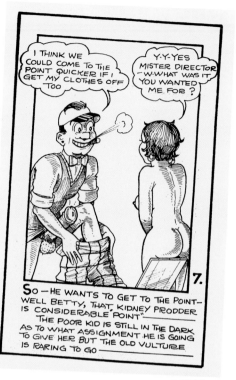

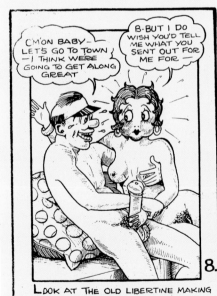

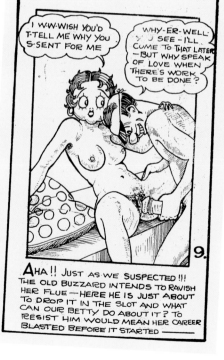

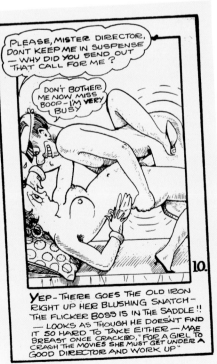

Betty Boop began as an animated film flapper at the end of the twenties. She was partly based on Helen Kane, the boop-boop-a-doop singer of the time, but visually she was derived from a pair of famous film flappers: sunny Colleen Moore and the cult figure Louise Brooks. Boop was both naive and fearsomely seductive, and her cartoons were very successful. Her creator, Max Fleischer, scored many other victories, but none of them compared to this flirtatious little lady with the hourglass figure and the tiny, tiny voice (actually that of Mae Questel). When the nostalgia binge of the sixties took off, it quickly retrieved Ms. Boop from her brief oblivion, and she has never left us.

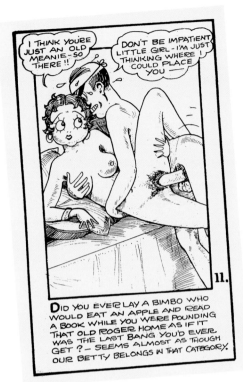

I THINK YOU'RE JUST AN OLD MEANIE—SO THERE!!

DON'T BE IMPATIENT LITTLE GIRL—I'M JUST THINKING WHERE I COULD PLACE YOU

11.

DID YOU EVER LAY A BIMBO WHO WOULD EAT AN APPLE AND READ A BOOK WHILE YOU WERE POUNDING THAT OLD ROGER HOME AS IF IT WAS THE LAST BANG YOU'D EVER GET?—SEEMS ALMOST AS THOUGH OUR BETTY BELONGS IN THAT CATEGORY.

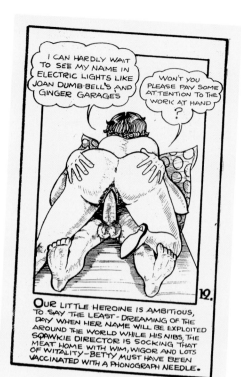

I CAN HARDLY WAIT TO SEE MY NAME IN ELECTRIC LIGHTS LIKE JOAN DUMB-BELL'S AND GINGER GARAGES

WON'T YOU PLEASE PAY SOME ATTENTION TO THE WORK AT HAND?

12.

OUR LITTLE HEROINE IS AMBITIOUS, TO SAY THE LEAST—DREAMING OF THE DAY WHEN HER NAME WILL BE EXPLOITED AROUND THE WORLD WHILE HIS NIBS, THE SQAWKIE DIRECTOR IS SOCKING THAT MEAT HOME WITH WIM, WIGOR AND LOTS OF WITALITY—BETTY MUST HAVE BEEN VACCINATED WITH A PHONOGRAPH NEEDLE.

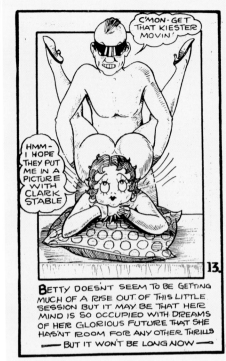

C'MON—GET THAT KIESTER MOVIN'

HMM—I HOPE THEY PUT ME IN A PICTURE WITH CLARK STABLE

13.

BETTY DOESN'T SEEM TO BE GETTING MUCH OF A RISE OUT OF THIS LITTLE SESSION BUT IT MAY BE THAT HER MIND IS SO OCCUPIED WITH DREAMS OF HER GLORIOUS FUTURE THAT SHE HASN'T ROOM FOR ANY OTHER THRILLS ——— BUT IT WON'T BE LONG NOW ———

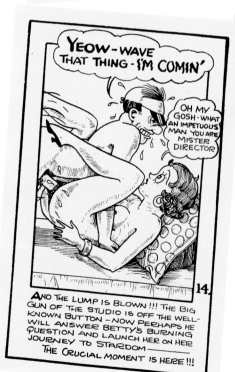

YEOW—WAVE THAT THING—I'M COMIN'

OH MY GOSH—WHAT AN IMPETUOUS MAN YOU ARE MISTER DIRECTOR

14.

AND THE LUMP IS BLOWN!!! THE BIG GUN OF THE STUDIO IS OFF THE WELL-KNOWN BUTTON—NOW PERHAPS HE WILL ANSWER BETTY'S BURNING QUESTION AND LAUNCH HER ON HER JOURNEY TO STARDOM ———— THE CRUCIAL MOMENT IS HERE!!!

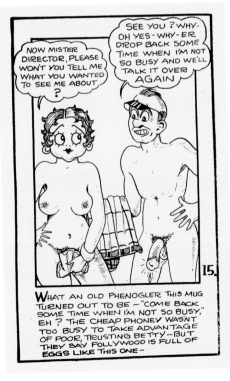

NOW MISTER DIRECTOR, PLEASE WON'T YOU TELL ME WHAT YOU WANTED TO SEE ME ABOUT?

SEE YOU? WHY—OH YES—WHY—ER DROP BACK SOME TIME WHEN I'M NOT SO BUSY AND WE'LL TALK IT OVER AGAIN

15.

WHAT AN OLD PHENOGLER THIS MUG TURNED OUT TO BE—"COME BACK SOME TIME WHEN I'M NOT SO BUSY," EH? THE CHEAP PHONEY WASN'T TOO BUSY TO TAKE ADVANTAGE OF POOR, TRUSTING BETTY—BUT THEY SAY FOLLYWOOD IS FULL OF EGGS LIKE THIS ONE—

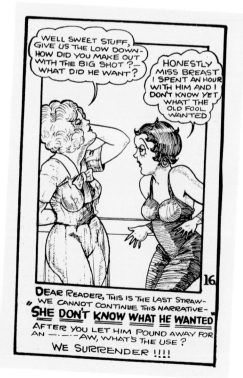

WELL SWEET STUFF, GIVE US THE LOW DOWN—HOW DID YOU MAKE OUT WITH THE BIG SHOT?—WHAT DID HE WANT?

HONESTLY MISS BREAST I SPENT AN HOUR WITH HIM AND I DON'T KNOW YET WHAT THE OLD FOOL WANTED

16.

DEAR READER, THIS IS THE LAST STRAW—WE CANNOT CONTINUE THIS NARRATIVE—"SHE DON'T KNOW WHAT HE WANTED" AFTER YOU LET HIM POUND AWAY FOR AN ————AW, WHAT'S THE USE? WE SURRENDER!!!!

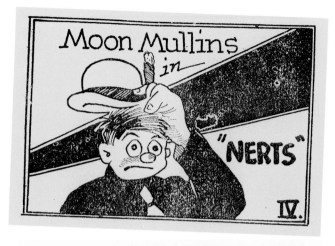

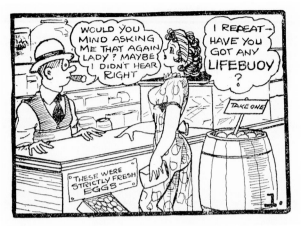

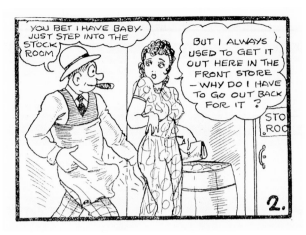

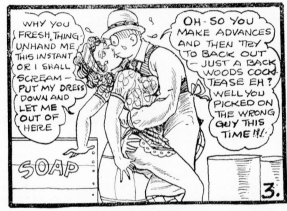

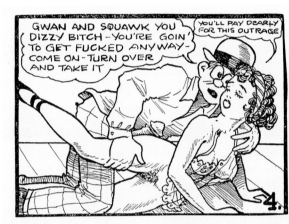

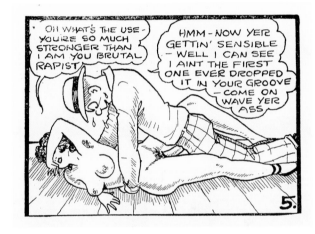

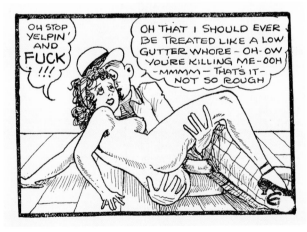

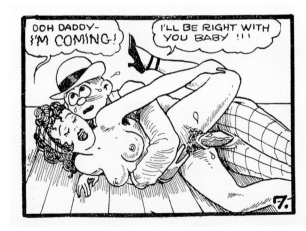

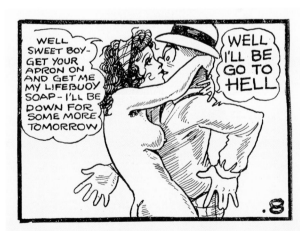

Moon Mullins was a robust and rich comic strip of, basically, the thirties, drawn by a man named Frank Willard. Moon Mullins the character was a lout, but a lout with klass, and his colorful ménage included a range of social types from rich to poor, from young to old, and from white to black. Mullins wore a derby and a cigar, perpetually, and the only work that interested him was horizontal. Those characteristics eminently qualified him for the Tijuana Bibles.

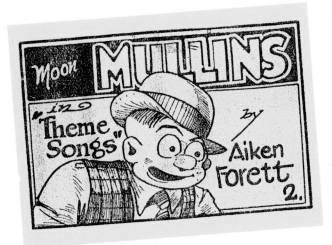

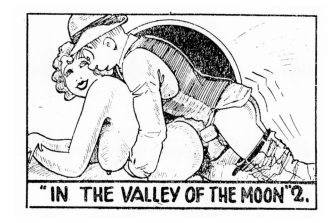

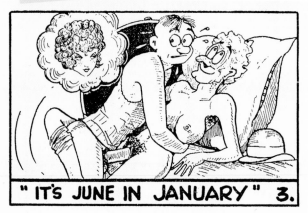

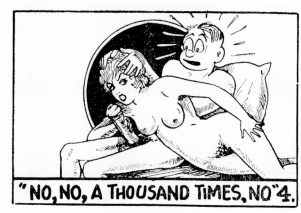

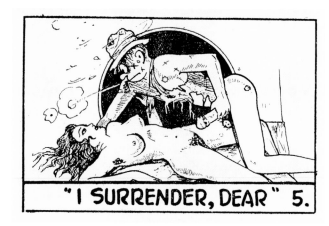

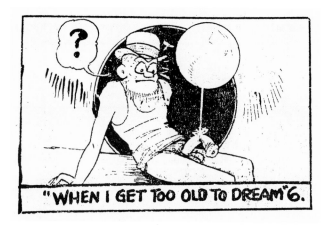

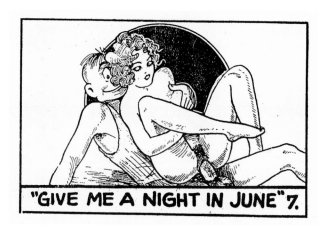

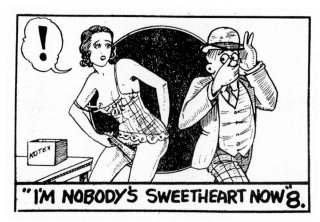

32

Theme Songs *employs Moon Mullins's best talents to illustrate the titles of eight popular songs of the time (ca. 1934). Few of these are around today, but they were all Hit Parade numbers then. Title number eight touches upon matters menstrual—a nuance unusual even for the audacious eight-pager.*

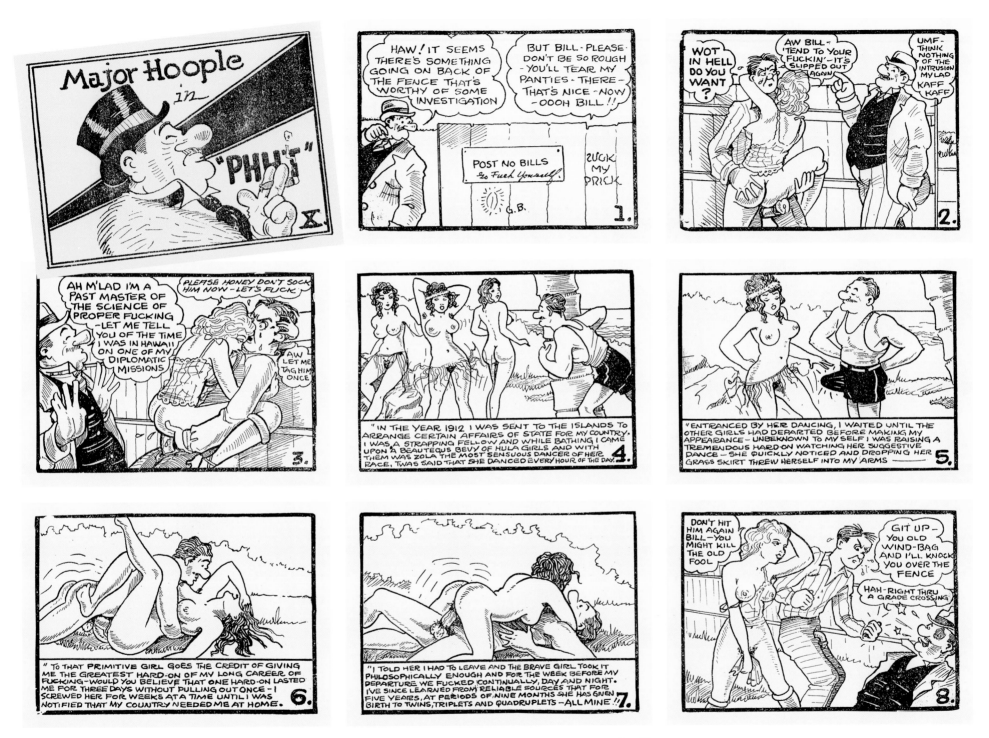

Major Hoople was a large, pompous windbag whose vocabulary was filled with exclamations like Faw! and Egad! His wife Martha owned and ran a boarding house, which may explain why his conversation generally focused upon very tall tales about his youth. Gene Aherne drew **Our Boarding House** in a single panel, and it was first published in 1921.

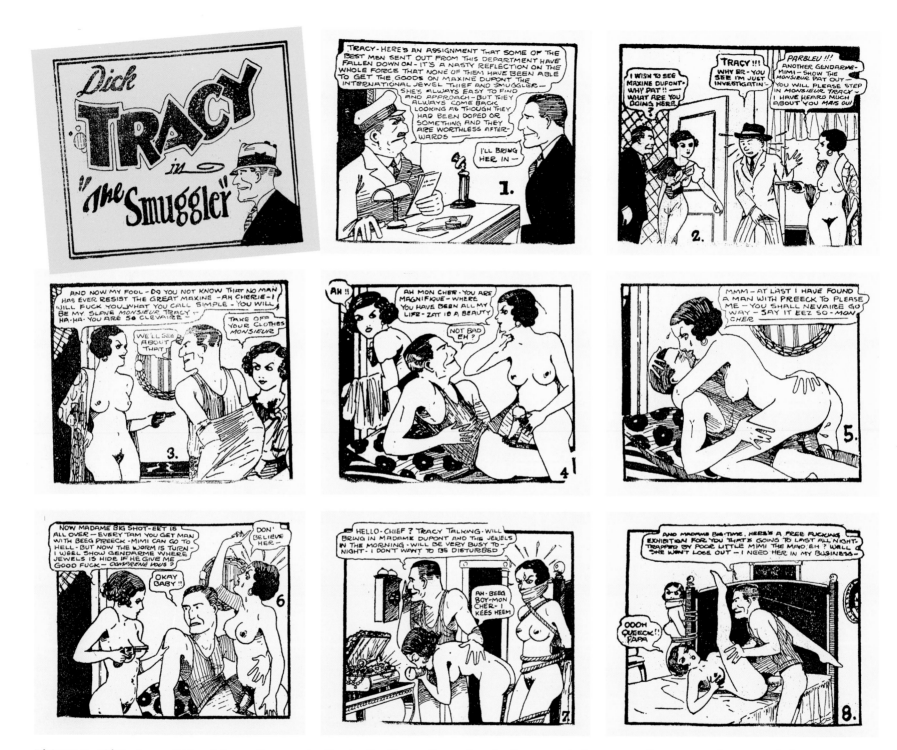

34

Dick Tracy, *which was created and drawn, for eons, by Chester Gould, was the classic cops-and-robbers strip. Inspired by the lawlessness of the Prohibition era, Tracy became the pin-up boy of the law-and-order folk. Gould's singular* *imagination concocted a never-ending parade of ghastly criminals like Flattop and Pruneface. Several years ago, many of them were resurrected for the big-budget film with Warren Beatty as the daring dick.*

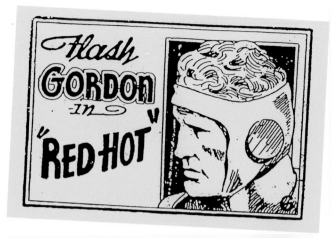

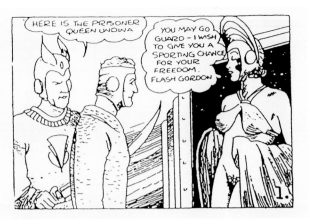

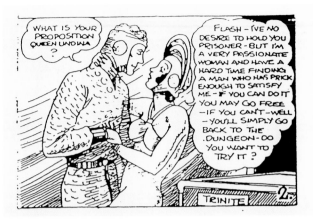

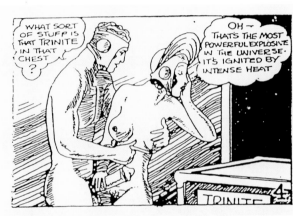

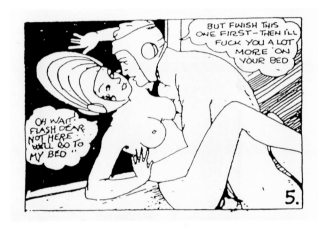

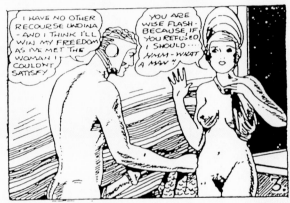

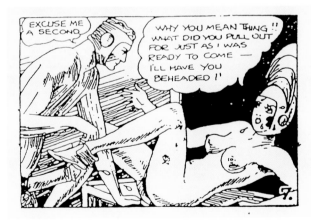

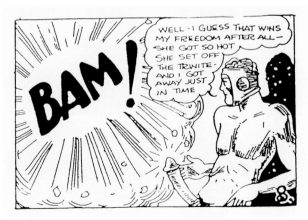

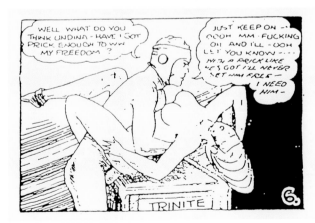

Of all the spaceman comic strips that cropped up in the very late twenties and early thirties, including Buck Rogers and Brick Bradford, the most glamorous and influential by far was Flash Gordon. Drawn first by Alex Raymond in 1929, it was surely one of the most elegant of all comic strips. Raymond, who died young and tragically in a car crash, was a draftsman of rare ability, and his strip became so popular that it spawned a series of films (now cult films) in the late thirties with Buster Crabbe as the dashing spaceman.

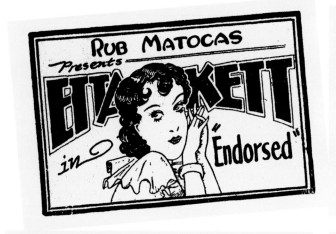
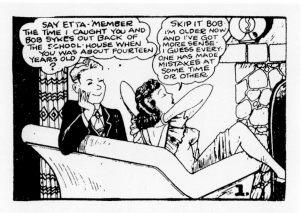
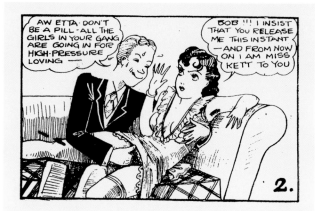
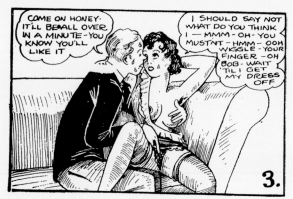
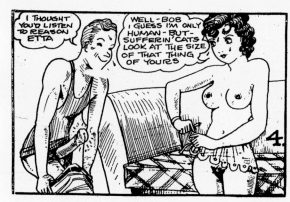
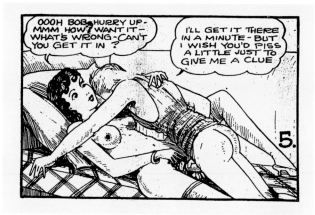
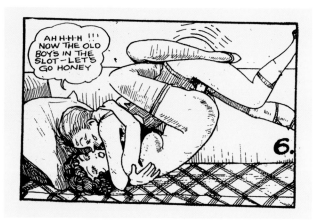
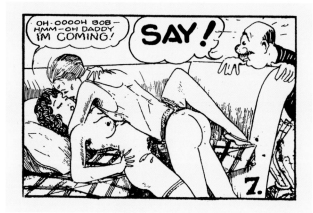
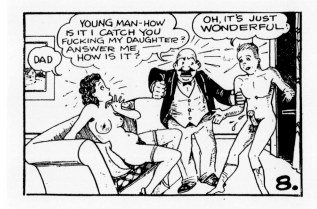

36

Etta Kett was one more girl strip, drawn by Paul Robinson under the auspices of King Features. While the strip was not of any particular historical note, the drawings had a nice style, and Etta Kett remained popular into the fifties.

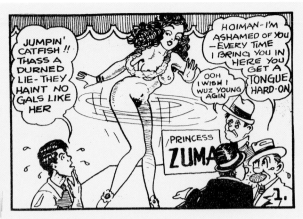

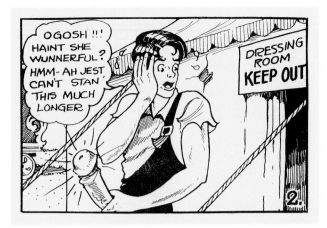

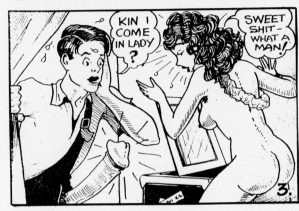

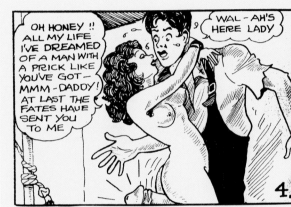

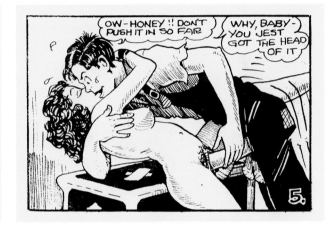

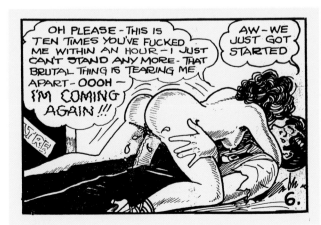

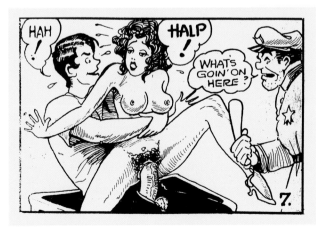

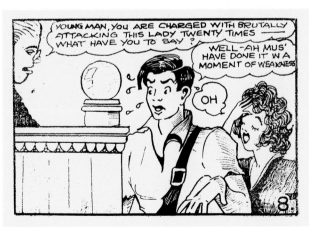

37

It's hard to realize now how enormously popular Li'l Abner once was. Aside from the strip, about the strapping young man and his yearning beauty and their hometown of Dogpatch, deep in hillbilly country, there were the toys, games, products, and even a rather successful Broadway musical and film. By the sixties, though, the creator of this world, Al Capp, lost touch with his public, particularly its social and political persuasions. Some strips go on forever, lamentably. Li'l Abner had a good run, as they say, but when it was over, it was over. The booklet, however, is from the good old days when, as you can see, Abner was an upstanding lad, the Pride of Dogpatch.

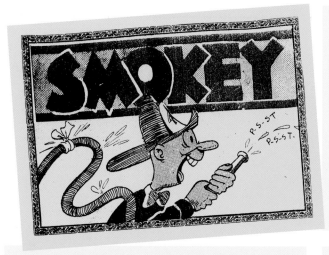

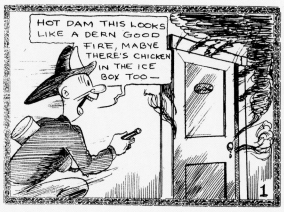

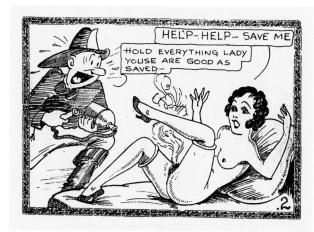

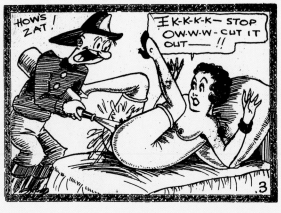

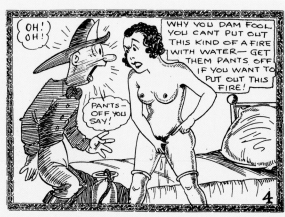

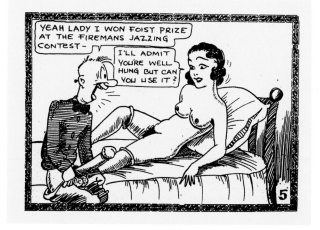

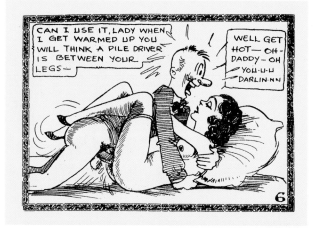

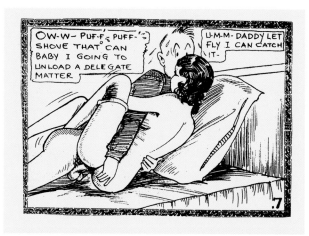

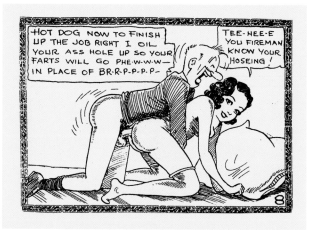

38

Smokey Stover *was a positively zany comic strip about a fireman of the same name. It began in the thirties and lasted some two decades, and while it was around, there was nothing else like it. Surreal to the point of grotesquerie, it mangled both form and language, but its fans would accept no other product. The originator was an artist named Bill Holman, and I fear that he has taken the secret of his success with him.*

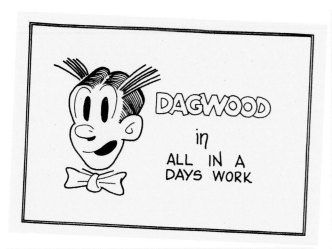

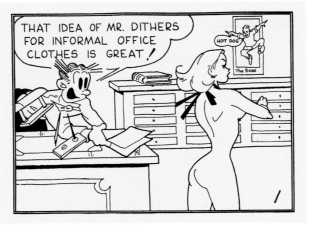

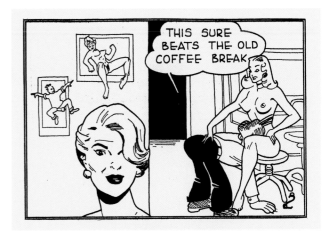

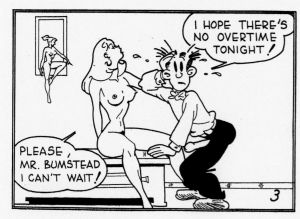

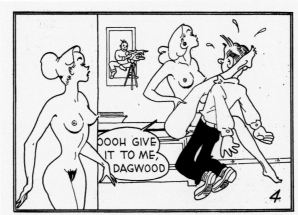

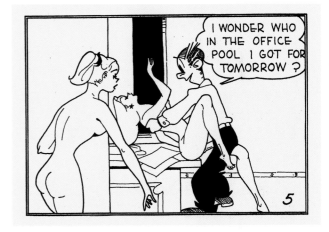

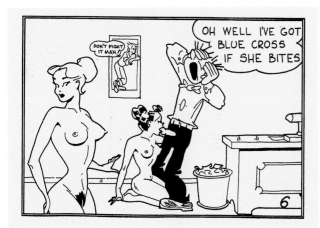

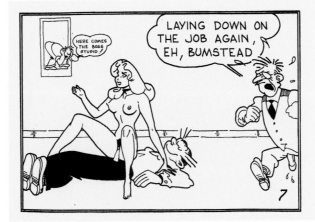

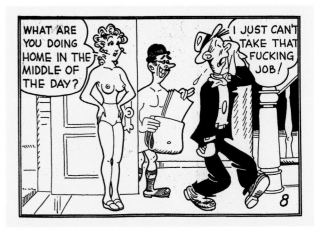

Dagwood was the beleaguered hubby of Blondie, from the strip of the same name, created in 1930. Blondie was more or less a streamlined domestic comic strip, far more hip than most of the married-couple strips that came before. The drawing in this eight-pager is superb, of a quality rarely found in this usually heavy-handed genre. Obviously from the forties or even early fifties, it is so deft that it looks as though it could have been done by Chic Young himself. In addition, the penetration is executed with a subtlety that is unusual as well.

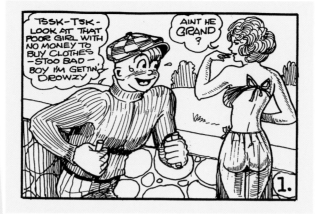

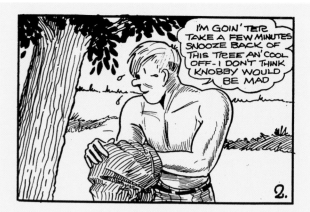

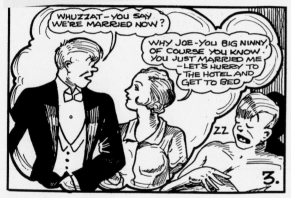

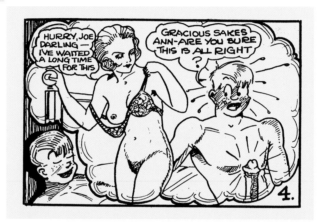

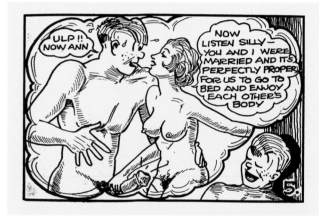

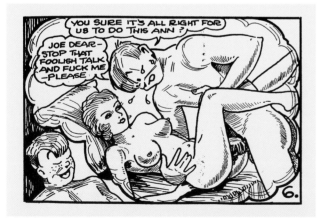

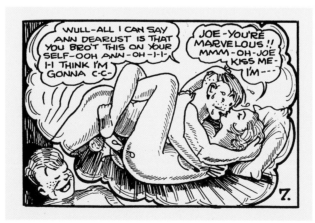

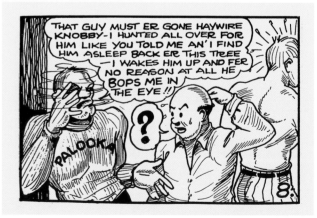

40

Joe Palooka is another of the comic strips that couldn't outrun Father Time. Created by the cartoonist Ham Fisher (who tragically committed suicide in 1955), Palooka was a simple, amiable young man who was just the greatest fighter of his time. Not unlike Li'l Abner in his naiveté (the comic strips adored lovable yokels), Joe was the idol of millions and a great role model back in the days when most athletes didn't mind that responsibility. He was a hero in the Second World War, and his popularity lasted into the sixties. Like the rest of lower echelon boxing, he was partially done in by that ol' devil television, and, probably, Cassius Clay, a.k.a. Muhammad Ali, who was the polar opposite of Joe Palooka.

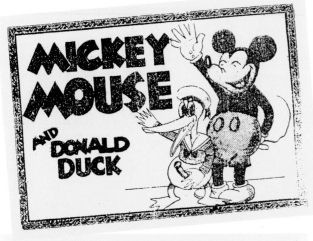

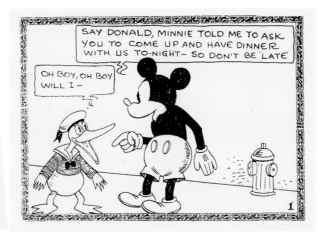

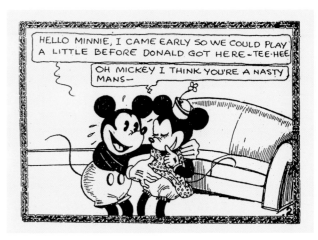

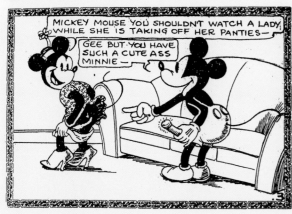

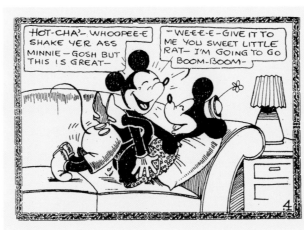

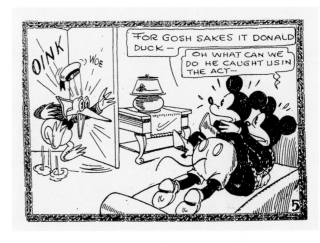

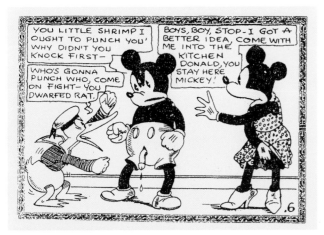

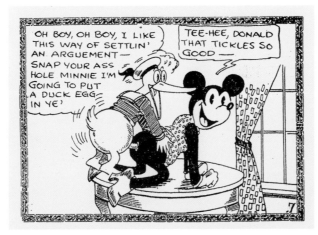

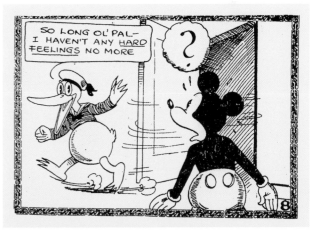

By the time the eight-pagers got around to lampooning Mickey Mouse (along with Minnie and Donald), the marvelous rodent, born in the twenties, already had a sizable stranglehold on the hearts and minds of the American populace. Like Mae West, Popeye, and Al Capone, MM was more than a current personality: he was a symbol, an icon, something uniquely ours and somehow urgent. That sense of urgency activated the need to satirize, so much a part of all cartoonists' fabric; and satirize they did.

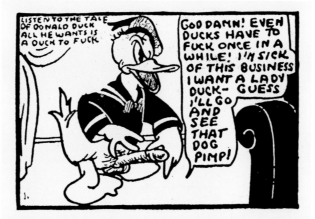

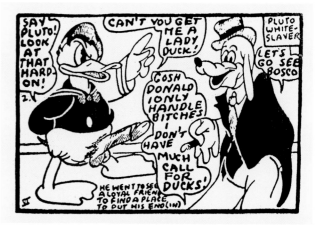

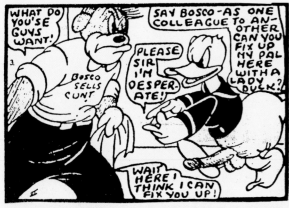

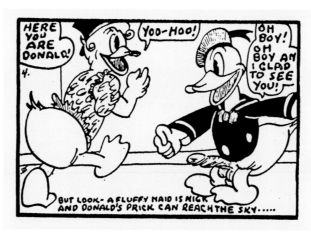

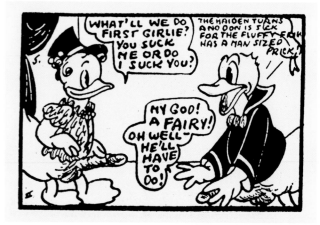

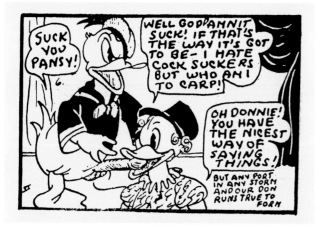

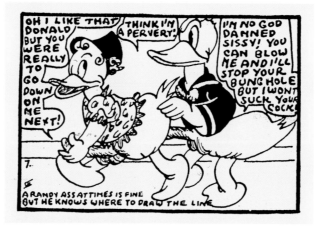

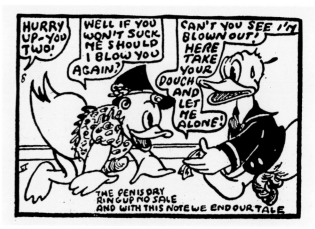

42

Mickey was nurtured by the thirties; Donald Duck, with his obvious neuroses, his squawks, and his uncontrollable tantrums, was closer to the soul of postwar America. Confused and eternally put-upon, Donald is the paranoid as victim (or the victim as paranoid), a kind of comic-strip cousin to the terror-filled paintings of the late Francis Bacon (another guide to the postwar mind). In this Tijuana Bible, the artist, somewhat clumsy to begin with, captures the special malevolence of the Duck That Acts Like a Man.

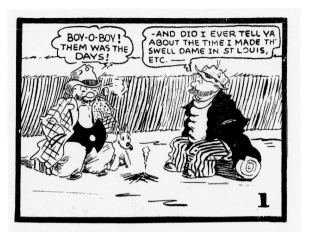

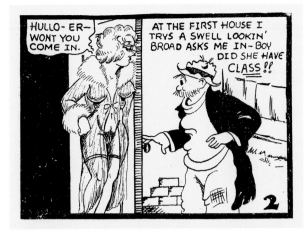

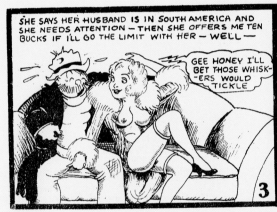

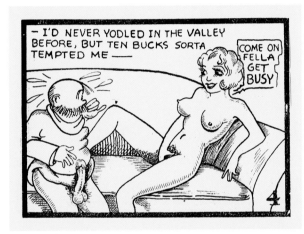

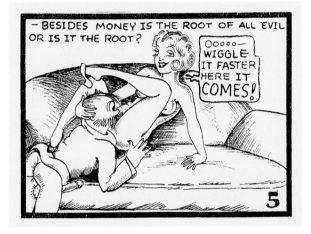

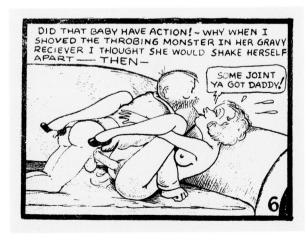

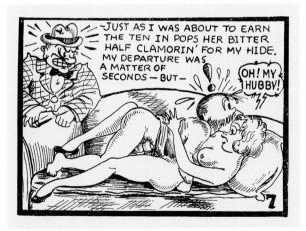

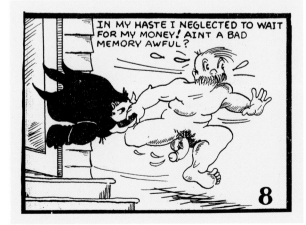

During the Great Depression, when there was no chicken in every pot nor even a pot for every family, the homeless, jobless hobo was a common sight, tramping the roads and riding the rails in search of food and casual labor. It was the golden age of tramp art, with songs like "Hallelujah, I'm a Bum," films like Wild Boys of the Road, *and comic strips like* Pete the Tramp.

Our Fellow Americans: Heebs, Wops, Traveling Salesmen, and the Farmer's Daughter

Like all pornography, the Tijuana Bibles sought, basically, to turn you on and perhaps to offend. Without knowing it, they performed several other tasks as well. First, they were a sexual primer for a generation or two that were not given condoms in high school (nor even in pharmacies). With the help of Maggie and Jiggs, adolescents were taught who did what and to whom. As Jimmy Durante once put it, "my father taught me about the boids and the bees—matter of fact, he did it so well it took me years to get used to goils!"

In addition, the eight-pagers performed another benevolent cultural service: they collected, illustrated (quite graphically), and recycled American sexual humor and folklore that had been around since the days of Harrigan and Hart. From pool halls, locker rooms, and burlesque houses, a fund of jokes and skits and bawdy scenarios were compiled, given a new coat of paint, and sent out to strut their stuff. It was almost as though the Tijuana Bible artists were engaged in some quaint subterranean WPA project: locating the Well of Nastiness, and, with the little books, conserving it for generations to come.

Take this scenario: Hymie, whose wife has recently gone to her reward, is busily copulating with Ella Cinders in *The New Maid.* His friend Izzy walks in and is aghast. Izzy: "Hymie, what on earth are you doing?" Hymie responds: "Izzy, in my grief I should know what I'm doing!!!" And so on.

Along these lines no sentence, with the possible exception of "Play 'Melancholy Baby,'" was quite so ubiquitous in barrooms and saloons as "Did you hear the one about the traveling salesman and the farmer's daughter?" Most of the time the traveling salesman referred to was the Fuller Brush Man, the Paul Bunyan of barbershop and burlesque-show banter. Half folk hero and half hapless Candide, the Fuller Brush Man was the original Neal Cassady of the endless American commercial highway. He dispensed his wares, and any other number of notions as well, to housewife, widow, maiden, and spinster, displaying a door-to-door charm that was lavishly laced with W. C. Fieldsian blarney. When this enduring myth caught the attention of the very best of the eight-pager colony, it was a match made in heaven. The cartoonist embarked upon a series of ten adventures of the peripatetic Lothario, producing a suite that is among the most memorable of all Tijuana Bibles.

"I am not only the poet of goodness," Walt Whitman declared; "I do not decline to be the poet of wickedness also." Like the culture they lampooned, the eight-pagers, bastard offspring of the American thirties, freely utilized the racial stereotypes and crude caricatures typical of this troubled time. Long before the current sensitivity to such things, ethnic differences and racial characteristics were described by gross distortion and painted with the very broadest brush. Examples of this attitude, outside the eight-pager, are utterly myriad. Not only were these attitudes accepted; they were the norm. Aunt Jemima, long-time logo for a pancake mix, is still with us though highly modified; Abie the Agent, a very successful comic strip, was drawn by Harry Hershfield, a Jew; and Henry Armetta was a character actor who parlayed a heavy Italian accent and a set of matching mannerisms into a long Hollywood career (as late as the fifties he starred in a TV sitcom called *Life with Luigi*). However derisive the material seems in hindsight, racial caricature was standard fare when the Tijuana Bibles were produced. The little books found every ethnic strain (and stain) in American folkways and reported the findings with a lewd passion uniquely theirs.

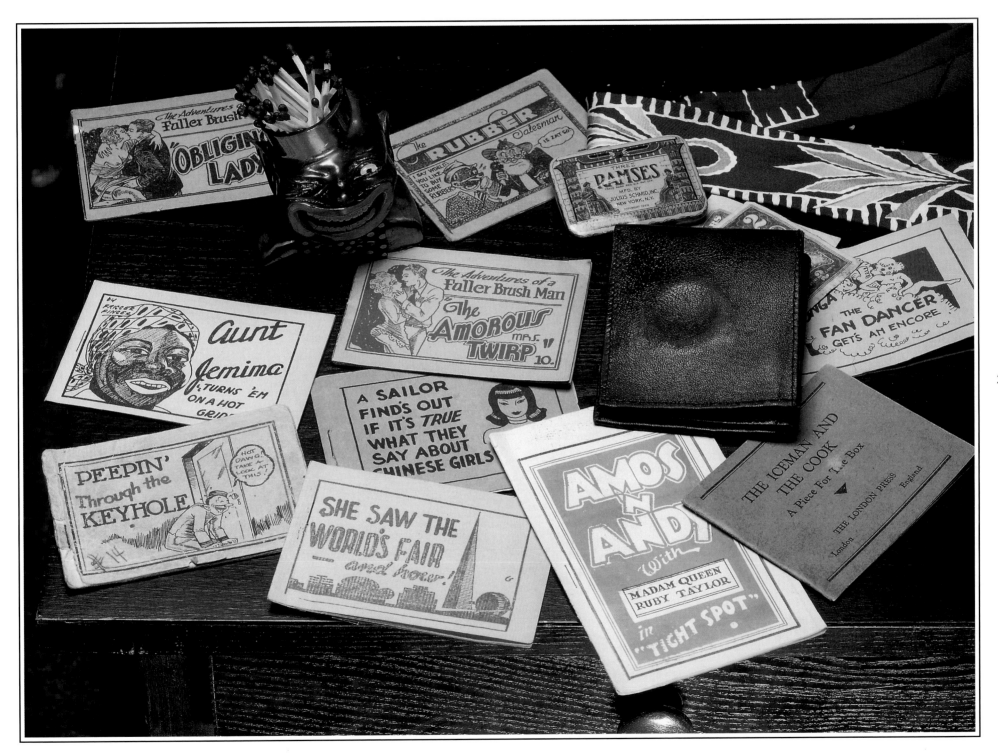

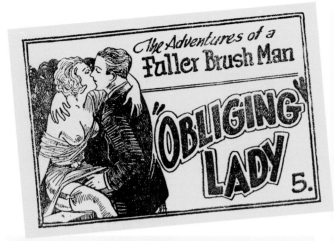

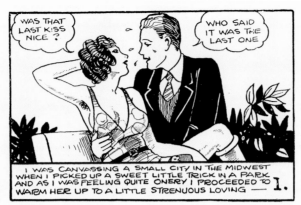

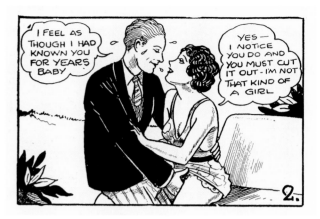

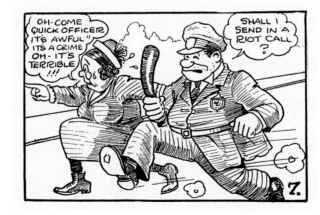

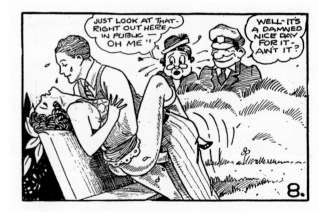

46

The aptly nicknamed Mr. Prolific did ten installments of The Adventures of a Fuller Brush Man, *which may well have been his crowning achievement. They are all exquisitely drawn and well composed, and the dialogue (and subsidiary text), while not exactly high literature, run smoothly and intelligently with the visual elements. The legendary salesman is portrayed as a traveling sex instructor. The cartoonist is so articulate, one could almost use his work as instructional booklets. (For a great many men, in particular, growing up in the late twenties and thirties, the Tijuana Bible was precisely that, as Spiegelman points out in his introduction to this collection.) In* Obliging Lady, *the specter of censorship tries to assert itself, only to be refuted by, of all people, the billy-clubbed policeman!*

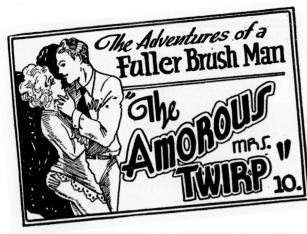

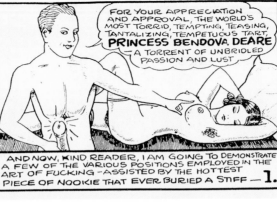

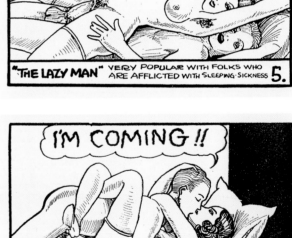

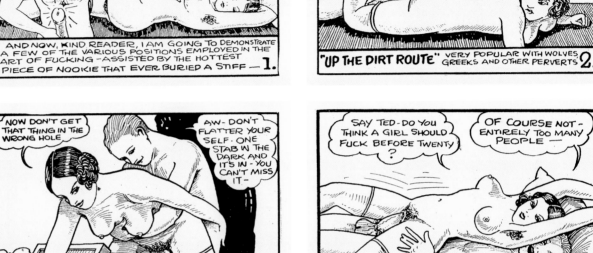

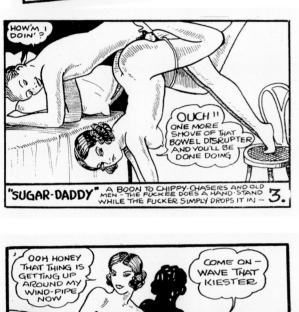

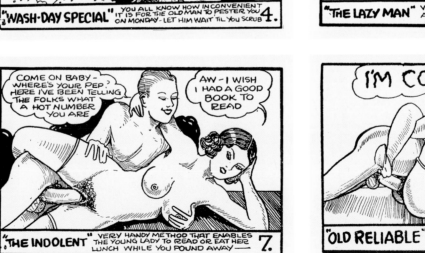

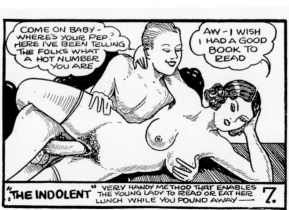

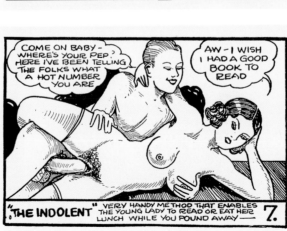

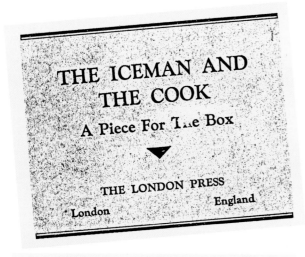

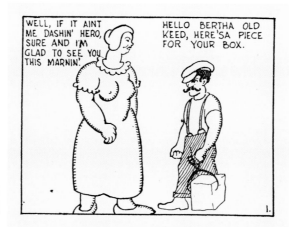

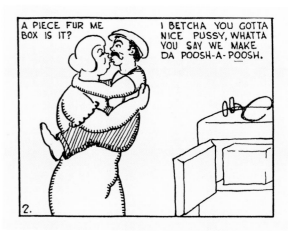

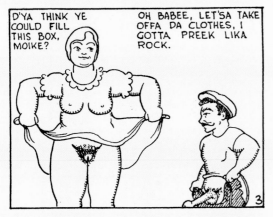

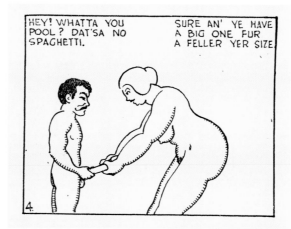

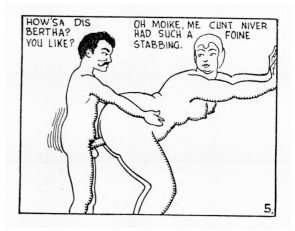

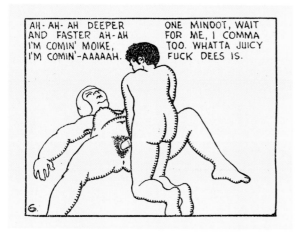

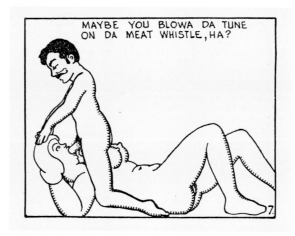

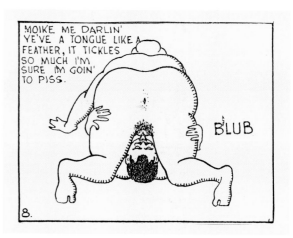

48

Despite its artistic shortcomings, The Iceman and the Cook is a singular bit of ethnic caricature, from a time that still found humor in such things. The dialogue is replete with both Italian and Irish accents, and the name of the supposed publisher, the London Press in England (where else?), suggests a hankering for pedigree. Needless to add, the locations of virtually all the "publishers" of Tijuana Bibles were wishful thinking.

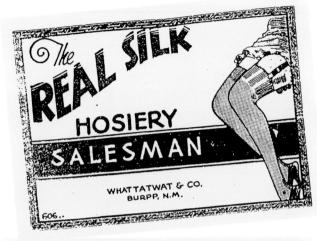

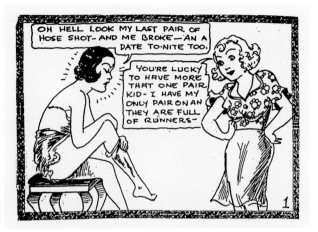

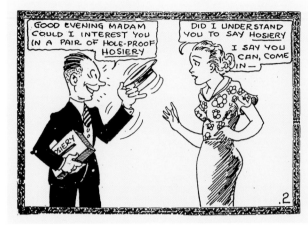

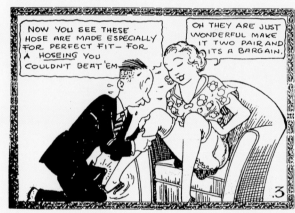

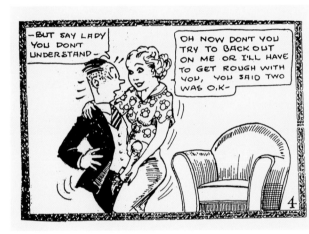

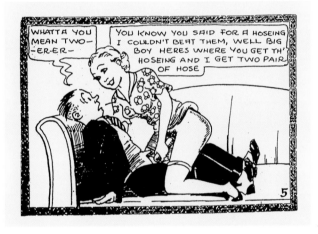

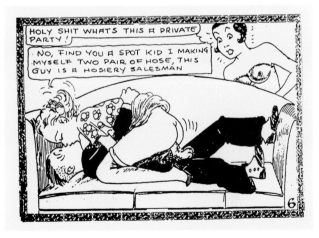

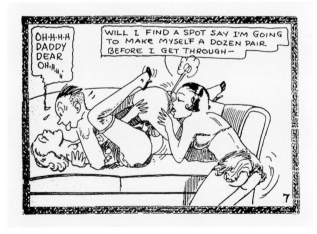

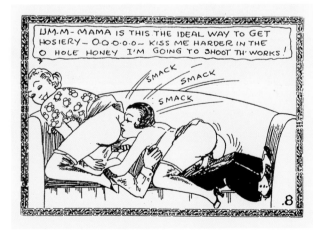

49

The traveling salesman was an indispensable component in any pornographic endeavor in the early days (this goes for porno films as well). He is the unexpected visitor bearing gifts, the serendipitous guest, and often a well-hung stud to boot. A classic example was the Fuller Brush man, but as long as the salesman had the goods, he was welcome.

In the Depression, real silk was a scarce commodity, and nylon was even rarer. But if it wasn't stockings he was selling, it could be virtually anything, so long as it goosed the plot and moved the action along to its happy ending.

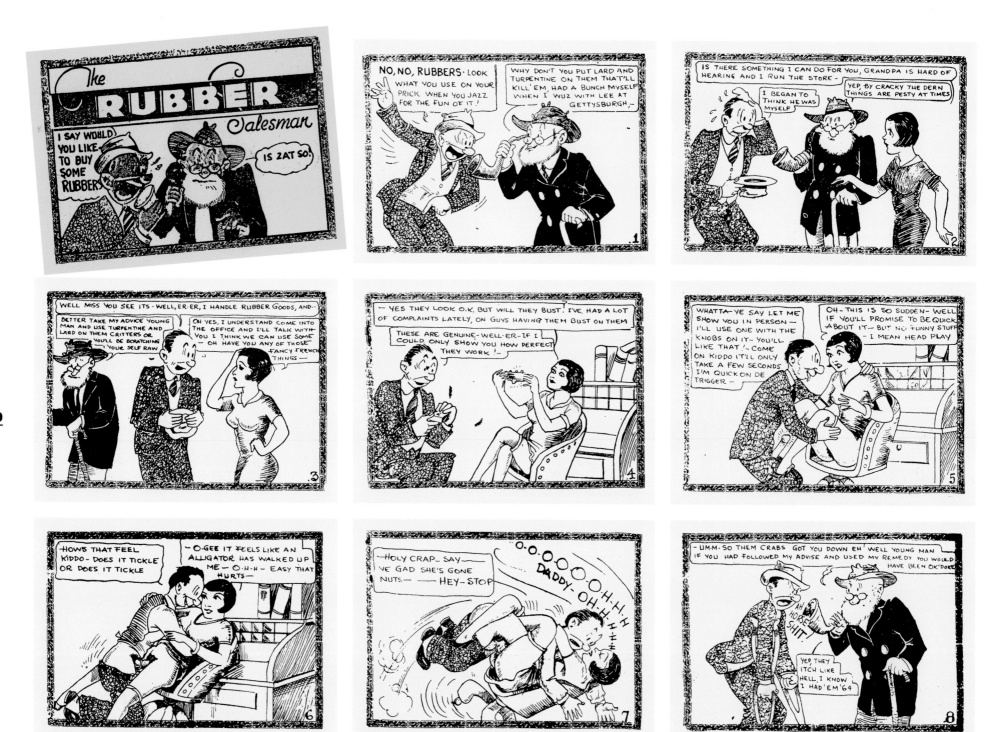

In this traveling-salesman variant, the hoary gentleman with the white beard thinks that crabs are the issue; fortunately, it's his more knowing granddaughter who runs the store. The whole episode proceeds with the brisk pace of a blackout sketch at Minsky's Burlesque.

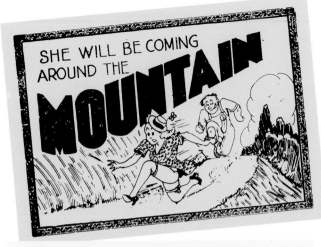

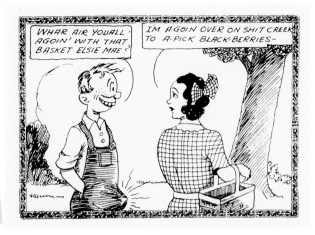

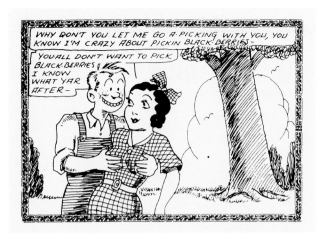

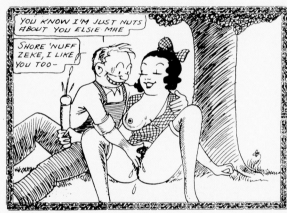

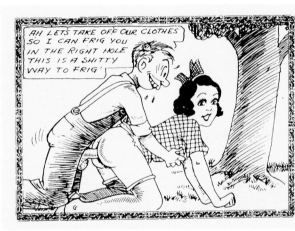

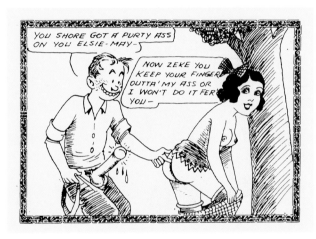

51

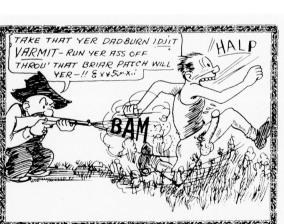

In the heyday of the eight-pager, there was a fascination with hillbillies and mountain folk that found its way into American humor and particularly into cartoons, comic books, funny postcards, and such. Country music had begun to generate a considerable audience as well, and series like the *Ma and Pa Kettle* films had taken root in Hollywood. This booklet puns on just how the lady in the song will be coming round the mountain, and it suggests what was meant by a shotgun wedding.

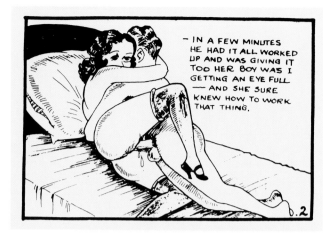

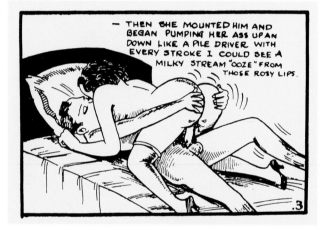

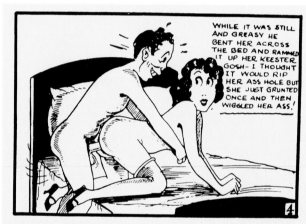

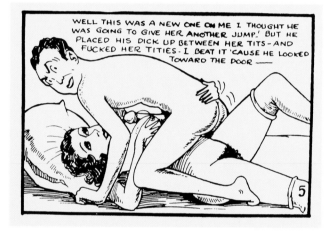

52

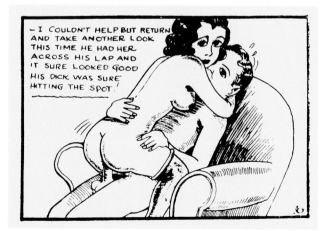

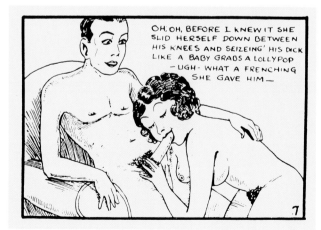

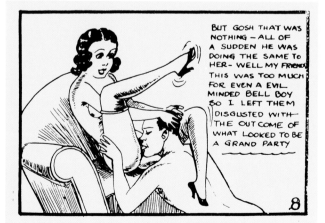

This is one of those eight-pagers that could almost serve as a rather florid and inspired sex manual. The figures are drawn large, and the activities are sequential. The bellhop's inability, in the last panel, to condone cunnilingus is not unusual for the time (the mid-thirties). Like quiche, it was not for "real men."

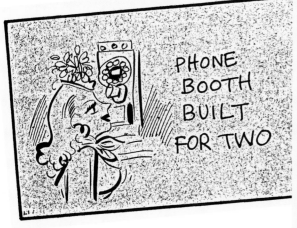

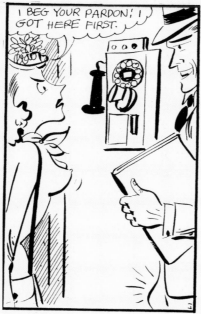

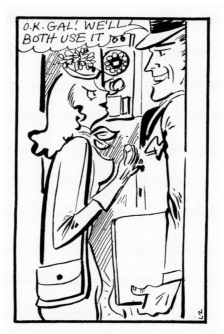

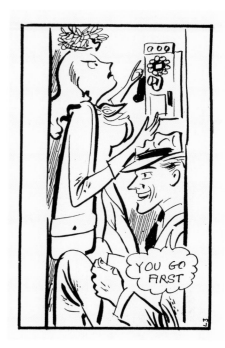

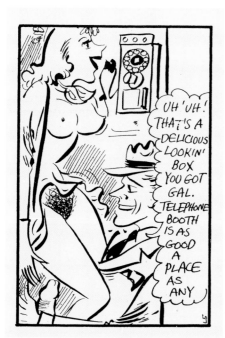

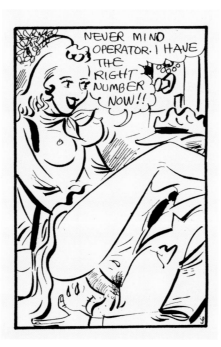

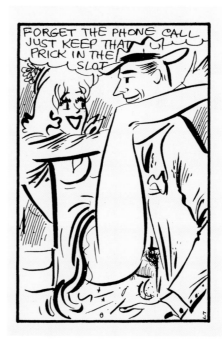

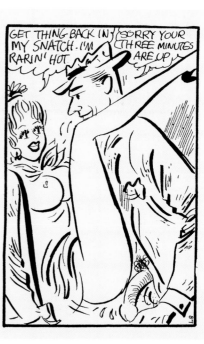

*The graphic style of **Phone Booth Built for Two** places it in the early fifties, and the panache of its line shows a skill that is just a step or two away from **The New Yorker**. Even the situation reflects the times: sex in public places was no longer unthinkable. The chance meeting, the ideal cosmopolitan romance, are light-years away from the eight-pagers of the thirties. Ironically, the freedom came as the genre approached its demise.*

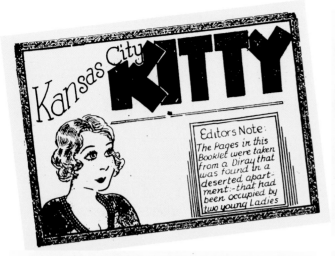
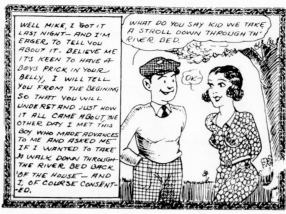
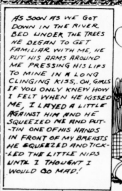
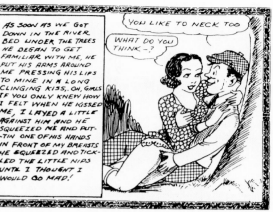
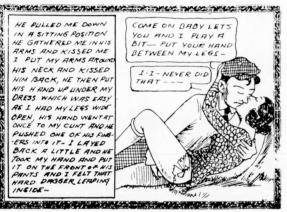
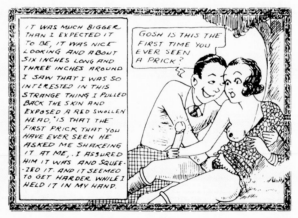
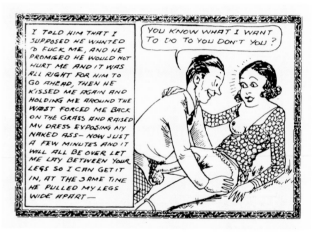
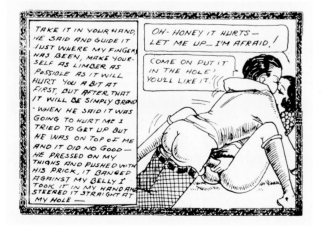
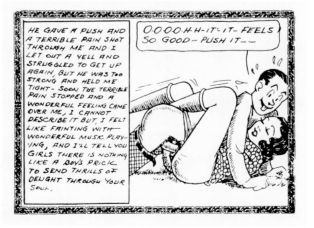
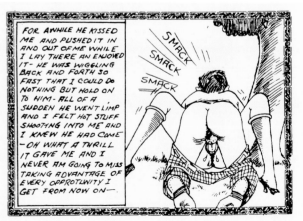

Kansas City Kitty is executed in a form that is nearly half literary—a "diary" that occupies half of each panel. In this sense it is highly unusual. Even the drawings, which are quite deft, seem rather demure, and almost play second fiddle to the printed words.

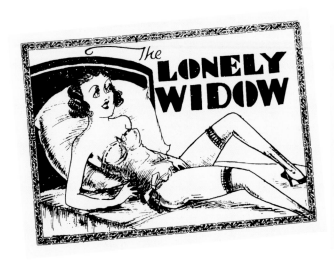

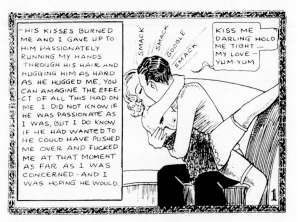

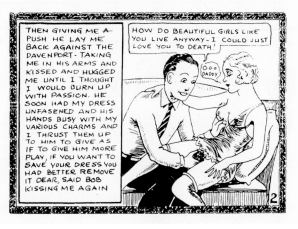

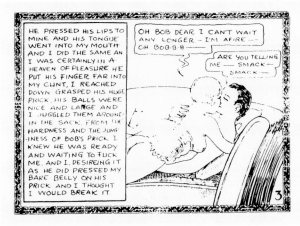

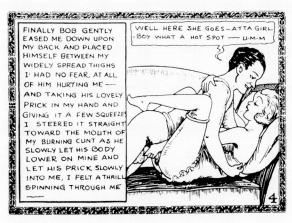

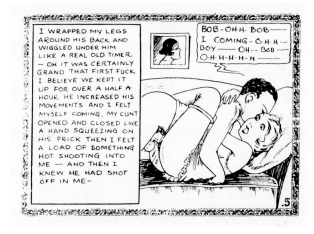

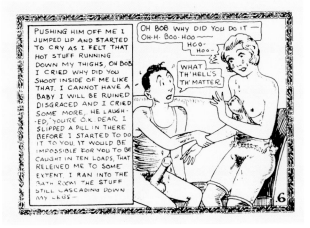

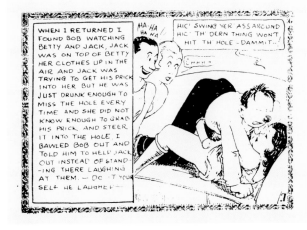

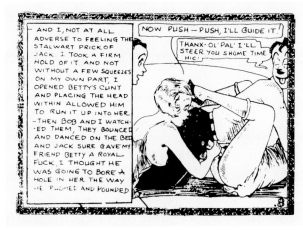

55

If the Tijuana Bibles occasionally lacked panache and sophistication in their graphic exertions, they usually had a blunt, straight-to-the-point quality that had its own charm. Beyond that, the drawings suited the narrative lines, even in the rare case when that line was a block of writing that took up half the page. The Lonely Widow, a rather generic title, is not the best of this petite outlaw genre, but it lives up to all that it intends to be, in the best eight-pager style.

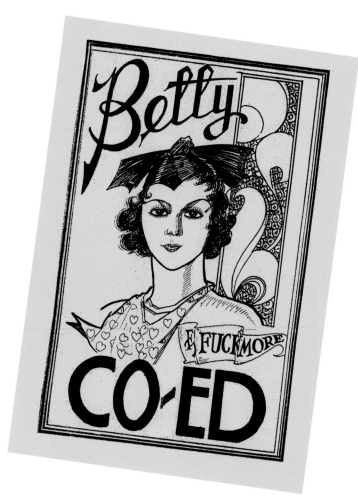

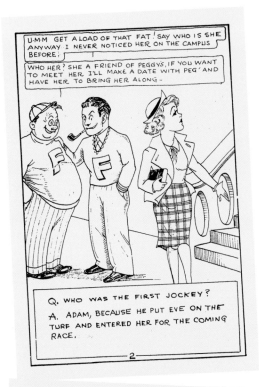

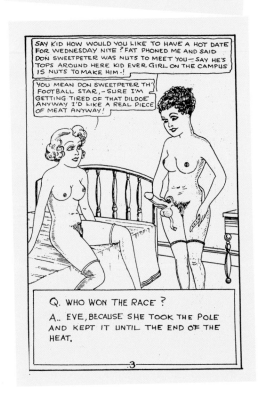

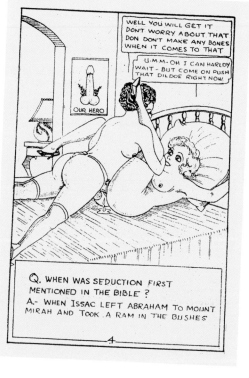

Betty Co-Ed seems to be the underside of those college films of the thirties, one of which was actually called So This Is College (not to mention the Marx Brothers' classic college satire Horsefeathers). Fantasizing about the comings and goings of co-eds was something of a full-time job in those days. The old man's prowess in the final frames looks like wishful thinking on the part of some professor emeritus.

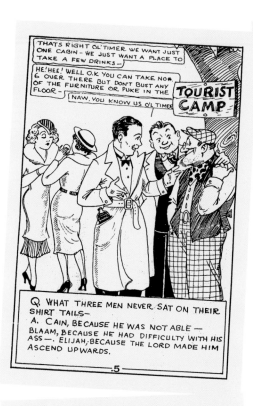

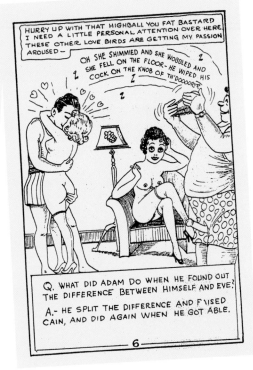

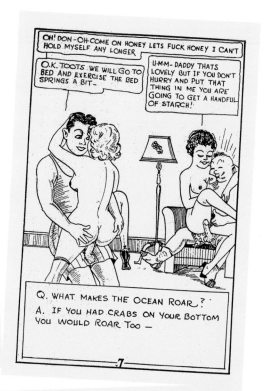

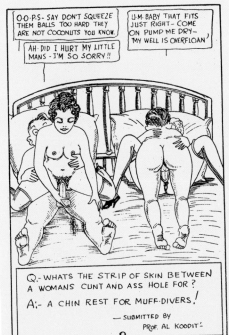

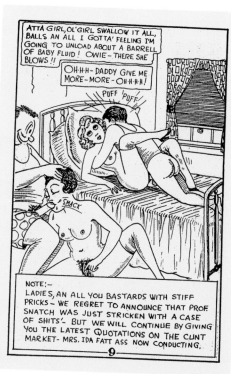

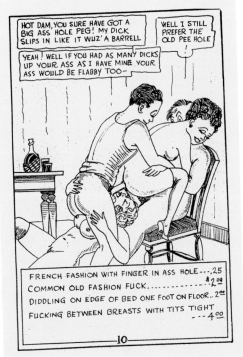

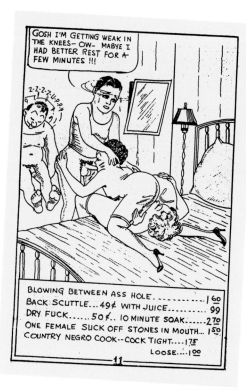

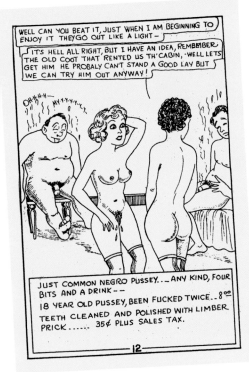

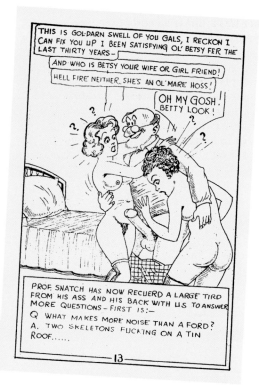

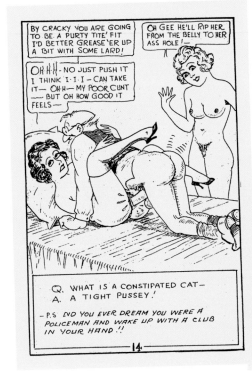

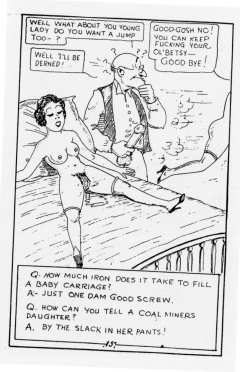

When Mother Was a Girl is an early exercise in nostalgia, back before it became a boom. The booklet is also a little potpourri of gadgets and such, including the Fucking Machine, which was drawn thousands of times, in thousands of forms — it simply never quits as a conceptual concern. The first four frames suggest that perhaps things were not always as they are now, an ever-present misconception to be sure. The drawings are by the prolific one himself, the Master of the Killer Dong.

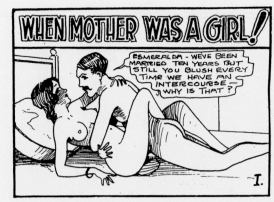

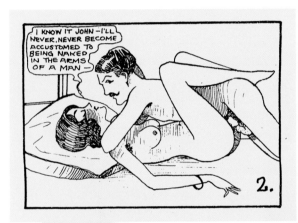

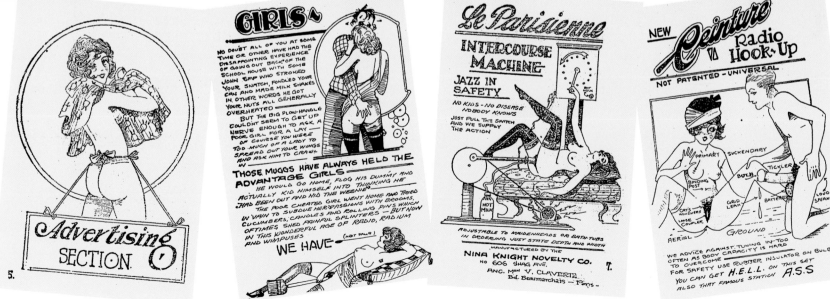

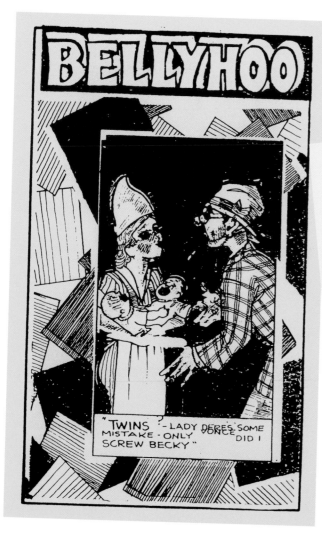

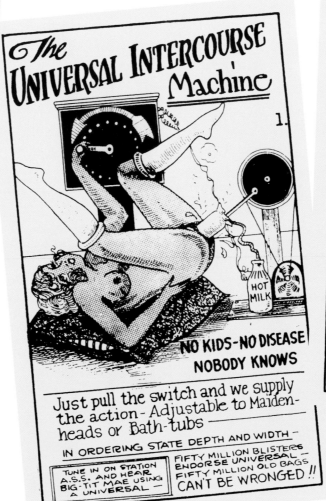

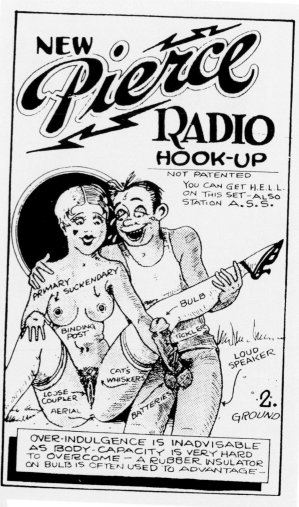

Bellyhoo is a parody of Ballyhoo, a humor magazine of the mid-thirties that poked fun at advertising, kulchur, and life in these United States. It was, in many ways, the forerunner of Mad Comics and Mad magazine. Ballyhoo is a rich potpourri of jokes, references, drawings, phrases, and situations that evoke the period with disarming vivacity, like the novels of William Kennedy or the paintings of Reginald Marsh. It is both frightening and touching, and it is funny.

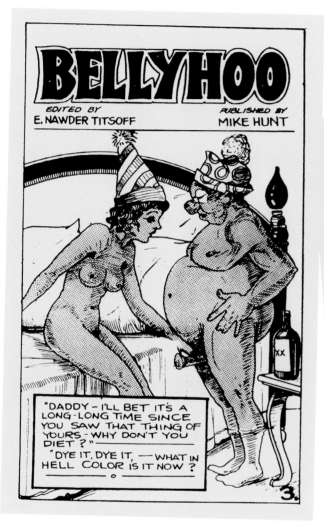

BELLYHOO

EDITED BY
E. NAWDER TITSOFF

PUBLISHED BY
MIKE HUNT

"DADDY — I'LL BET IT'S A LONG-LONG TIME SINCE YOU SAW THAT THING OF YOURS — WHY DON'T YOU DIET?" —

"DYE IT, DYE IT, — WHAT IN HELL COLOR IS IT NOW?"

— o —

3.

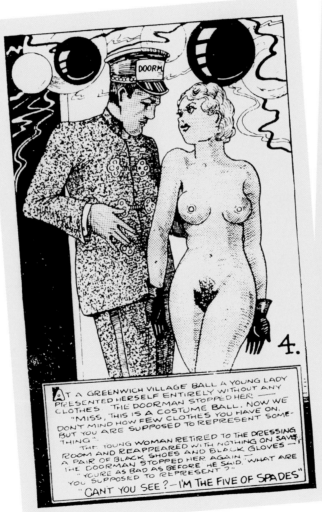

AT A GREENWICH VILLAGE BALL A YOUNG LADY PRESENTED HERSELF ENTIRELY WITHOUT ANY CLOTHES — THE DOORMAN STOPPED HER —

"MISS, THIS IS A COSTUME BALL. NOW WE DON'T MIND HOW FEW CLOTHES YOU HAVE ON, BUT YOU ARE SUPPOSED TO REPRESENT SOMETHING."

THE YOUNG WOMAN RETIRED TO THE DRESSING ROOM AND REAPPEARED WITH NOTHING ON SAVE A PAIR OF BLACK SHOES AND BLACK GLOVES — THE DOORMAN STOPPED HER AGAIN —

"YOU'RE AS BAD AS BEFORE" HE SAID. "WHAT ARE YOU SUPPOSED TO REPRESENT?"

"CAN'T YOU SEE? — I'M THE FIVE OF SPADES"

4.

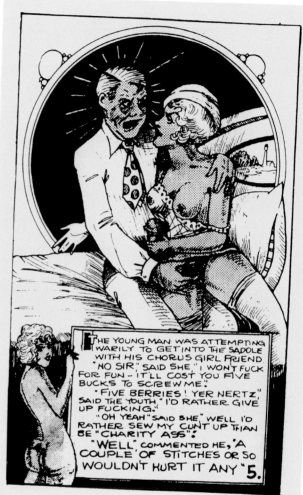

THE YOUNG MAN WAS ATTEMPTING WARILY TO GET INTO THE SADDLE WITH HIS CHORUS GIRL FRIEND.

"NO SIR", SAID SHE "I WON'T FUCK FOR FUN — IT'LL COST YOU FIVE BUCKS TO SCREW ME."

"FIVE BERRIES! YER NERTZ" SAID THE YOUTH. "I'D RATHER GIVE UP FUCKING."

"OH YEAH" SAID SHE "WELL I'D RATHER SEW MY CUNT UP THAN BE 'CHARITY ASS'."

"WELL" COMMENTED HE, "A COUPLE OF STITCHES OR SO WOULDN'T HURT IT ANY"

5.

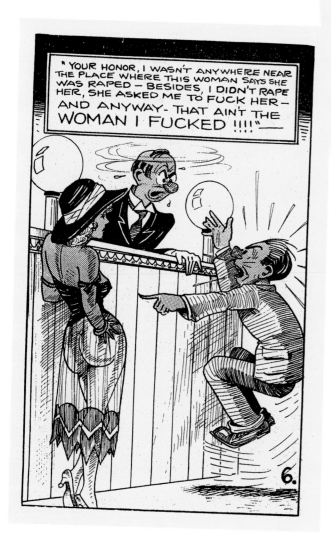

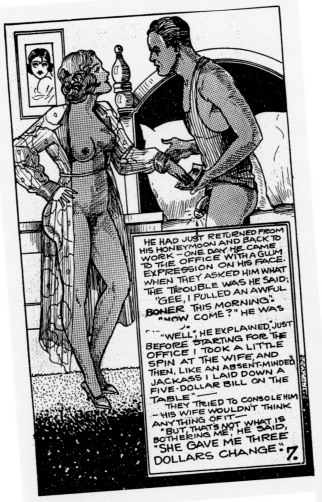

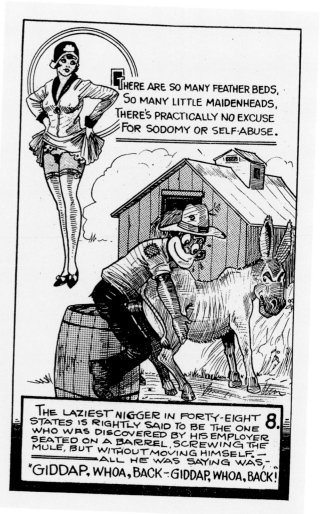

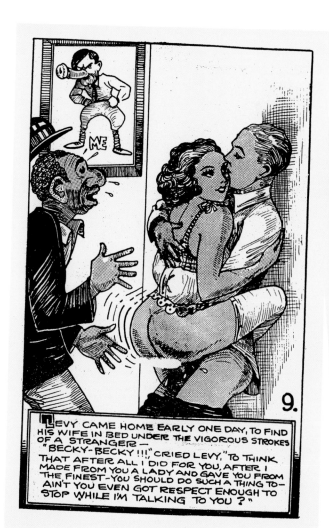

LEVY CAME HOME EARLY ONE DAY, TO FIND HIS WIFE IN BED UNDER THE VIGOROUS STROKES OF A STRANGER— "BECKY-BECKY!!!" CRIED LEVY, "TO THINK THAT AFTER ALL I DID FOR YOU, AFTER I MADE FROM YOU A LADY AND GAVE YOU FROM THE FINEST—YOU SHOULD DO SUCH A THING TO-AIN'T YOU EVEN GOT RESPECT ENOUGH TO STOP WHILE I'M TALKING TO YOU?"

9.

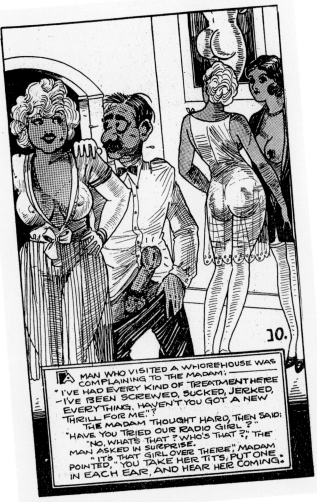

A MAN WHO VISITED A WHOREHOUSE WAS COMPLAINING TO THE MADAM: "I'VE HAD EVERY KIND OF TREATMENT HERE—I'VE BEEN SCREWED, SUCKED, JERKED, EVERYTHING, HAVEN'T YOU GOT A NEW THRILL FOR ME"? THE MADAM THOUGHT HARD, THEN SAID: "HAVE YOU TRIED OUR RADIO GIRL?" "NO, WHAT'S THAT? WHO'S THAT?," THE MAN ASKED IN SURPRISE. "IT'S THAT GIRL OVER THERE", MADAM POINTED, "YOU TAKE HER TITS, PUT ONE IN EACH EAR, AND HEAR HER COMING."

10.

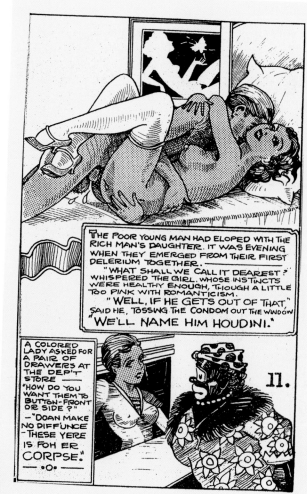

THE POOR YOUNG MAN HAD ELOPED WITH THE RICH MAN'S DAUGHTER. IT WAS EVENING WHEN THEY EMERGED FROM THEIR FIRST DELERIUM TOGETHER. "WHAT SHALL WE CALL IT DEAREST?" WHISPERED THE GIRL, WHOSE INSTINCTS WERE HEALTHY ENOUGH, THOUGH A LITTLE TOO PINK WITH ROMANTICISM. "WELL, IF HE GETS OUT OF THAT," SAID HE, TOSSING THE CONDOM OUT THE WINDOW "WE'LL NAME HIM HOUDINI."

A COLORED LADY ASKED FOR A PAIR OF DRAWERS AT THE DEP'T STORE— "HOW DO YOU WANT THEM TO BUTTON-FRONT OR SIDE?" —"DOAN MAKE NO DIFF'UNCE—THESE YERE IS FOH ER CORPSE."

11.

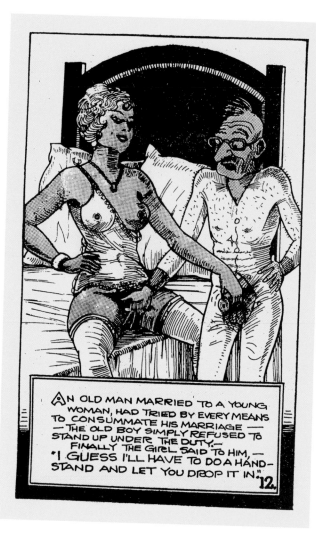

AN OLD MAN MARRIED TO A YOUNG WOMAN, HAD TRIED BY EVERY MEANS TO CONSUMMATE HIS MARRIAGE — THE OLD BOY SIMPLY REFUSED TO STAND UP UNDER THE DUTY.—
FINALLY THE GIRL SAID TO HIM, —
"I GUESS I'LL HAVE TO DO A HAND-STAND AND LET YOU DROP IT IN." 12.

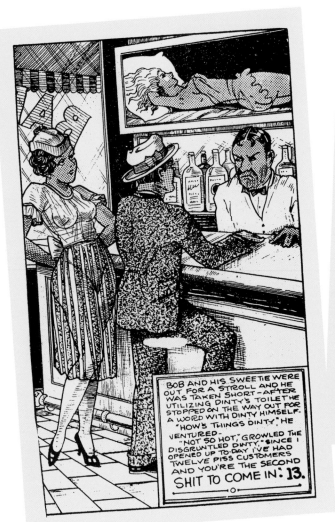

BOB AND HIS SWEETIE WERE OUT FOR A STROLL AND HE WAS TAKEN SHORT—AND HE UTILIZING DINTY'S TOILET HE STOPPED ON THE WAY OUT FOR A WORD WITH DINTY HIMSELF.
"HOW'S THINGS DINTY," HE VENTURED.
"NOT SO HOT," GROWLED THE DISGRUNTLED DINTY, "SINCE I OPENED UP TO-DAY I'VE HAD TWELVE PISS CUSTOMERS AND YOU'RE THE SECOND SHIT TO COME IN." 13.

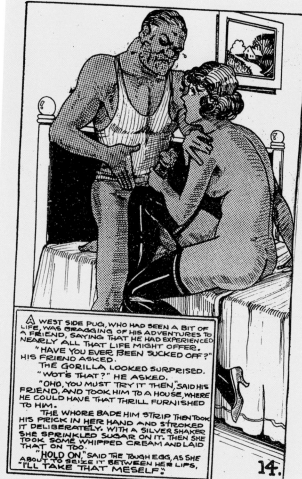

A WEST SIDE PUG, WHO HAD SEEN A BIT OF LIFE, WAS BRAGGING OF HIS ADVENTURES TO A FRIEND, SAYING THAT HE HAD EXPERIENCED NEARLY ALL THAT LIFE MIGHT OFFER.
"HAVE YOU EVER BEEN SUCKED OFF?" HIS FRIEND ASKED.
THE GORILLA LOOKED SURPRISED.
"WOT'S THAT?" HE ASKED.
"OHO, YOU MUST TRY IT THEN," SAID HIS FRIEND, AND TOOK HIM TO A HOUSE, WHERE HE COULD HAVE THAT THRILL FURNISHED TO HIM.
THE WHORE BADE HIM STRIP THEN TOOK HIS PRICK IN HER HAND AND STROKED IT DELIBERATELY. WITH A SILVER SHAKER SHE SPRINKLED SUGAR ON IT. THEN SHE TOOK SOME WHIPPED CREAM AND LAID THAT ON TOO.
"HOLD ON," SAID THE TOUGH EGG, AS SHE ABOUT TO SEIZE IT BETWEEN HER LIPS, "I'LL TAKE THAT MESELF." 14.

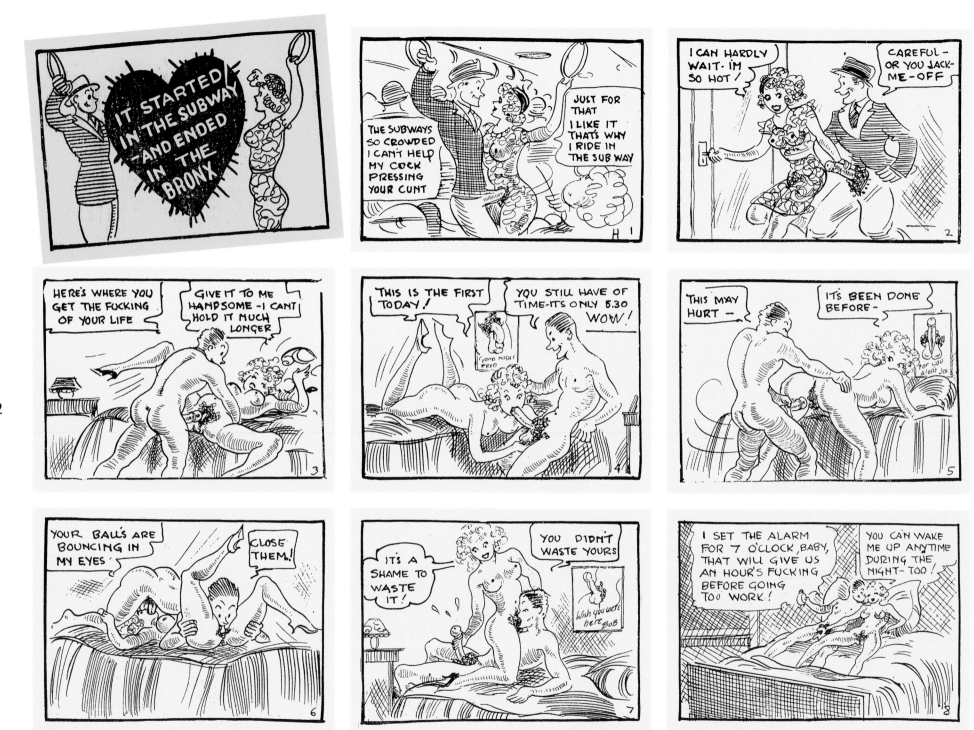

66

It Started in the Subway and Ended in the Bronx is a *Big Apple love story, pure and simple—and more than likely, it mirrors myriad experiences of New Yorkers since the construction of the subways. As in most of Wesley Morse's work, there are deft and ingenious little touches that raise the drawings way, way above the fray: the heroine* flinging her panties away, the high-heeled shoes left on, the penis portraits on the wall, all autographed like the 8x10s at Sardi's. This is the eight-pager at its most romantic and most charming.

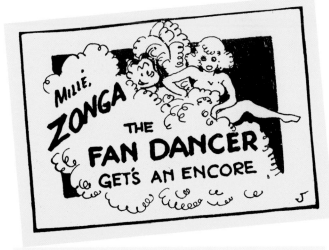

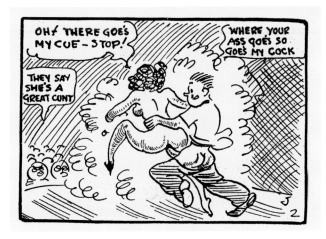

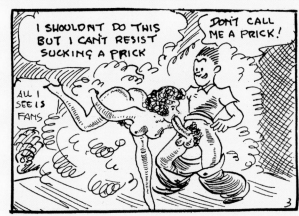

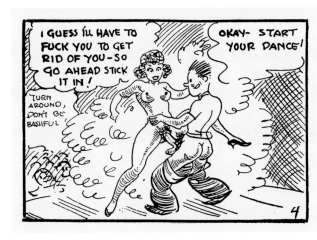

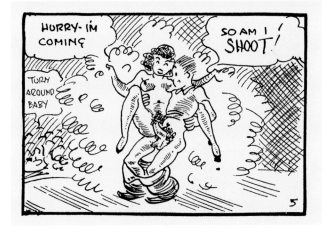

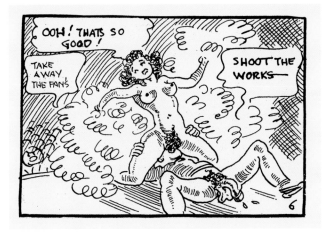

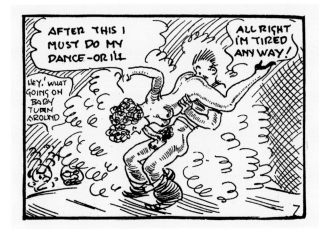

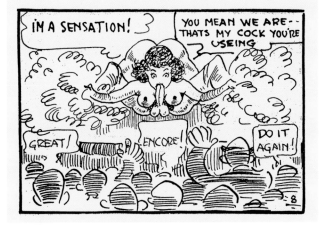

67

In these, well, explicit times, the fan dancer is rather a relic of the past. The affair consisted of dancing while using a pair of fans, usually of ostrich plumes, to conceal that which should be concealed. Occasionally the fan would slip a bit, usually toward the end of the act, revealing what little girls are made of. The most renowned of these damsels, and perhaps the originator of the form, was Sally Rand, a platinum-blond "exotic dancer" who gained fame at the Century of Progress Fair in Chicago in 1933, and continued to perform nearly forever. Besides the fan, she was adept at the bubble dance, which used slightly different equipment —sort of.

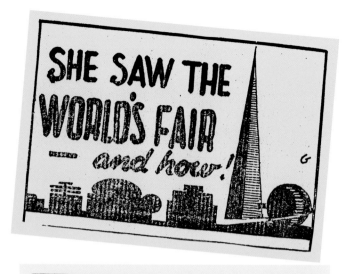

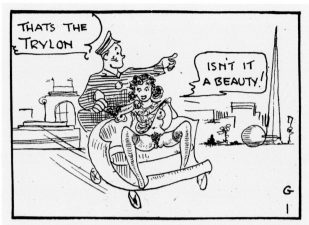

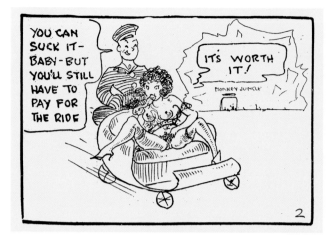

68

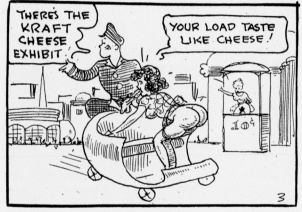

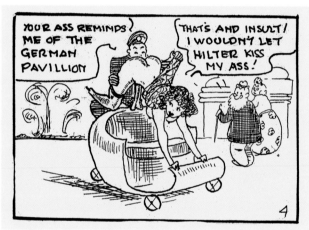

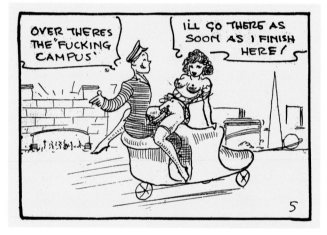

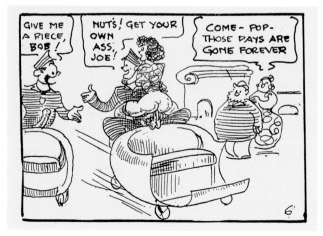

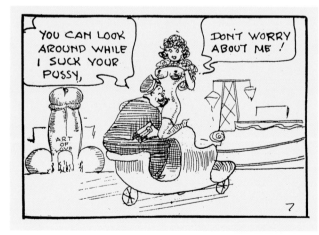

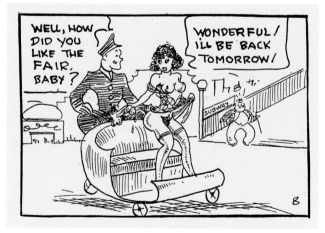

It's usually hard to locate, precisely, the date that a Tijuana Bible was done. The subjects are often generic or based upon a comic strip that ran for decades. The work of this cartoonist, thought to be Wesley Morse, offers no such problem: there are references to New York City, and many of the booklets are directly inspired by activities at the New York World's Fair of 1939–40 (not the pale imitation of 1964–65). Morse's work is sprightly and charming, with the touch of a graphic poet, and the lovemaking is always great fun, however kinky.

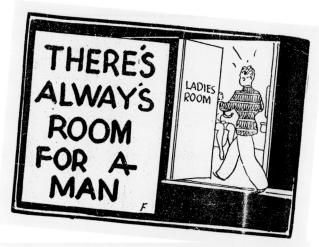

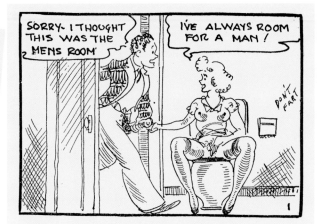

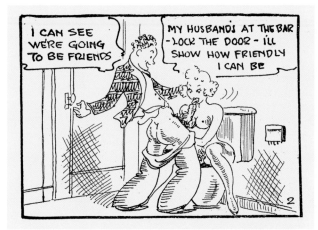

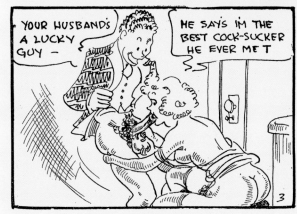

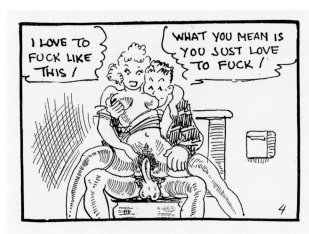

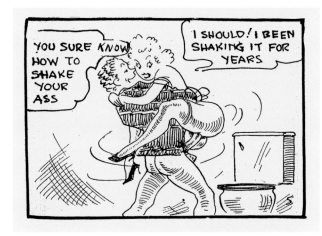

69

The Morse adventures always came with some romantic element of chance and seren-dipity. In There's Always Room for a Man, Bob and Dot are at it again, blithely going through the menu of dance routines in the ladies' room (quite possibly at a restaurant at the World's Fair!). "Dot" appears to be married now, but nothing stops Morse's cheer-ful cherubs. Everything in his drawings is descriptive and informative, sketching the era in style, manner, and even dialogue.

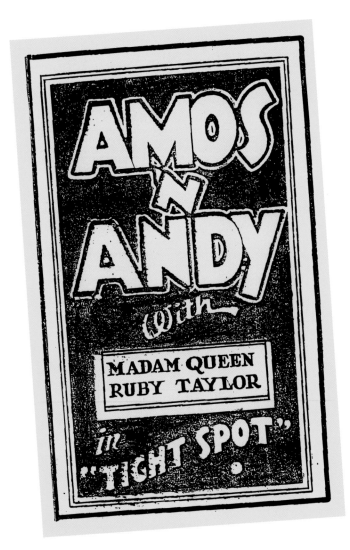

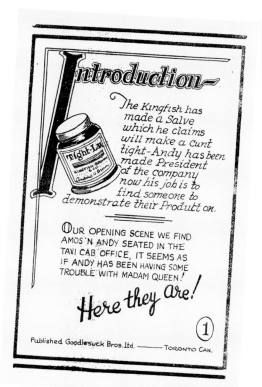

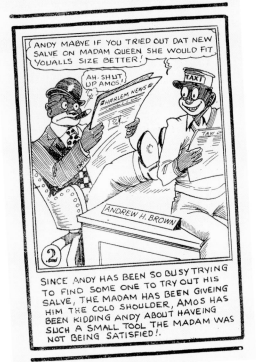

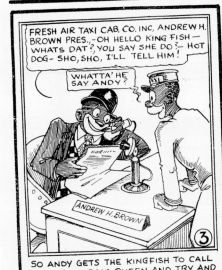

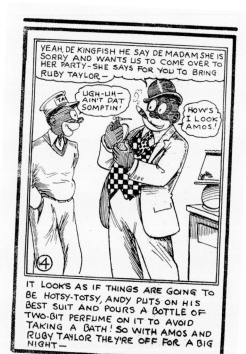

The original Amos 'n' Andy was a radio show that enjoyed enormous success during the thirties and forties. Its characters—feckless family men given to high-flown language and lowbrow schemes—were played by white actors, who often appeared in minstrel-style blackface. That was unacceptably racist when the show moved to television, so a black cast took over. (Eventually, in more sensitive times, the NAACP and other black groups hastened the show's demise.) This sixteen-pager is drawn superbly, and its broad burlesque is very funny. Today, of course, this strain of humor seems as remote as the Piltdown Man.

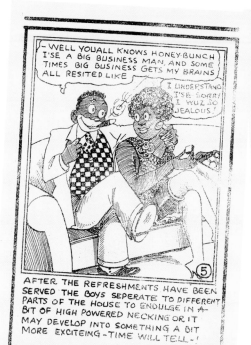

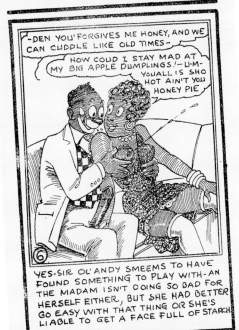

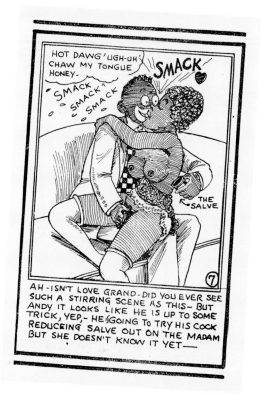

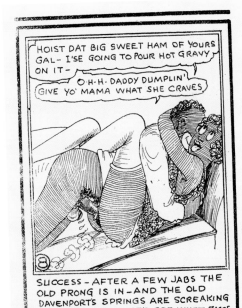

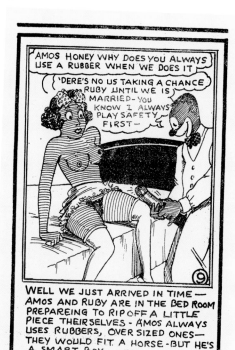

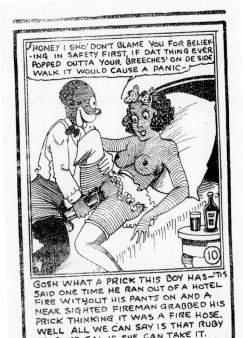

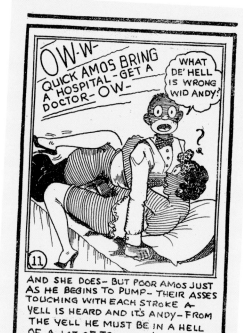

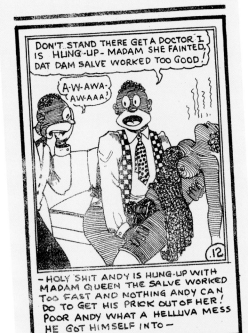

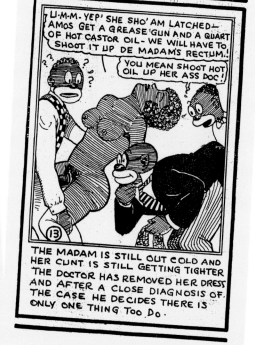

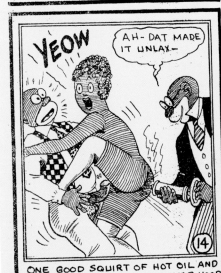

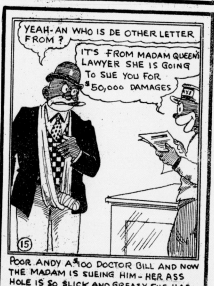

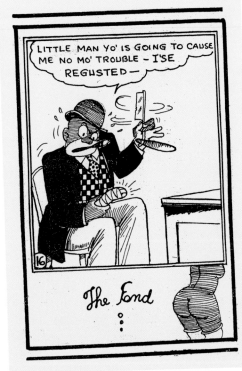

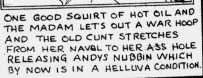

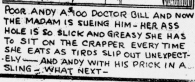

72

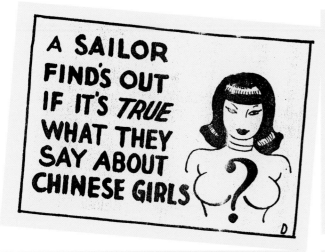

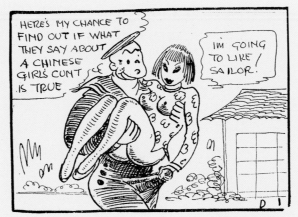

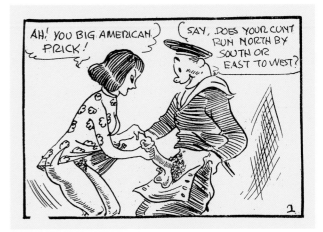

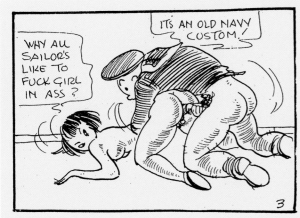

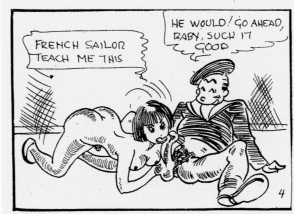

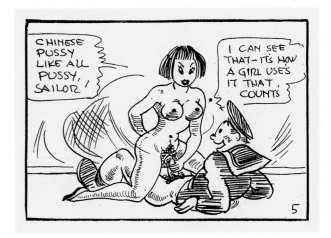

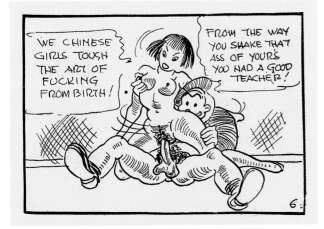

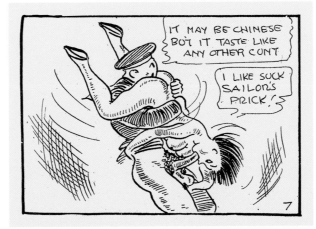

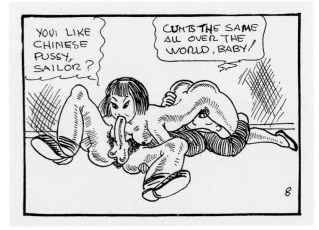

In the long, long ago, when the Chinese were stereotyped as the embodiment of all things different—they lived on the opposite side of the world; the men wore gowns and the women wore pants; their eyes were narrow and slanted—there was even a rumor that the Chinese vagina ran sideways. There were endless jokes about this horizontal phenomenon, as well as drawings and even one faked photograph that "proved" the point conclusively. Here, that misconception comes up against the dismissive street maxim "All women are alike when you turn them upside-down," and the sailor is enlightened.

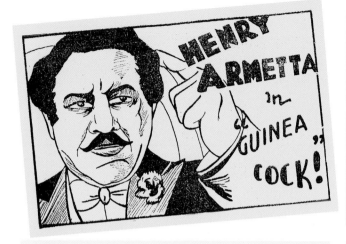

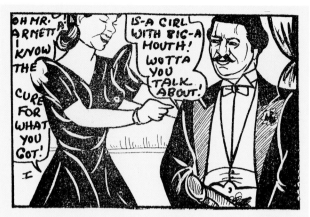

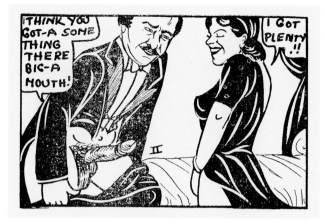

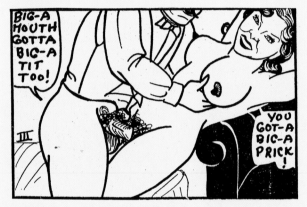

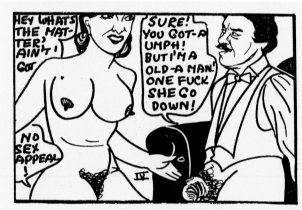

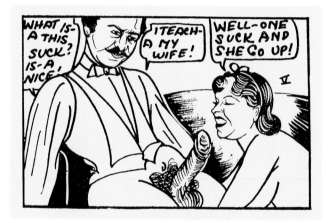

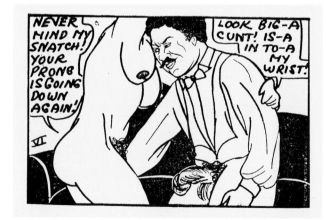

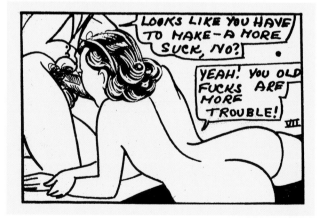

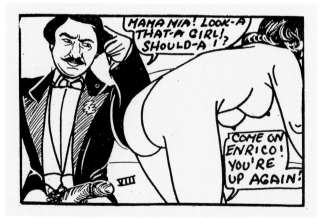

74

In the days when Hollywood found ethnic stereotyping acceptable, there were any number of actors and actresses who specialized in ethnic and racial types—caricatures, if you will. Henry Armetta was surely considered the classic Italian: short, swarthy, volatile, and with an accent that would make Chico Marx blush. He parlayed these characteristics into a lengthy career, occasionally playing a Spaniard or a Greek. In The Big Store, a lesser Marx Brothers film, he plays an emotional Italian father in a department-store sequence that simply wouldn't cut it today. Later, in the early days of TV, Armetta played the lead in a sitcom called Life with Luigi.

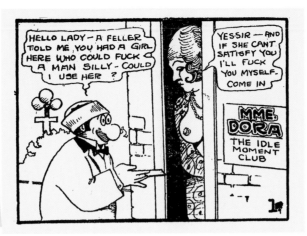

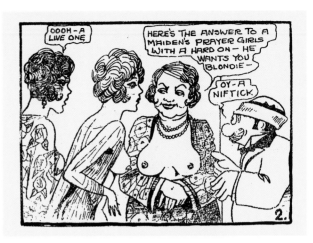

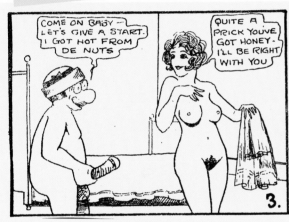

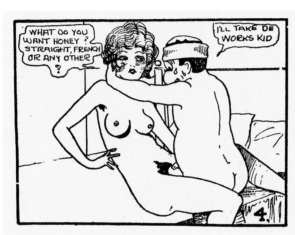

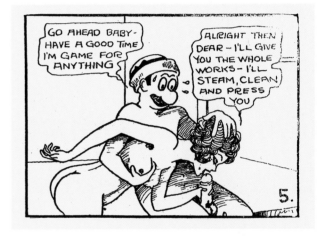

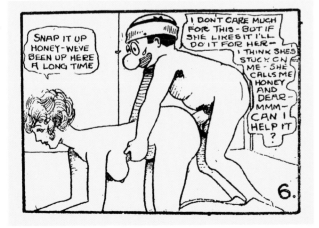

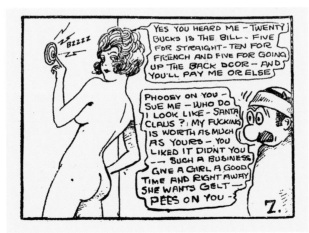

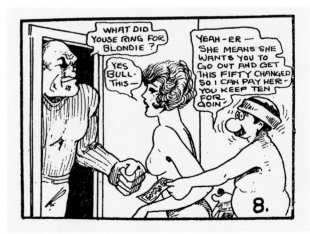

Abie the Agent was a popular comic strip by Harry Hershfield that ran from 1914 until World War II. It was based on the urban Jewish experience and was once described as a strip that dealt with "an up-to-date businessman beset by diverse problems." It was *ethnic caricature, to be sure, but of a highly loving nature. Here, the loving business-man is persuaded not to press for bargain rates.*

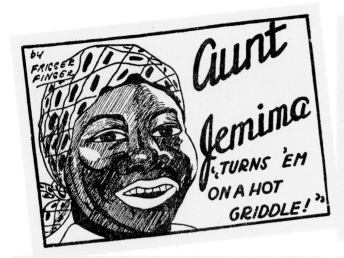

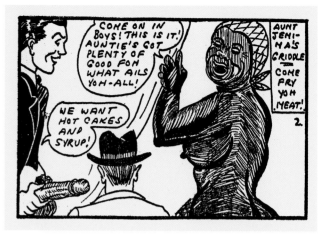

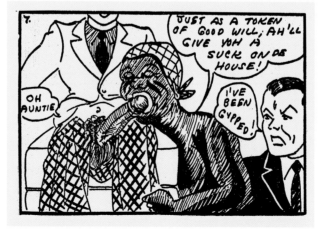

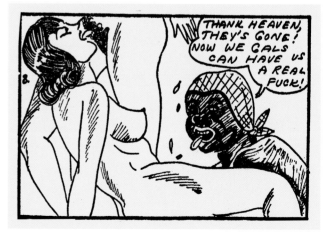

76

Aunt Jemima has been a part of the American consciousness for a century and more. She was invented in 1889 to represent a new self-rising pancake flour, and her plump, jovial image remained unaltered for decades. By the 1960s, the undeniably racist stereotype was rejected in favor of a svelte, almost chic Aunt Jemima, far from the original, and even farther from the crude caricature shown in this eight-pager.

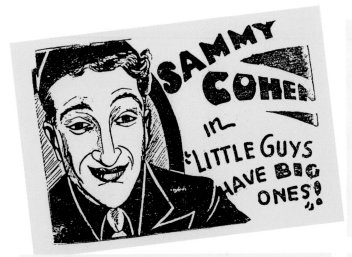
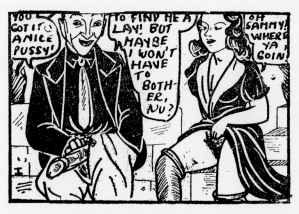
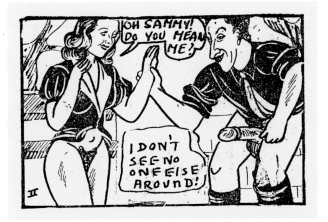
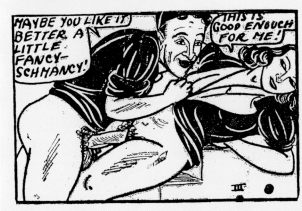
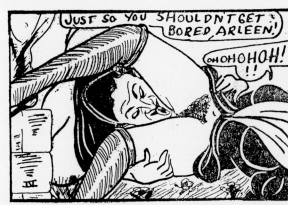
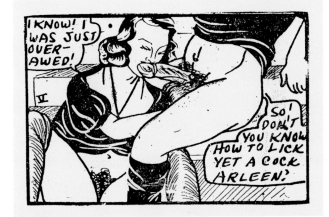
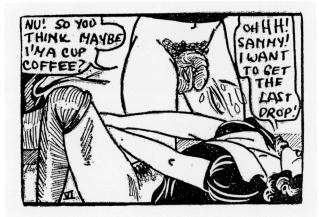
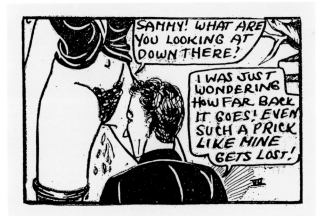
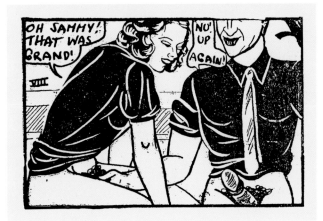

It is unlikely that Sammy Cohen is meant to portray an actual person, but rather to be a stereotyped Jew. There is a smattering of Yiddish, and Sammy's face has the usual exaggerated features.

There's No Bizness Like Show Bizness!

While there's no disputing the fact that the Sunday funnies provided the initial soil for the Tijuana Bible cartoonists, it's equally true that show business, the Great White Way, and that quaint invention called Hollywood provided a much-needed mulch for their curious garden.

Long before the coming of the first eight-pager, the movie colony, already seen as Sodom-by-the-Sea, had produced an awesome laundry list of scandals—including the Fatty Arbuckle fiasco, the lurid murder of the director William Desmond Taylor, the drug-related deaths of stars Olive Thomas, Barbara La Marr, and Alma Rubens, and especially the ghastly and well-publicized demise of the matinee idol Wallace Reid, who died quivering in a padded cell. Add to these the outrageous peccadilloes of stars like Charlie Chaplin and Mae Murray and one has a milieu that was simply waiting to be Tijuana Bibled, as it were.

Every attribute of Hollywood was grist for the mill of the febrile eight-pager imagination: the oozing glamour, the glitz, the unbridled pomposity, the propensity for scandal and slander, the eternal current of innuendo, and the torrid tales of sexual depravity—whether actual or conjured up hardly mattered. Like Tinseltown columnists, the feisty little booklets fed upon rumors such as the supposed homosexuality of Robert Taylor or Cary Grant. When solid rumor was not forthcoming, the artists were certainly not above robust invention, as in the boudoir strategies of the Marx Brothers, Laurel and Hardy, or the now-forgotten team of Wheeler and Woolsey. Some of the adventures were predictable in the extreme—one simply knew how that famed schnozzola of Jimmy Durante was eventually going to be put to use—but the surreal arrived upon the scene quite frequently, as in *Using A Wooden One* with the celebrated dummy Charlie McCarthy.

Usually the stories of the Tijuana Bibles were executed with the very broadest of brushes, but every so often there is a nuance, a moment that rings with a special clarity. In the booklet *Nuts to Will Hays*, starring Myrna Loy and William Powell (the original Nick and Nora), there is a sustained comment regarding Will Hays, who had been installed as the film czar and arbiter of morality when it seemed as though the industry lacked the "will" to censor itself. The Ingrid Bergman–Roberto Rossellini love affair, so shocking for its time, provoked an eight-pager, though hardly a well-executed one. Not content with mere movie stuff, the artist produced a highly arcane work dealing with Benny Goodman, a law-abiding citizen by all accounts, who played excellent clarinet and fronted what were actually among the first desegregated bands. The Goodman item is particularly interesting for its miniature glossary of swing terms, all rather accurate. By and large, however, the Tijuana Bible sensibility hankered after the "big fish," and during the period no major star was left unviolated. Greta Garbo, with her haughty and well-publicized quest for seclusion ("I vant to be alone!"), appeared in several volumes; Clark Gable was her male counterpart in popularity. Wesley Morse contributed a sveltely drawn W. C. Fields, and there is even a Barbara Hutton, who while not a Hollywood star did manage to marry one, among a number of other husbands.

In pursuing a collection of Tijuana Bibles today, one is afforded a splendid peek at Who Was Who. A great many of the subjects, almost all household names back then, have been consigned to the back shelves of Cinelandia's archives, if not its dust bins. How many would recognize names like Patsy Kelly today? Or Ed Wynn, the Texaco Fire Chief? Even Clara Bow—the original It Girl, the Madonna of her time—is a figure now best known to film buffs of a certain age. One of the things that the Tijuana Bible does better today than it did at the time is recycle!

The absolute queen of our little genre, though, was Mae West, the brassy, busty, and outspoken blonde whose predilection for the earthy and the erotic was pronounced (in real life as much as on reel). With the possible exception of Popeye the Sailorman, with whom she shared billing for at least one sixteen-pager, she was the subject of more of these lewd little booklets than any other character. If the genre had a patron saint, it would be she, for Mae West was the Tijuana Bible come to life.

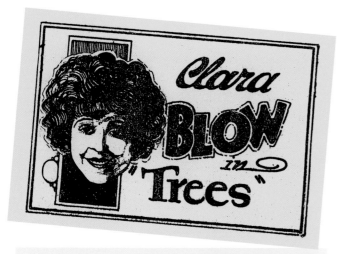

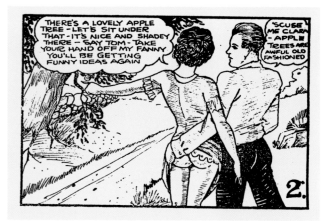

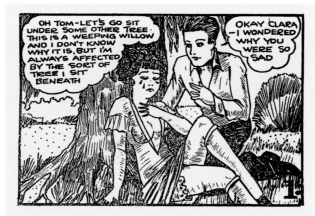

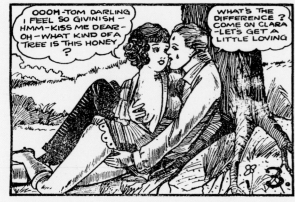

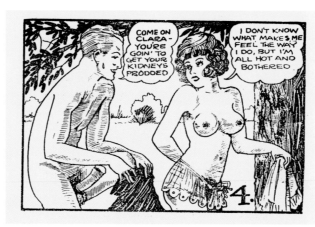

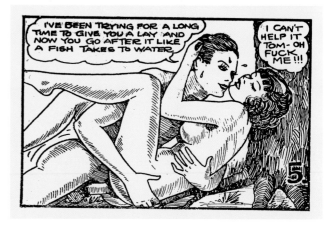

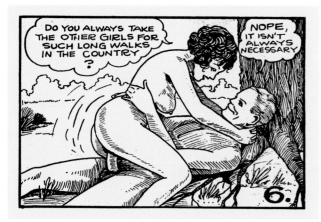

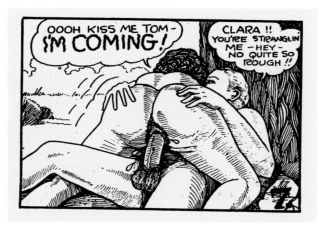

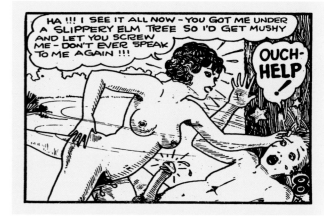

No actress better embodied the excesses of the Roaring Twenties than Clara Bow, the original It Girl. (According to novelist Elinor Glyn, she had it, whatever it was.) Bow personified Hollywood before the coming of responsibility. With cheerful abandon, she burned her candle at both ends; even toward the end of her restless, careless life, she still professed no regrets from a sanitarium in 1951, she reminisced, "I'd whiz down Sunset Boulevard in my open Kissel . . . with several red chow dogs to match my hair. Today, they're sensible and end up with better health," she said of latter-day movie stars, "but we had more fun."

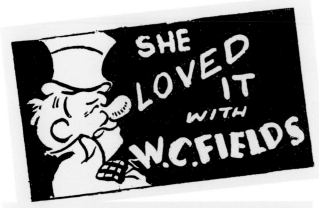

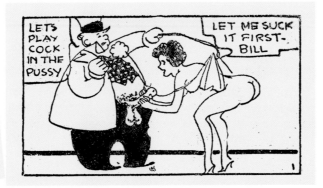

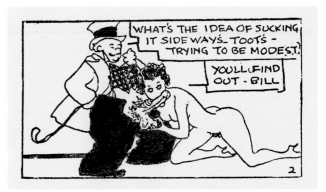

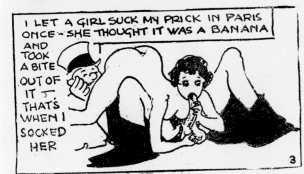

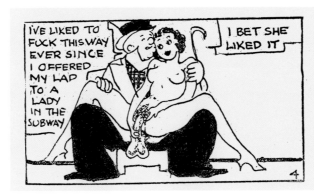

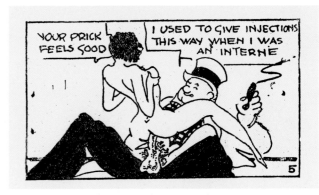

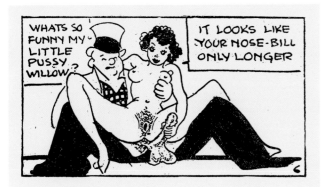

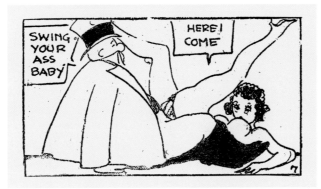

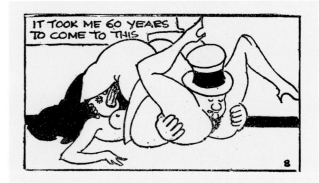

William Claude Dukinfield, who came to be known as W. C. Fields, began as a juggler in the Ziegfield Follies but developed into "the greatest comic artist ever known," according to his biographer, Robert Taylor. Fields's star rose with the advent of the talkies, for he was the master of jaunty and acerbic patter, much of it devastating and, alas, much of it lost on today's audience. His blatant alcoholism, his hatred of children, and his arch descriptions of things domestic are all characteristics that might lift a few eyebrows today. Be that as it may, he was a comic original, and his portrayal of Mr. Micawber, in David Copperfield, displayed an actor in a role he was born to play.

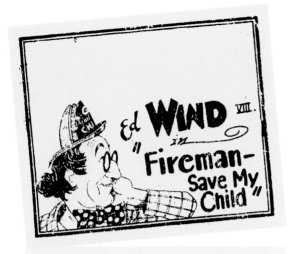

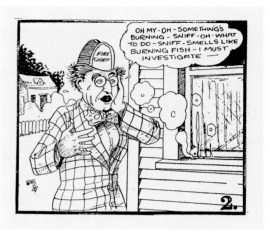

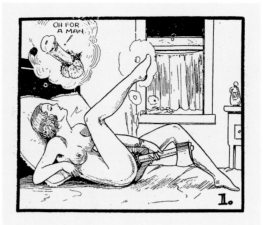

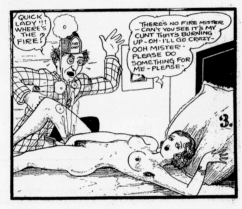

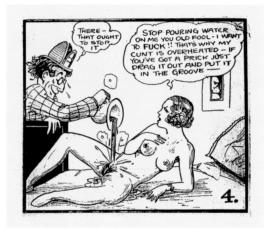

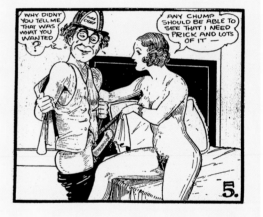

Sadly forgotten these days, Ed Wynn was once considered the funniest man in America. In the twenties, he was a star in the Ziegfield Follies, playing a lovable buffoon with an endless supply of utterly silly hats: the Boy with the Funny Hat, or the Perfect Fool. In the thirties, he became the Fire Chief (sponsored by Texaco). In the fifties, he made a comeback on TV with serious, touching roles, for which he was well suited.

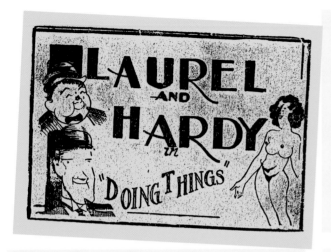

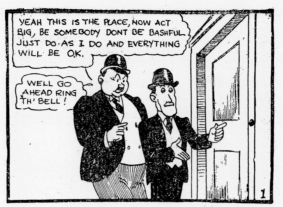

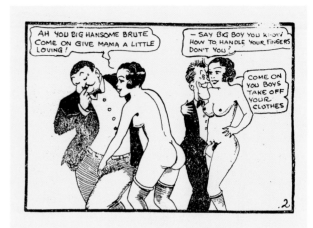

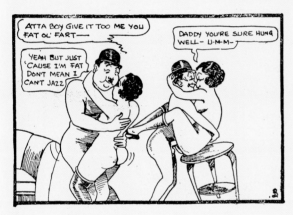

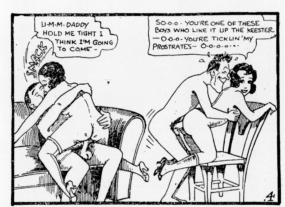

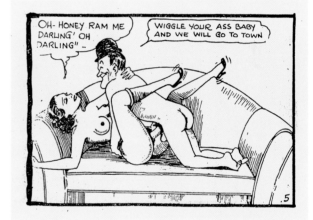

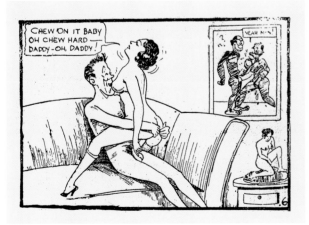

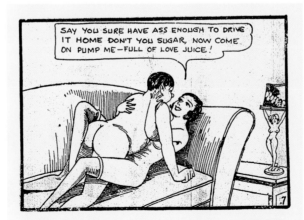

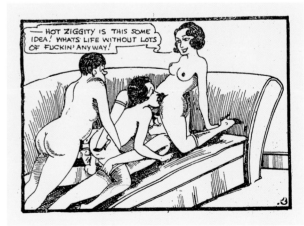

Many eight-pagers were generic, equally applicable to any celebrity the artist could draw. This booklet featuring Stan Laurel and Oliver Hardy is noteworthy in that it captures the characteristics of this original odd couple with insight and grace: Hardy's ponderous bluster and Laurel's quaint timidity. The duo's success spanned the decades, from the silent films of the twenties, through the early talkies, right up until the Second World War and beyond. Then television found them and all their great movies, and by now their constituency seems evergreen.

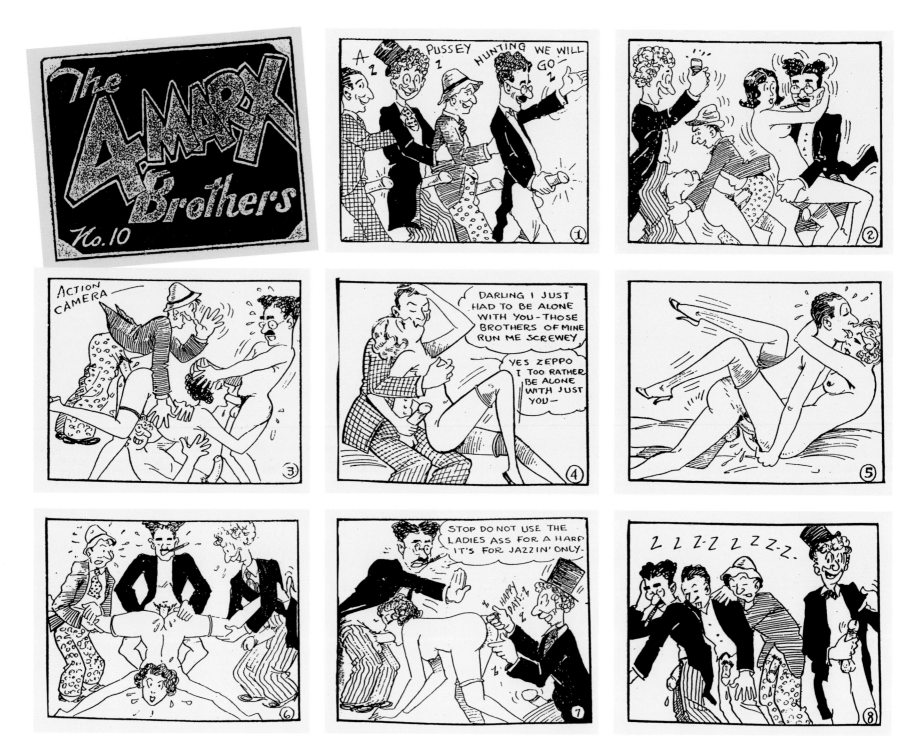

Zany and iconoclastic, the Marx brothers (four until Zeppo left in 1934) were born for the Tijuana Bible. Their movies were filled with sexual escapades, perpetrated by the leering Groucho or by Harpo, who was half-angel, half-satyr.

The brothers mellowed considerably with age, but this eight-pager seems to have found them at the time of Horsefeathers or Duck Soup (the early thirties) when the testosterone was flowing.

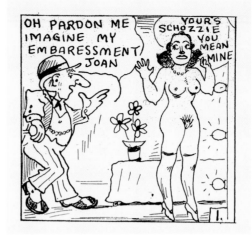

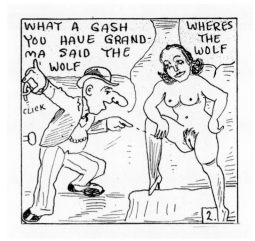

With Joan Crawford and Jimmy Durante, the Tijuana Bible found an ideal pair — two movie stars with already stylized physiques and patterns of behavior. Crawford was torrid, in a low-current sort of way. She had been a chorine in the early twenties, dancing under the name Lucille LeSeuer, but by the time of this booklet, she was a major star, appearing in movies like Grand Hotel. Durante had begun as a jazz musician and became a highly successful nightclub performer. By the mid-thirties, he was a star of both stage and screen, and his nose was known the world over. One might say they were born for each other.

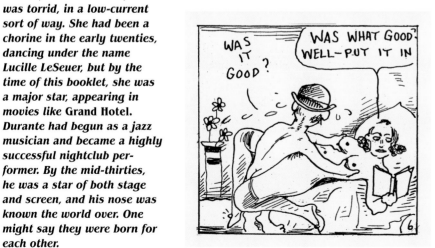

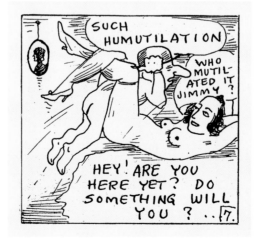

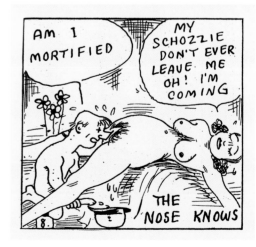

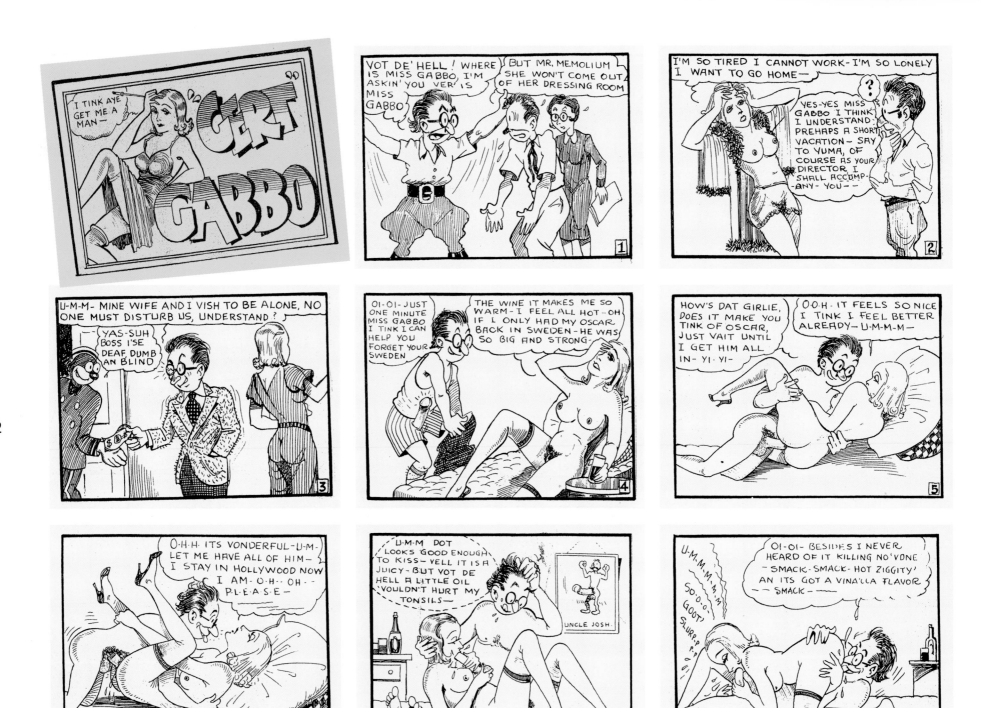

86

Like Clark Gable and Mae West, Greta Garbo was a darling of the eight-pager set. Her smoldering good looks, the trappings of her legend, and most of all her histrionic demand for privacy—"I vant to be alone!"—were obviously a joy to the caricaturists. The director with the ability to coax a great performance out of the mournful star is another of those Hollywood folk tales that, more than likely, had a nugget of fact to it.

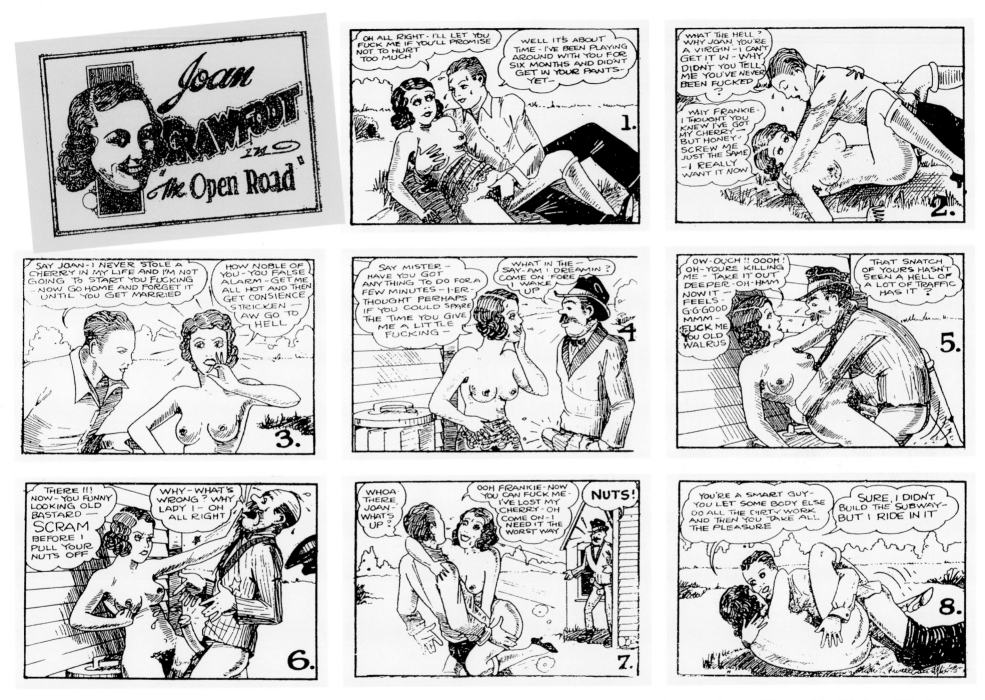

Joan Crawford rose from a poor childhood to become the utter and absolute epitome of a Star. As a chorine she had been rather pudgy, but she nibbled crackers to lose weight and, with Grand Hotel, it was clear that a singular actress had arrived. "Joan Crawford is an American phenomenon," Richard Schickel put it years later, "the incredibly strong and determined woman." In 1945 she won an Oscar for playing the lead in Mildred Pierce, but, in truth, she might have been playing Joan Crawford.

87

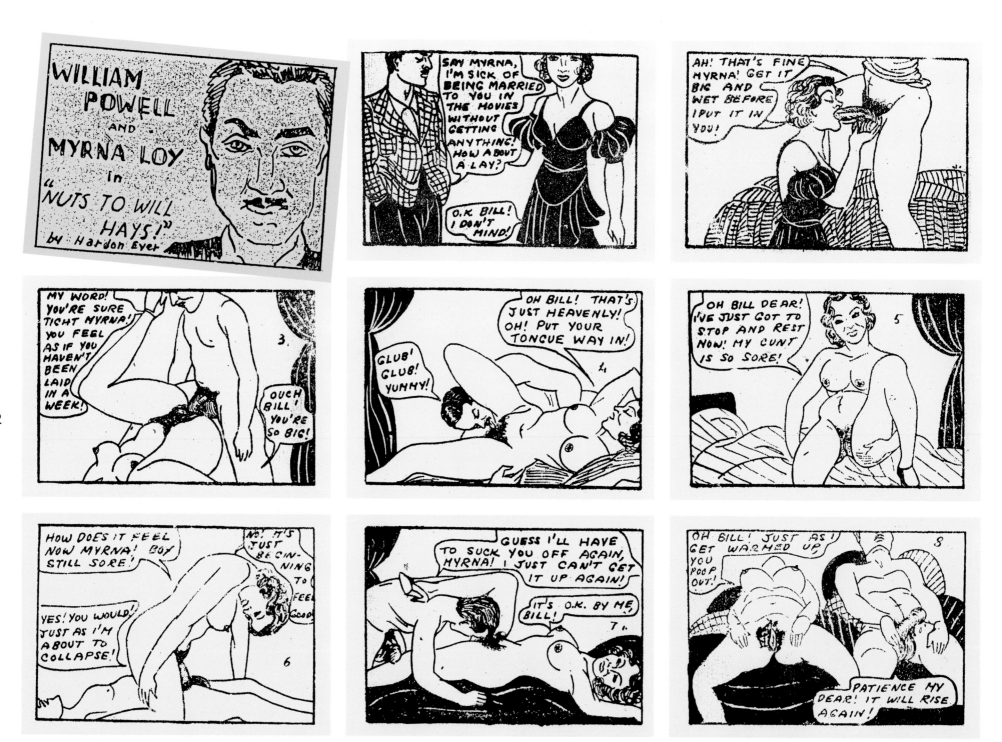

88

More than one avid fan of the Thin Man series must have wondered what Nick and Nora looked like when they were getting it on; this little vignette was meant for them. The likenesses to William Powell and Myrna Loy are not bad (nor are they good), the curtains are a quaint touch, and there is something believably . . . well, domestic about this story. Will Hays was the emperor of censorship in Tinseltown, a position created in 1922 after periodic scandals had tarnished the tinsel, so here we are witnessing the Thin Man folks (and the artist of this episode) thumbing their noses at the specter of repression — probably after the Hays Code was formalized in 1930.

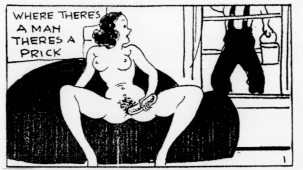

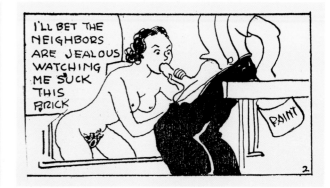

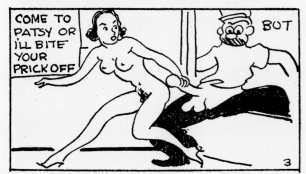

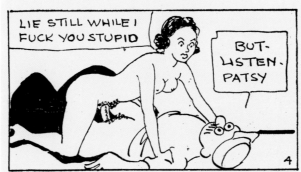

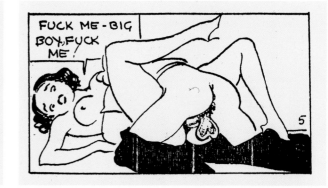

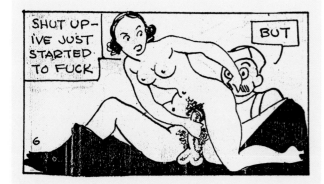

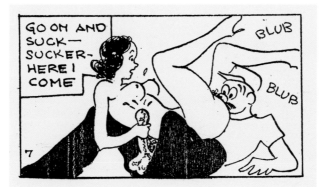

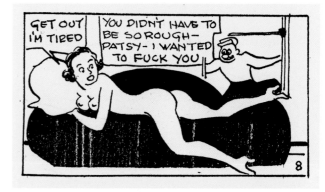

Patsy Kelly was a robust Hollywood comedienne in the thirties. Dark-haired and very funny, she was often teamed with blondes like Thelma Todd or Betty Grable (who were equally funny) in utterly forgettable items like Pigskin Parade. *While hardly beautiful, she always projected a kind of urban Irish charm, and she was convincing. In the old studio system, Patsy Kelly more than earned her keep.*

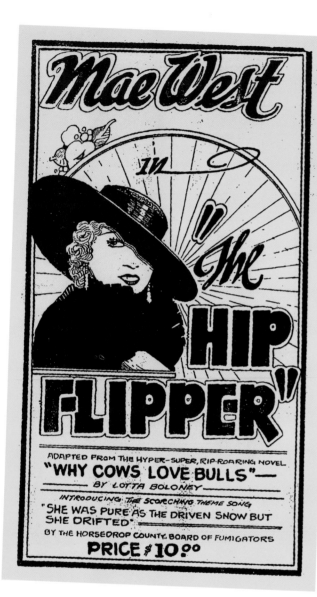

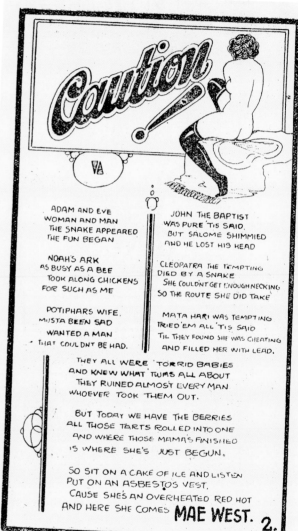

Very few of the Tijuana Bibles ventured beyond sixteen pages, but The Hip Flipper, starring Mae West, did. It's surely one of the best of all the genre. It is exquisitely drawn, and although somewhat predictable in its composition, it is sparkling and moves along at its own pace. In a way, it is the ultimate Mae West movie—the one that could not be made, of course. Jimmy Durante is seen in a supporting role, and there is a picture on the wall that changes to one film star after another. The Hip Flipper is the Tijuana Bible at its epic best, and the $10 price tag (whether he got it or not) suggests that Mr. Prolific knew he had a masterpiece.

INTRODUCING
OUR DASHING HEROINE
MISS LOTTA LEADPIPE
THE BELLE OF WEST HUCKLEBERRY, IOWA

AN INNOCENT COUNTRY DAMSEL WHO CRASHES THE LAND OF THE SQUAWKIES

PORTRAYED BY THE SWIVEL-HIPPED LANGUOROUS, INCANDESENT GORGEOUS

WOW! Mae WEST

MAE SEZ —
A LOT OF THESE FLAPPERS WHO IMAGINE THEY'VE GOT HOT NUTS ARE ONLY SUFFERING FROM PRICKLY HEAT —

THE SCENARIO FOR THIS RIP-ROARING CATACLYSM OF SEETHING, HISSING, SEARING TORNADO OF LUST AND PASSION WAS FOUND IN THE WASTE BASKET

CONTINUITY BY IDA DUNNITT

COSTUMES BY IMA JAZZ

DRAMATIZED BY OPHELIA PRATT WHO APPEARED IN THE SENSATION OF THE SEASON WITH THE FAMOUS O. HOWITT HOYT IN A "TIGHT PLACE"

3.

(thought bubble) I'M FED UP WITH PLAYING NURSE-MAID FOR A LOT OF COWS AND CHICKENS

4.

BREAKING HOME TIES

WAY OUT WEST IN THE LITTLE TOWN OF HUCKLEBERRY GREW UP ON A LONELY FARM A CORN-FED BY THE NAME OF LOTTA LEADPIPE AND LOTTA HAD AN INSATIABLE DESIRE TO GET SOMEWHERE IN LIFE —

'TWOULD SOON BE CHRISTMAS AND THE HOUSE WOULD SMELL TERRIBLE - ESPECIALLY WHEN THE HIRED MAN HUNG UP ALL THE DIRTY SOX HE COULD FIND ON THE CHIMNEY PIECE AND EVEN THE EVER GREEN TREE WAS FEELING NAUSEOUS —

SO SHE PACKED UP WHAT LITTLE SCENERY SHE OWNED IN A SHOE BOX AND SALLIED FORTH FOR PARTS UNKNOWN — 'TWAS BITTER COLD, BUT SHE WRAPPED THE CAT AROUND HER NECK, ROLLED DOWN HER SOX AND FLITTED THRU THE BARN-YARD KISSING THE PIGS GOOD-BYE AS SHE FLITTED —

SHE HESITATED LONG ENOUGH IN FRONT OF OLD MAN FUZZY-NUTS HOUSE TO MAKE A COUPLE OF SNOOTS AT HIM — FUZZY-NUTS, THE OLD NICKLE-NURSER WHO HELD THE MORTGAGE ON THE OLD HOME, WHOM SHE WAS TO HAVE MARRIED AND WHO SENT OUT BEAUTIFUL CHRISTMAS PRESENTS C.O.D.

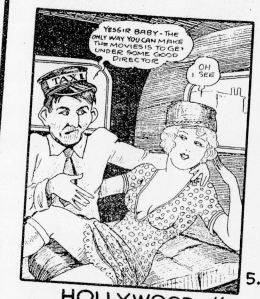

(speech bubble, man) YESSIR BABY - THE ONLY WAY YOU CAN MAKE THE MOVIES IS TO GET UNDER SOME GOOD DIRECTOR

(speech bubble, woman) OH I SEE

5.

HOLLYWOOD !!

LOTTA'S WANDERINGS ENDED IN SILLYWOOD. WHERE MEN ARE MEN AND THE WOMEN ARE DOUBLE BREASTED — SHE SEARCHED FOR DAYS FOR A JOB AND FINALLY LANDED IN ONE OF THOSE OPEN AIR BARBECUES AS SORT OF COMBINATION WAITRESS - HOSTESS WHERE THOSE COMELY DAMSELS DRESSED IN VIVID HUED PAJAMAS BREEZE OVER TO YOUR CAR AS YOU DRIVE IN - YOU GET A MILLION DOLLAR SMILE SHE TAKES YOUR ORDER - YOU GET INDIGESTION AND A PHONE NUMBER

'TWAS HERE THAT OUR LOTTA CAUGHT UP WITH A DUMB KLUCK HACK PUSHER WHO DIDN'T HAVE CHANGE FOR A DIRTY COLLAR AND LET HIM DRIVE HER HOME — HE PROMISED TO SHOW HER THE WAY AROUND AND TEACH HER ALL THE ANSWERS

LOTTA WAS DETERMINED — FOLKS WOULD HEAR FROM HER SOME DAY — SHE WAS GOING TO BECOME ONE OF THOSE GIRLS WHO WAKE UP TO FIND THE WOLF AT THE DOOR AND COME OUT WITH A FUR COAT

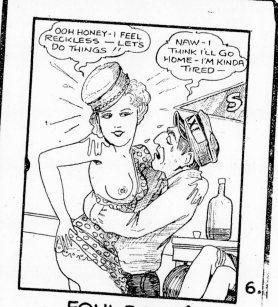

FOUL BALL!

ONE OF THE MERRY VILLAGERS THREW LOTTA A DEUCE TIP AT THE BARBECUE AND OUR LOTTA BEING A REGULAR SORT OF FELLOW DRAGGED THE BOY FRIEND OUT THAT NIGHT TO HELP HER TO SQUANDER IT - THEY WOUND UP IN ONE OF THOSE BATH-TUB GIN ORGIES AND LOTTA GOT HER EARS BACK ———

AND WHAT A PILL HE TURNED OUT TO BE !' THREE DRINKS AND HE WANTED TO SCRAM AND SWEET LOTTA WAS RIGHT IN THE MOOD FOR A LITTLE HIGH PRESSURE LOVING - SO·O·O·O·O SHE GOT SO MAD THAT SHE WENT BACK TO THE BARBECUE AND HANDED IN HER SUIT - NO SIR !! OUR LOTTA HAD GOT A BELLY-FULL OF HACK-PUSHERS ETC. SHE WAS DETERMINED TO FIND A JOB WHERE SHE COULD AT LEAST FIND SOME JOHN WHO WOULDN'T SEND HER HOME WITH HOT NUTS —UNSATISFIED

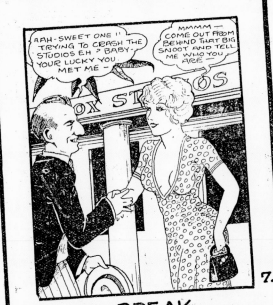

A BREAK

LOTTA THEN SET OUT TO DO OR DIE - FOR DAYS SHE MOPED AND SLOPED AROUND THE CASTING OFFICES BUT DIDN'T GET A TUMBLE - THE DEPRESSION WAS OVER AND THE PANIC WAS ON - THEY HAD EVEN CUT DOWN ON THE WAGES OF SIN - AND THEN KIND READER, AS THE POOR GIRL WAS ABOUT TO GIVE UP THE SHIP WHO SHOULD ANKLE UP AND GIVE HER A PLAY BUT THE ANSWER TO A MAIDEN'S PRAYER, THAT HE-VAMP OF THE FLICKERS, THE GREAT ONE AND ONLY

SCHNOZZOLLA HIMSELF !!

HE OF THE ELONGATED PROBOSCIS - HALF MAN - HALF NOSE LOTTA TOLD HIM OF SEARCHING IN VAIN FOR SOME KIND OF WORK AND THAT SHE WAS A MEMBER OF THE SELDOM-FED CLUB, WAS SEEING MORE MEAL-TIMES THAN MEALS AND SCHNOZZLE WAS TOUCHED DEEPLY - "WHY BABY, WHAT A BREAK!" CHIRPED HE. "I'VE GOT AN APPOINTMENT THIS AFTERNOON WITH THE GREAT DIRECTOR EDMUND GOLDING UP IN MY APARTMENT, HE DIRECTED "GLAND HOTEL - WHAT A BREAK YOU'RE GETTIN' KID"

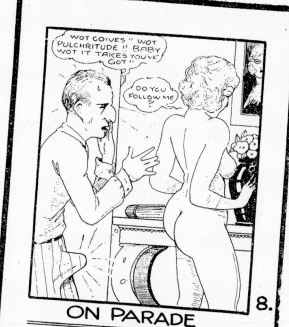

ON PARADE

THE POOR UNSUSPECTING LOTTA FELL FOR THE SCHNOZZOLLA'S PATTER AND WENT UP TO HIS APARTMENT TO AWAIT THE ARRIVAL OF THE GREAT GOLDING — SHE'S A TRUSTING THING-

AND THEN SCHNOZZLE HAD AN INSPIRATION - HE WOULD MAKE AN ANATOMICAL SURVEY OF THIS PROSPECTIVE MOVIE QUEEN - SO LOTTA, WHO WASN'T GOING TO ALLOW ANYTHING TO STAND IN THE WAY OF HER SUCCESS, DISROBED AND GAVE HIM AN EYEFULL OF THE MOST TEMPTING AND VOLUPTUOUS TORSO THAT EVER CAME DOWN THE PIKE ———

BUT SCHNOZZOLLA IS EQUAL TO THE TASK - HE'S HAD A WORLD OF EXPERIENCE WITH A LOT OF BIMBOES WHO THINK THAT ONE GOOD TURN DESERVES A SCREEN TEST BUT NEVER CRASH A STUDIO GATE — AND THE FEW WHO DO CRASH, FINALLY WIND UP GETTING THE GATE

KEEP YOUR MIND ON YOUR WORK SCHNOZZLE SEEMS TO BE A SORT OF DISTURBANCE IN YOUR DRAWERS

GETTING FRIENDLY

THE SCHNOZZOLLA THEN STARTED IN TO DEMONSTRATE THAT MARVELOUS LOVE-MAKING TECHNIQUE THAT HAS CAUSED THE CRITICS TO ACCLAIM HIM THE GREATEST SCREEN-LOVER SINCE VALENTINO

AND FOLKS, WHEN SCHNOZZLE STARTS TO PUT THE PRESSURE ON 'EM, WHEN HE GAZES INTO THEIR EYES WITH THAT DYING DUCK LOOK IN HIS LIMPID, PALE GREEN GLIMS AND THEN WHISPERS THOSE SWEET NOTHINGS IN HIS OWN INIMITABLE WAY, WELL NEIGHBOR, SOME THINGS BOUND TO HAPPEN —

HE HAD CAUGHT UP WITH LOTS OF THOSE MOVIE-STRUCK BLISTERS IN GIGGLEWOOD BUT HE WAS DUE FOR A RUDE AWAKENING — OUR HEROINE IS ONE OF THE SISTREN THAT STARTS IN WHERE THE OTHERS LEAVE OFF - AND SHE'S ABOUT READY TO START —

RELIEF IN SIGHT

THE GREAT SCHNOZZOLLA THEN BRAVELY PREPARED FOR THE RAVAGE - DISROBING COMPLETELY LOTTA GOT A FLASH OF THE JOHNSON BAR THAT HAS BROKEN UP MORE HOMES THAN CARTER'S GOT LIVER PILLS — AND OUR HERO MODESTLY ADMITS HE KNOWS JUST HOW TO USE THAT THING —

NO DOUBT SOME OF OUR READERS WILL CENSOR THE SWEET LOTTA FOR BEING SO READY TO SPREAD HER WINGS AND BE PLUNDERED - BUT WHAT WOULD YOU DO IF YOU HAD HOT PANTS AND TIME ON YOUR HANDS ? AND - HAVENT FOLKS BEEN DOING IT EVER SINCE OLD ADAM MET HIS FIRST INTRODUCEE ?

FIFTY MILLION BUFF ORPINGTON'S CAN'T BE WRONG !!!!

SO I GUESS WE'LL HAVE TO LET OUR HEROINE GET DOMESTIC — *EVEN POULTRY COMMIT ADOULTRY*

ROUND ONE

— AND THEN SCHNOZZOLLA CLAWLED INTO THE SADDLE AND GAVE THE DELIGHTED LOTTA THE OLD GIGGLEWOOD GRIND, OF WHICH HE WAS A PAST MASTER

LOTTA WAS PROUD TO THINK THAT HER INTOXICATING BEAUTY HAD WON HER THIS LITTLE SPIN WITH THE GREAT SCHNOZZLE AND WAS ALDREADY LOOKING FOWARD TO THE DAY WHEN THE FOLKS BACK IN WEST HUCKLEBERRY WOULD READ OF HER SUCCESS IN THE SQUAWKIES

SHE THREW THAT RUMBLE SEAT AROUND AT SCHNOZZLE WITH SUCH FERVOR THAT HE QUICKLY DELIVERED A LOAD THAT DRAINED HIS TESTICULES TO THE DREGS — AND HE HAD BEEN KIDDING HIMSELF THAT HE WAS A PETER-PITCHING-PAPA —

CHALLENGED !!

12.

LOTTA SOON HAD THE DROOPING ROGER
BACK IN SHAPE AGAIN AND HERE WE SEE HER
CAMPING ON THE PEG — A LIMBER PETER
DOESN'T STAY THAT WAY LONG AROUND THE
SIZZLING LOTTA

AND NOW THE FOOLISH SCHNOZZOLLA UP AND
DECLARES HIMSELF, OPENLY DEFYING LOTTA AND
PRACTICALLY CHALLENGING HER TO AN ENDURANCE
CONTEST — WELL NEIGHBORS, HE MIGHT OUT-LAST
THE SENSUOUS LOTTA, BUT IF HE DOES, WELL
HE'LL NEVER LOOK QUITE THE SAME —

LOTTA RODE THAT BOWEL-RAVAGER LIKE
A RABBIT AND SCHNOZZLE AGAIN RANG THE
BELL —— AND WHILE SHE AGAIN WENT TO
WORK TO REVIVE THE SHRUNKEN JOY-PRONG
HE TRIED TO APPEASE HER BOUNDLESS LUST
BY CHEWING ON HER MILK ROUTE AND
STROKING HER BLUSHING SNATCH —

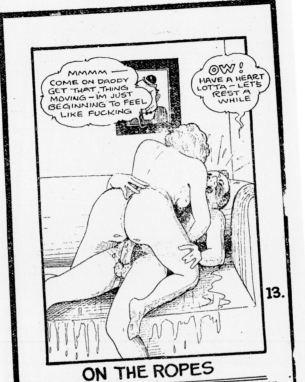

13.

ON THE ROPES

THE SCHNOZZOLLA IS MAKING A GALLANT
ATTEMPT TO STAY IN THE BATTLE BUT APPEARS
TO HAVE BEEN SADLY OVERMATCHED — THIS
TYPHOON OF WARM YOUNG FLESH WOULD TAX
THE ENERGY OF A STUD-HORSE

AGAIN HE REGISTERED AND THE OLD
KIDNEY-PRODDER WENT LIMP AS A DISH RAG —
LOTTA TRIED EVERY KNOWN ARTIFICE
TO REVIVE IT BUT 'TWAS EVER THE SAME
OLD BROMIDE OF GOING TO THE WELL ONCE
TOO OFTEN - HE HAD SIMPLY GONE THE WAY
OF ALL FLESH —

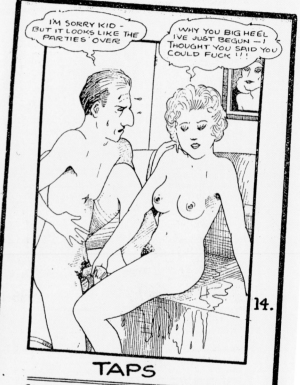

14.

TAPS

GAMELY SCHNOZZLE TRIED TO GET THE OLD
BOY UP AGAIN BUT 'TWAS HOPELESS —
AND WHAT A POSITION HE WAS IN !!! THE POOR
GIRL'S NUTS WERE ON FIRE - SHE NEEDED
PRICK AND PLENTY OF IT —

THIS TIGERISHLY PASSIONED TART WOULDN'T
BE SATISFIED WITH KING KONG FOR A PLAYMATE
BUT THE GALLANT SCHNOZZOLLA COULDN'T
BEAR THE THOUGHT OF WALKING OUT AND
LEAVING HER ALONE WITH HER UNSATISFIED
CRAVINGS — SOMETHING HAD TO BE DONE
AND DONE RIGHT AWAY —

AND SCHNOZZLE PROVED EQUAL TO IT —

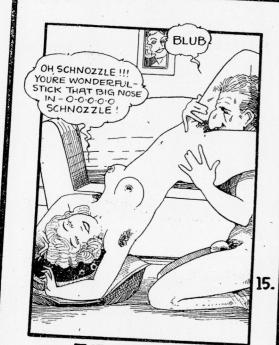

THE SUBSTITUTE

FAR BE IT FROM THE SCHNOZZOLLA TO NOT ASSIST A FAIR DAMSEL IN DISTRESS - NOT IN THIS CHIVALROUS DAY OF PERVERSIONS-

GRASPING OUR BEAUTEOUS HEROINE BY THE HAUNCHES HE YODELED IN THE CANYON TO LOTTA'S DELIGHT

THE TRICK SOON PRODUCED THE DESIRED EFFECT AND LOTTA'S SUMPTUOUS TORSO SOON SHOOK AND SHIVERED LIKE A BOWL OF JELLY ON A FROSTY MORNING, SWAYED LIKE THE LEAVES OF A TREE, WAVED LIKE THE WAVES OF THE OCEAN UNTIL

LOOK WHO'S WITH US —

(Speech bubble: OH SCHNOZZLE !!! YOU'RE WONDERFUL- STICK THAT BIG NOSE IN - O-O-O-O-O SCHNOZZLE !)

(BLUB)

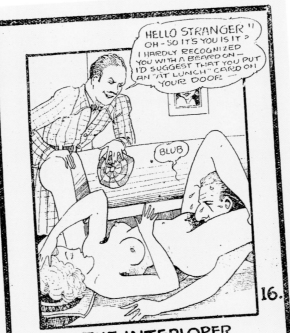

THE INTERLOPER

JUST AS LOTTA WAS AT LAST READY TO TOSS THAT LUMP WHO SHOULD SLOPE IN BUT HIS NIBS, THE GREAT DIRECTOR AND MOVIE MAGGOT —

EDMUND GOLDING

AND WAS THE SCHNOZZOLLA MORTIFIED ? WELL FOLKS - THIS SORT OF BROKE UP THE SCHNOZZLE'S FESTIVE RELIEF OF THE RAVENOUS LOTTA AND JUST WHEN HE HAD COMMENCED TO ENJOY PEEPING IN THE HEATER-

SCHNOZZLE SAYS HE'S GOING TO CONCOCT A SORT OF TOILET WATER THAT WILL MAKE A SNATCH HAVE THE FLAVOR OF ORANGES - BUT GOLDING SUGGESTS THAT JUDGING FROM THE GUSTO WITH WHICH THE SCHNOZZLA WAS DIVING IN THE BUSH THAT HE WOULD BE MORE SUCCESSFUL IF HE COULD GROW ORANGES THAT WOULD TASTE LIKE A PUSSY—

(Speech bubble: HELLO STRANGER !! OH - SO IT'S YOU IS IT ? I HARDLY RECOGNIZED YOU WITH A BEARD ON — I'D SUGGEST THAT YOU PUT AN "AT LUNCH" CARD ON YOUR DOOR —)

(BLUB)

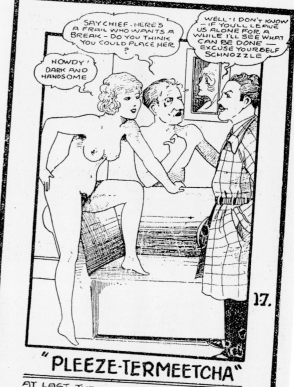

"PLEEZE-TERMEETCHA"

AT LAST THE AMBITIOUS LOTTA COMES FACE TO FACE WITH A HIGH-MOGUL OF HORRORWOOD AND SCHNOZZLE WAS GIVEN THE OFFICE TO AMSCRAY - AND WAS HIS FACE RED ?

SECRETLY THE SCHNOZZOLLA OWED HIS NIBS A DEBT OF GRATITUDE FOR POPPING IN WHEN HE DID AND SAVING HIM ANY FURTHER HUMILIATION — HIS DIAPHRAGM WAS SORE AND SPENT AND THE ULTRA-AMOROUS LOTTA WOULD HAVE RUINED HIM COMPLETELY BUT FOR THE DIRECTOR'S TIMELY ARRIVAL — AND HE HAD BEEN KIDDING HIMSELF THAT HE COULD PITCH PETER !!

(Speech bubble: SAY CHIEF - HERE'S A FRAIL WHO WANTS A BREAK - DO YOU THINK YOU COULD PLACE HER ?)

(Speech bubble: WELL - I DON'T KNOW - IF YOU'LL LEAVE US ALONE FOR A WHILE I'LL SEE WHAT CAN BE DONE - EXCUSE YOURSELF SCHNOZZLE)

(Speech bubble: HOWDY! DARK AND HANDSOME)

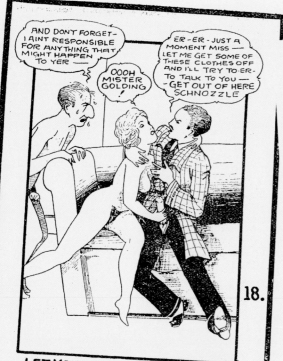

LET YOUR DRAWERS HANG DOWN

AND THEN OUR LITTLE SEX-PANTHER WENT TO WORK ON THE GREAT GOLDING - HADN'T THAT DUMB HACK-PUSHER ADVISED HER TO GET UNDER SOME GOOD DIRECTOR AND WORK UP? SURE HE WAS DUMB - HE WAS SO DUMB THAT HE HAD TO TIE A STRING AROUND HIS FINGER SO HE WOULDN'T FORGET TO PUT HIS PANTS ON WHEN HE GOT UP IN THE MORNING — BUT DUMB AS HE WAS LOTTA FIGURED HE WAS RIGHT ON THIS ONE — — BESIDES, SHE WANTED SOME NOOKIE AND WANTS IT RIGHT NOW - AND IN THIS SUBURB OF LOS ANGELES THE MOVIE MAGGOTS WORK ON A BARTER SYSTEM — "BODIES FOR CONTRACTS" —

18.

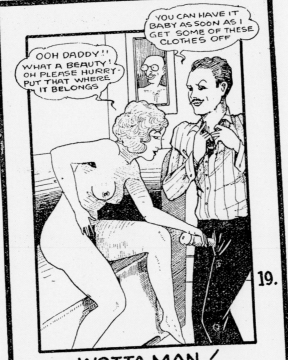

WOTTA MAN !

LOTTA PLAYED FEVERISHLY WITH HIS NIB'S JOY-DISPENSER 'TIL IT GREW TO UNHEARD OF PROPORTIONS AND THE POOR GIRL KNEW THAT AT LAST HER SEARCH WAS ENDED — HERE IN HER VERY GRASP WAS ONE OF THE MOST STUPENDOUS TONSIL-TICKLERS THAT EVER CRASHED A CHERRY —
BUT OH !!! THE DIRECTOR DISCOVERS THAT HE HASN'T ANY RUBBER GOODS WITH HIM BUT WILL RUSH DOWN TO THE CORNER DRUGGIST AND GET SOME — AND LOTTA WON'T LET HIM - SHE CLAIMS THAT FUCKING WITH A RAINCOAT IS LIKE PEEPING THRU A KEYHOLE WITH A GLASS EYE —

19.

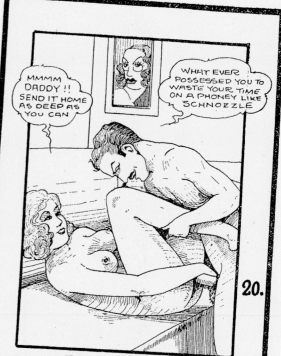

BULLS-EYE

HIS NIBS THEN SHOT THAT BRUTAL ROGER INTO HER QUIVERING QUIM - HE HAD PLAYED AROUND WITH A LOT OF MOVIE-STRUCK EXTRAS WHO WEREN'T SO EXTRA BUT HE'D NEVER CAUGHT UP WITH ANYTHING QUITE AS WARM AN ARRANGEMENT AS THE HIP-TOSSING LOTTA —
AND LOTTA HAD NEVER HAD A SESSION WITH A MAN WHO COULD PROD HER INTESTINES AROUND LIKE THE GREAT GOLDING — LOTTA CAN BE DEPENDED ON TO GIVE HER NEW BIG MOMENT A RIDE HE'LL NEVER FORGET - YESSIR - SHE'LL STEAM-CLEAN AND PRESS THIS HIGH MOGUL OF SILLYWOOD —

20.

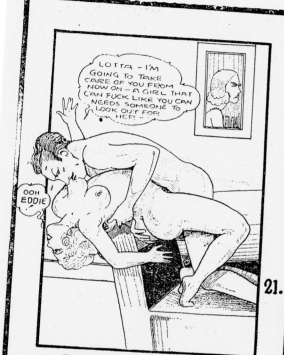

FAIR AND WARMER

WELL FOLKS IT LOOKS LIKE THE KID IS REALLY REGISTERING WITH THE BIG GUN OF FLICKERVILLE — HE SAYS HE PREFERS BLONDS BECAUSE THEY GET DIRTY QUICKER AND BESIDES, WHERE THERE'S LIGHT, THERE'S HEAT

THAT GIGANTIC JOY PRONG IS RIGHT UP TO THE HILT NOW AND LOTTA IS THROWING THAT KIESTER AT THE HIGH GAZABO OF GIGGLEWOOD LIKE ONE POSSESSED — AND THE PYROTECHNICS SHE WENT THRU JUST WEREN'T IN THE BOOK — NOT THAT DIRECTOR GOLDING HADN'T BEEN PROPERLY STAID WITH BEFORE, HE'S BEEN TRADING REPUTATIONS FOR FLESH AND LEGS AND TORSOS FOR CELLULOID FOR YEARS BUT HERE WAS A BABY WHO REALLY THROW A NASTY HIP

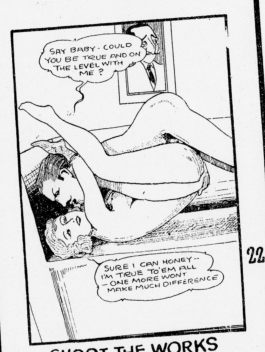

SHOOT THE WORKS

OH·OH !!! THE GREAT GOLDING IS WEAKENING RAPIDLY AND IT LOOKS AS THOUGH LOTTA'S FUTURE WELFARE IS ASSURED — YES FOLKS OUR HEROINE IS PRATICALLY THERE — AND WHO WOULDN'T GO FOR THIS LANGUROUS, SEDUCTIVE AND TEMPTING GUST OF PASSION? HIS NIBS IS READY TO SURRENDER, THE FAMILY JEWELS TO OUR LOTTA, ESPECIALLY THAT THREE PIECE SET HE'S GOT UP LOTTA'S FLUE RIGHT NOW — AND IS CONSIDERING SETTING HER UP IN A SCRUMPTUOUS LAYOUT WHERE HE CAN RUN IN WHENEVER HE FEELS LIKE PLAYING HOUSE AND PUT ON A BLANKET PARTY (PAGE WALTER WINDSHIELD)

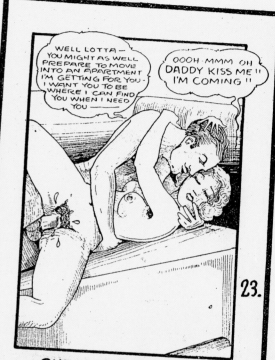

SHE SPINS THE DIAL

AT LAST THE INCOMPARABLE LOTTA HAS THROWN THAT LUMP AND IS ABOUT TO BECOME MISTER DIRECTOR'S OWN PRIVATE LITTLE HOTTENTOT — IT JUST GOES TO SHOW WHERE A GIRL LIKE OUR HEROINE CAN GET IF SHE'S A FIRST CLASS HIP-MERCHANT

AND THERE'S NOTHING A MODERN, INDEPENDENT BROAD LIKES AS MUCH THESE DAYS AS BEING A HIGH-PRICED CAPTIVE — AND DEAR READER- A BUNDLE OF THOSE GREEN, STEEL ENGRAVINGS THAT THE MINT ISSUES WILL QUICKLY OVERCOME A TON OF CONSCIENCE, BOGUS MORALITY OR WHAT HAVE YOU, AND A GIRL CAN SET DOWN AND ENJOY LIFE WITH A FEW SCRUPLES MISSING

98

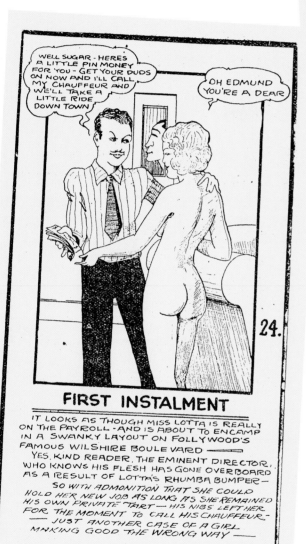

FIRST INSTALMENT

IT LOOKS AS THOUGH MISS LOTTA IS REALLY ON THE PAYROLL - AND IS ABOUT TO ENCAMP IN A SWANKY LAYOUT ON FOLLYWOOD'S FAMOUS WILSHIRE BOULEVARD ——

YES, KIND READER, THE EMINENT DIRECTOR, WHO KNOWS HIS FLESH HAS GONE OVERBOARD AS A RESULT OF LOTTA'S RHUMBA BUMPER —

SO WITH ADMONITION THAT SHE COULD HOLD HER NEW JOB AS LONG AS SHE REMAINED HIS OWN PRIVATE TART — HIS NIBS LEFT HER FOR THE MOMENT TO CALL HIS CHAUFFEUR — —— JUST ANOTHER CASE OF A GIRL MAKING GOOD THE WRONG WAY ——

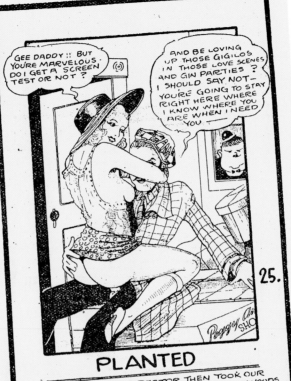

PLANTED

THE SMITTEN DIRECTOR THEN TOOK OUR HEROINE ON A WHIRLWIND TOUR OF JOLLYWOODS SMARTEST SHOPS AND SPENT ENOUGH OF THE OLD "GEETUS" TO PAY THE SOLDIER'S BONUS IN DECKING OUT LOTTA LIKE ASTOR'S PET POODLE —

HATS, COATS, FROCKS, SHOES, COSMETICS, LINGERIE, JEWELRY AND WHAT-NOTS, BESIDES ANOTHER LITTLE DONATION TO HER SPENDING ACCOUNT — AND OUR LITTLE CORN-FED IS EMBARKED ON HER GLAMOROUS CAREER AS A HIGH CLASS KEPTEE — SO HIS NIBS LEFT HER TO GET AQUAINTED WITH HER NEW SURROUNDINGS WHILE HE RETURNED TO THE STUDIOS ——

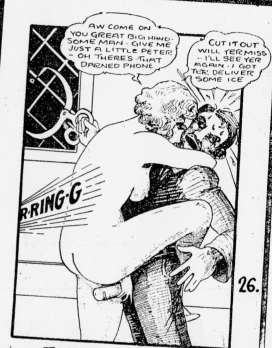

TIME ON HER HANDS

LOTTA'S FIRST DAY AS AN EXPENSIVE KEPTEE WAS RATHER UNEVENTFUL UNTIL THE ICEMAN CALLED AND OUR ALLURING HEROINE MADE A VAIN ATTEMPT TO RAPE HIM - HE WAS SAVED FROM THE IMPENDING PLUNDER BY THE JANGLING OF THE TELEPHONE — IT WAS THE GREAT GOLDING CALLING FROM THE STUDIO TO WARN LOTTA THAT HE HAD RAISED ANOTHER HARD-ON AND WAS ON THE WAY UP RIGHT AWAY TO DROP IT IN HER PANTS - SO SHE HURRIED TO ADJUST HER COMPLEXION AND GET READY TO RELIEVE HIS NIBS - ANGELS LIKE THE DIRECTOR WITH HIS DRIPPING WET BANK ROLL CAN'T BE GIVEN TOO MUCH ATTENTION -

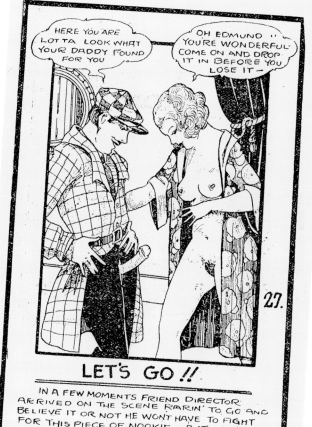

LET'S GO !!

IN A FEW MOMENTS FRIEND DIRECTOR ARRIVED ON THE SCENE RARIN' TO GO AND BELIEVE IT OR NOT HE WONT HAVE TO FIGHT FOR THIS PIECE OF NOOKIE — BUT— HE MIGHT ENCOUNTER A STRUGGLE IF HE DIDN'T HIDE THE WEENIE-PRONTO !!!

LOTTA'S ATTEMPT TO TAKE ADVANTAGE OF THAT POOR ICE-MAN HAD KINDLED HER DESIRES TO THE POINT WHERE SHE WAS JUST AN INFERNO OF LUST AND PASSION —

IT WOULD REQUIRE A DIVISION OF COX'S ARMY TO KEEP THIS BABY SATISFIED— SHE IS STRONG FOR BUT TWO THINGS AND HER PETER IS BOTH OF 'EM —

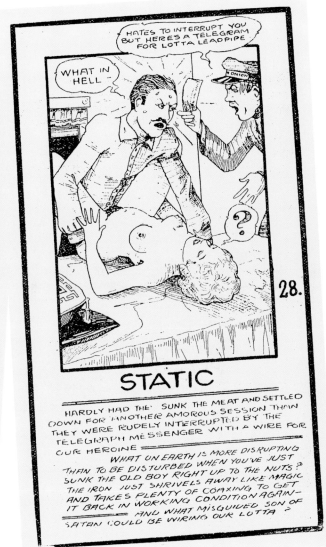

STATIC

HARDLY HAD THEY SUNK THE MEAT AND SETTLED DOWN FOR ANOTHER AMOROUS SESSION THAN THEY WERE RUDELY INTERRUPTED BY THE TELEGRAPH MESSENGER WITH A WIRE FOR OUR HEROINE —

WHAT ON EARTH IS MORE DISRUPTING THAN TO BE DISTURBED WHEN YOU'VE JUST SUNK THE OLD BOY RIGHT UP TO THE NUTS? THE IRON JUST SHRIVELS AWAY LIKE MAGIC AND TAKES PLENTY OF COAXING TO GET IT BACK IN WORKING CONDITION AGAIN— AND WHAT MISGUIDED SON OF SATAN COULD BE WIRING OUR LOTTA?

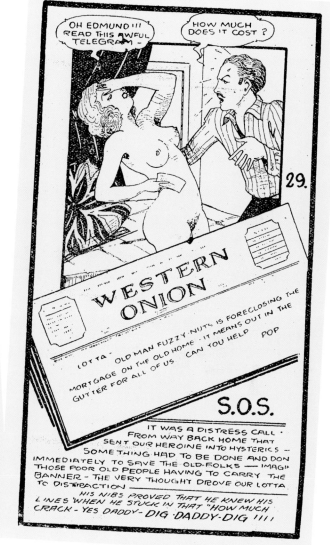

S.O.S.

IT WAS A DISTRESS CALL FROM WAY BACK HOME THAT SENT OUR HEROINE INTO HYSTERICS — SOMETHING HAD TO BE DONE AND DONE IMMEDIATELY TO SAVE THE OLD-FOLKS — IMAGINE THOSE POOR OLD PEOPLE HAVING TO CARRY THE BANNER — THE VERY THOUGHT DROVE OUR LOTTA TO DISTRACTION —

HIS NIBS PROVED THAT HE KNEW HIS LINES WHEN HE STUCK IN THAT "HOW MUCH CRACK- YES DADDY- DIG DADDY-DIG !!!!

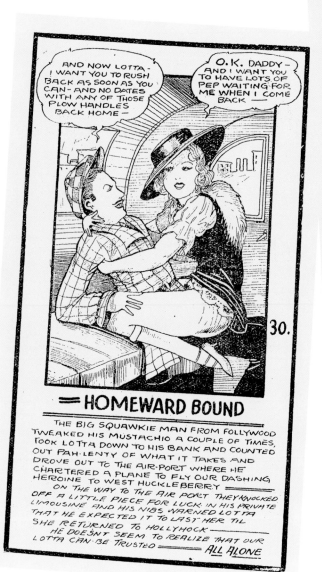

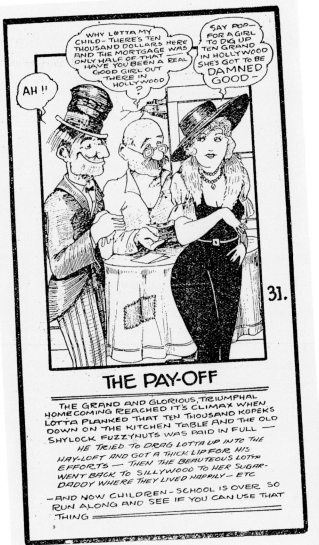

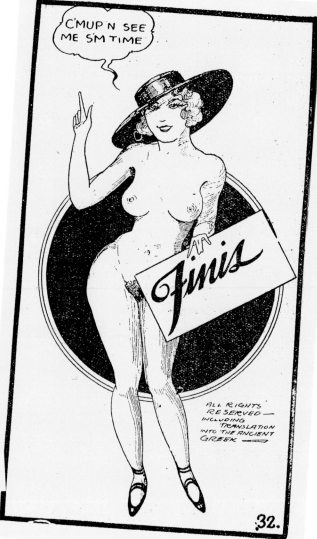

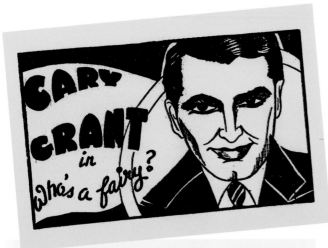

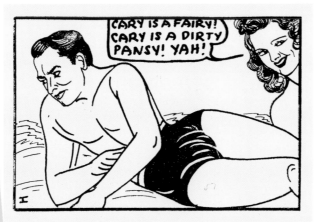

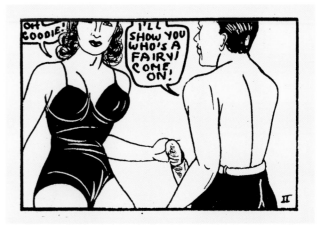

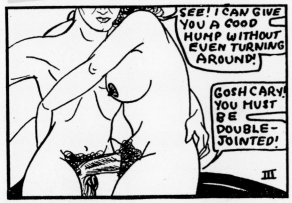

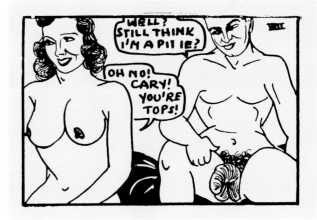

Back in the pre-Stonewall days, allegations of homosexuality could derail a Hollywood career, and rumors were a serious proposition for a number of leading men, including Cary Grant. (Rock Hudson, who was surely gay most of his career, was whispered about continually, and actually entered a sham marriage to defuse the accusations.)

Grant, long the most sought-after leading man in Hollywood, was surely a complex man with many parts to his persona. Handsome beyond belief, he lived into his eighties, married several times, and was around when the whole issue of Who's a Fairy? became irrelevant.

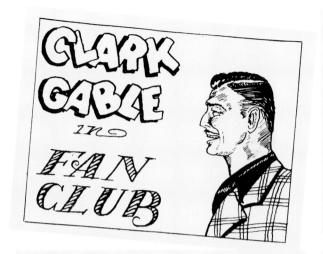

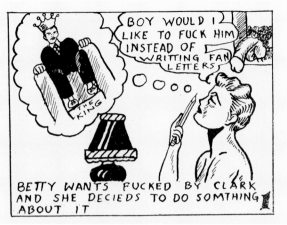

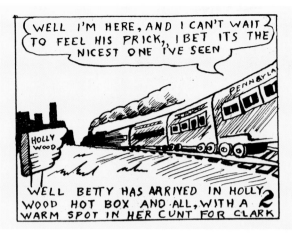

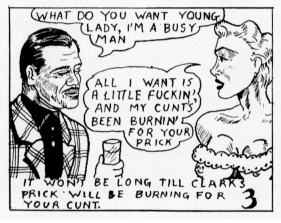

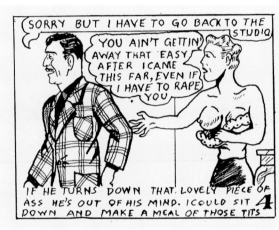

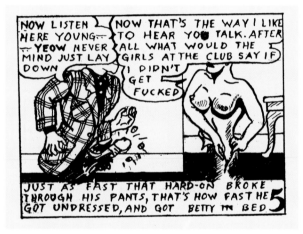

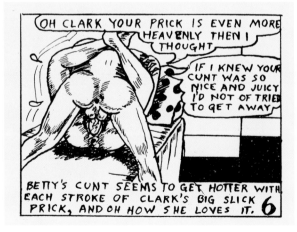

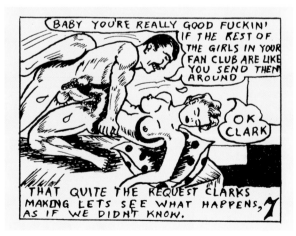

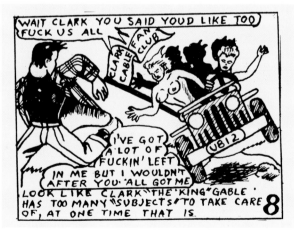

102

Clark Gable started on Broadway and the movies in the late twenties; he was soon everyone's favorite romantic leading man, and by the end of the thirties he was called the King of Hollywood. Unsurprisingly, he was the hero of a number of eight-pages, always the virile, devastatingly handsome man that his films suggested. In this story he turns out to be like so many studs, a real Don Juan — done after one.

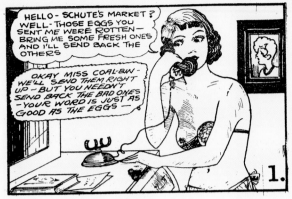
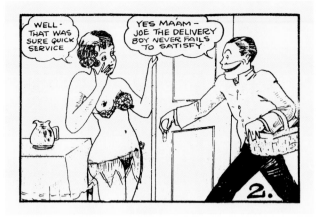
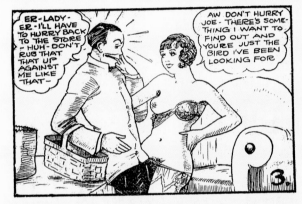
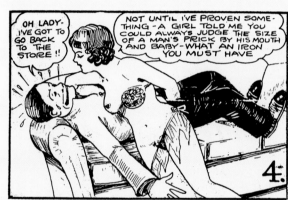
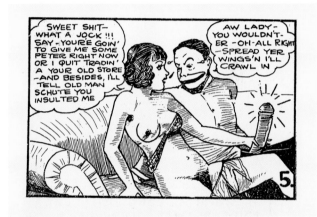
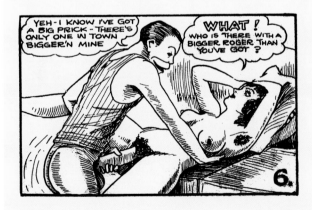
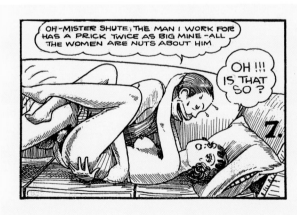
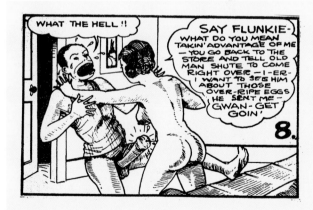

103

Claudette Colbert became a great Hollywood star, but it was hard to surpass her 1934 performance opposite Clark Gable in It Happened One Night. *(Here she plays opposite the comedian Joe E. Brown—you can tell by the mouth.) Beautiful, exotic in a Parisian mode, Colbert maintained her popularity. Always a deft comedienne, she matured like the finest of French wines, and her comedic range seemed to grow with time.*

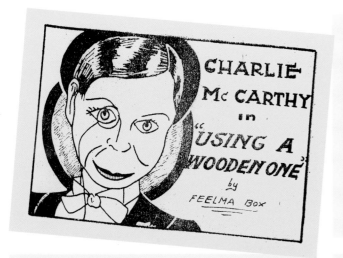
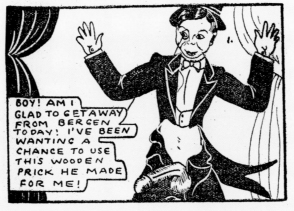
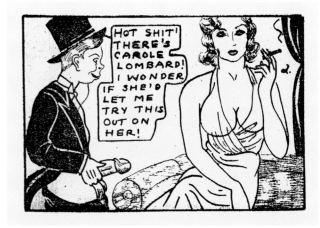
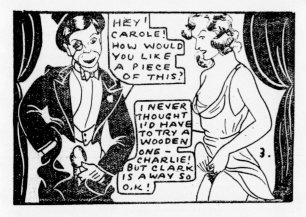
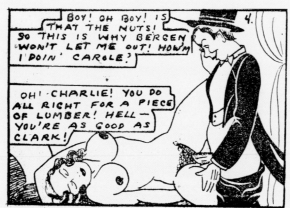
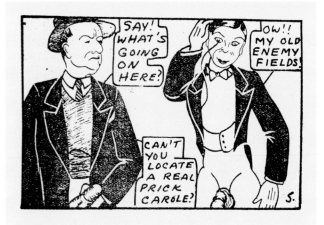
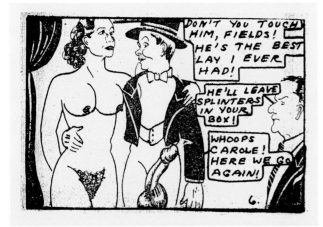
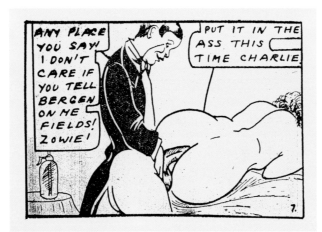
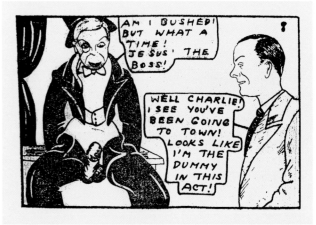

104

Charlie McCarthy, a wooden bon vivant, started giving voice to ventriloquist Edgar Bergen's wit in 1933, and through numerous movie shorts grew hugely popular. No eight-pager artists could possibly pass up an oak wang with all its implications, so

Charlie was also the hero of several Tijuana Bibles. In today's thriving porno industry, the male erection is referred to as "wood"; Charlie's would be worth a king's ransom.

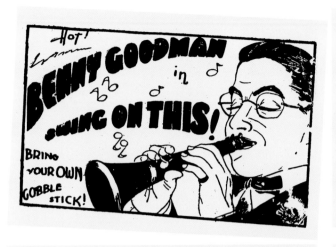

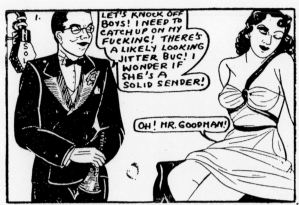

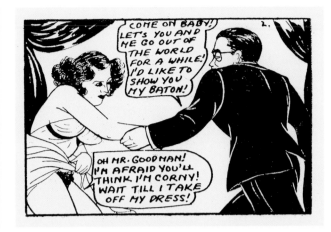

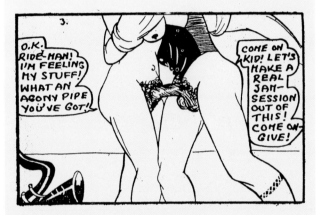

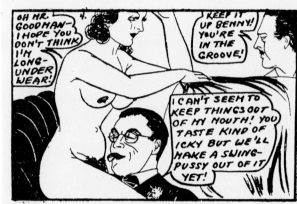

Page missing from booklet

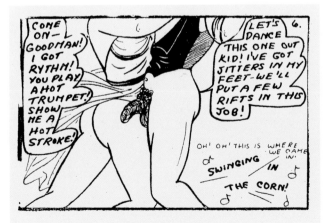

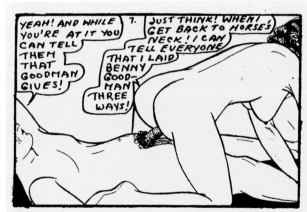

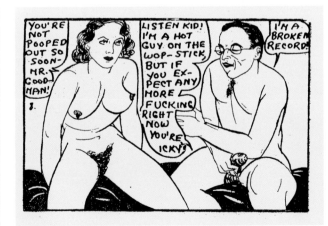

Today it seems rather odd to find Benny Goodman in a Tijuana Bible, but that's only because he spent so many respectable years as an elder statesman of jazz and an acknowledged clarinet virtuoso. In the late thirties, though, Goodman was the apotheosis of the swing musician — and swing was jazz before the arrival of be-bop. The hipster lingo here suggests that the man who drew the booklet was indeed a cool cat and a solid sender, like the great BG himself.

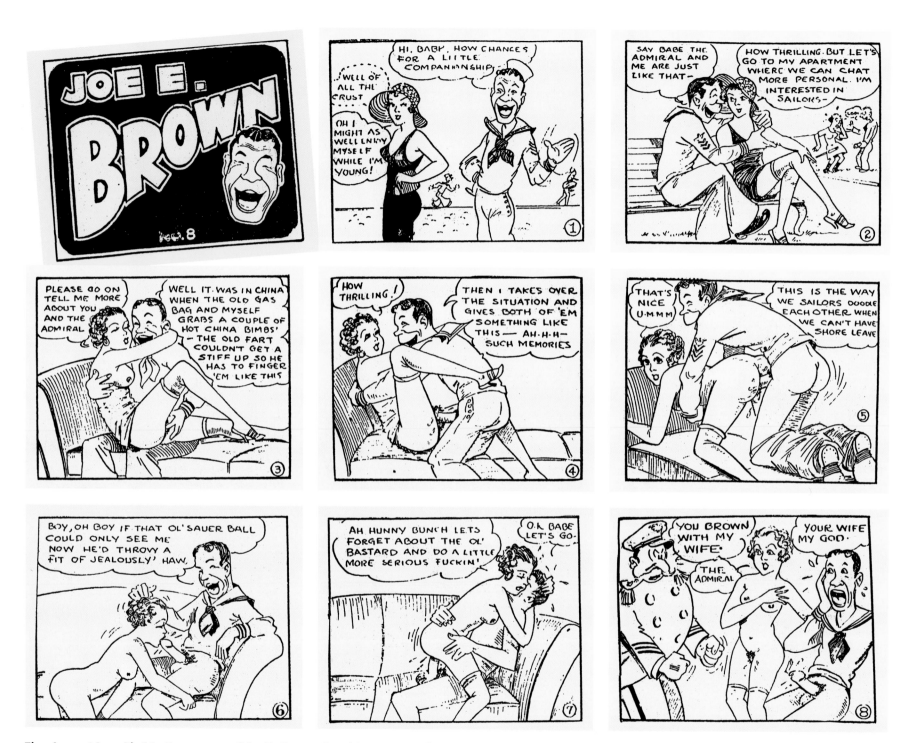

Time has not been kind to the memory of Joe E. Brown, the wide-eyed athletic comedian of the thirties and forties. Blessed with a mouth of particularly large size and a vacant, comical expression, Brown held a constituency enthralled.

Other than A Midsummer Night's Dream in the thirties, his films were not memorable, but in 1951 he came back to play Cap'n Andy in Show Boat and, even later, the millionaire in Some Like It Hot.

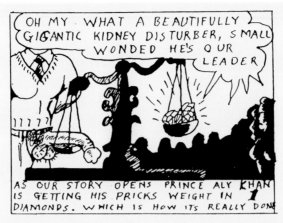

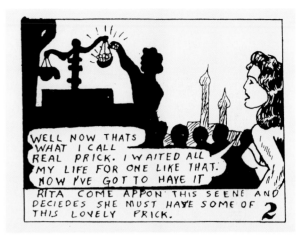

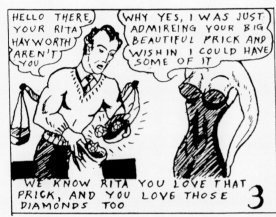

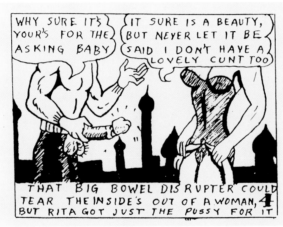

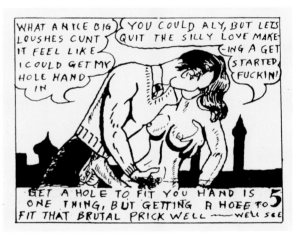

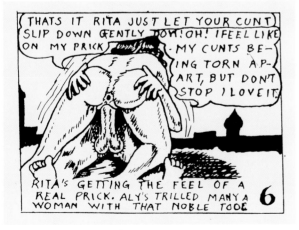

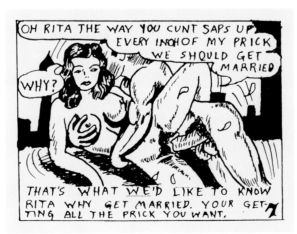

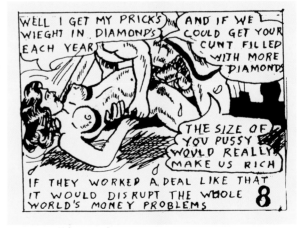

Many men found Rita Hayworth the sexiest woman in the world; she was a favorite pinup girl during the Second World War. She was married a number of times, once to actor Orson Welles, with whom she co-starred in the now-classic Lady from Shanghai, and once to Aly Khan, a wealthy sportsman and playboy who was said to be extraordinarily well-equipped. Mild by today's standards, the affair was hot stuff in the early fifties when it all happened.

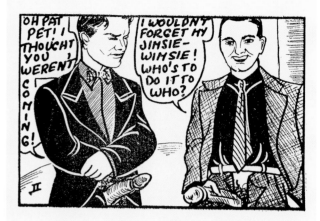
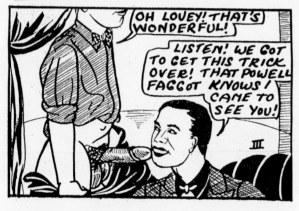
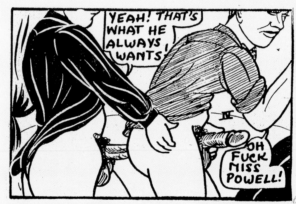
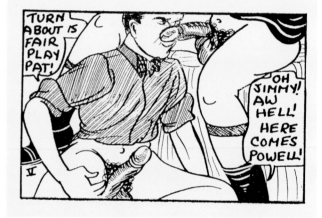
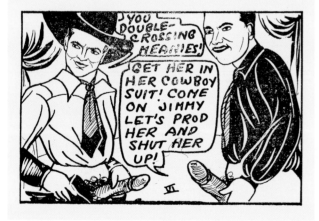
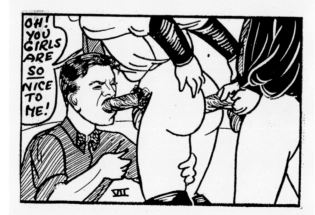
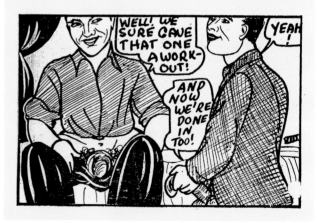

Jimmy Cagney was a hoofer who achieved success in 1931 in his first film, Public Enemy, and didn't dance a step in it. The film established him as a gangster type, but one of singular and special characteristics: he was cheerful, jauntily charming, and utterly immoral. Small and dapper, he was imbued with an odd grace—even when pushing a grapefruit into a gun moll's puss. A consummate pro, he stayed around for a long time; when one watches the evergreen Yankee Doodle Dandy, one sees George M. Cohan—but only through Cagney.

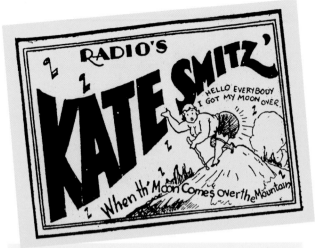

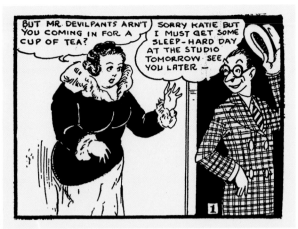

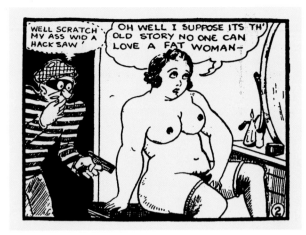

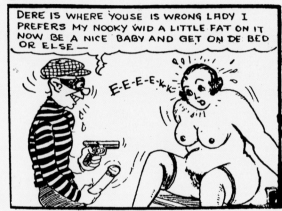

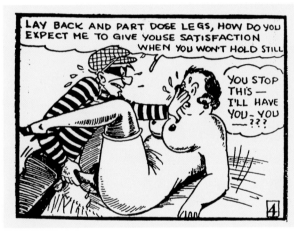

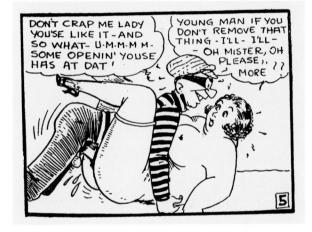

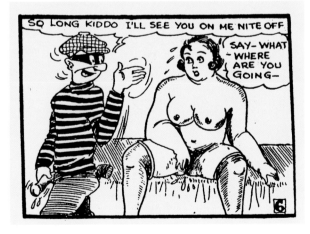

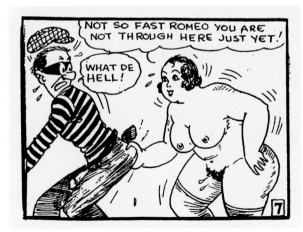

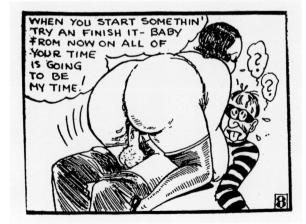

Kate Smith was a talented lady of mild demeanor who sang on the radio in its heyday during the thirties and the forties; she was fondly known as the Radio Warbler. Since it was radio, most of the audience didn't see or know that the young soprano singing "God Bless America" was severely overweight.

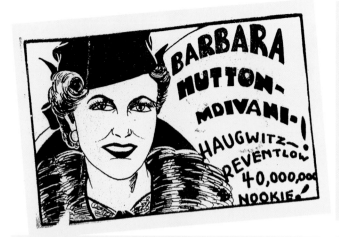

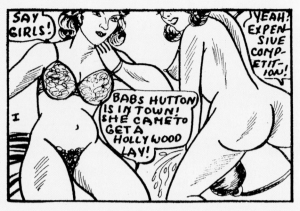

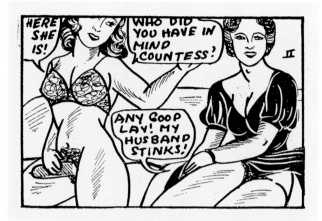

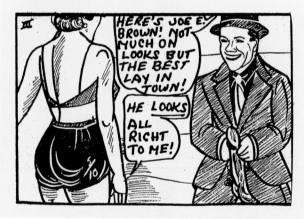

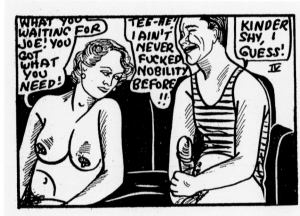

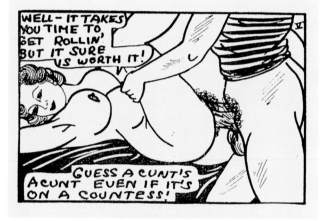

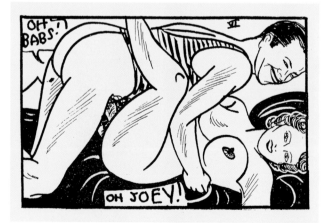

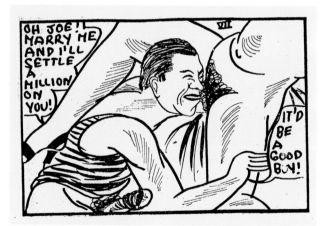

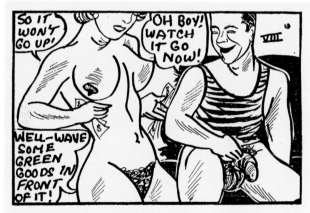

Heiress Barbara Hutton was not terribly complex, it was said, but she had more money than she could fold. Lamentably, it did not bring her happiness, but it did secure the services of a parade of hubbies that included actor Cary Grant and playboy Porfirio

Rubirosa, a Dominican sportsman whose virility was said to be positively equine. Hutton's marital dance card did not include the comedian Joe E. Brown, but here he appears to be just what the doctor ordered.

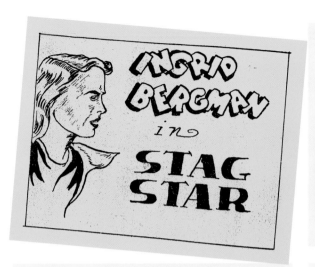

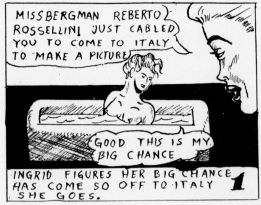

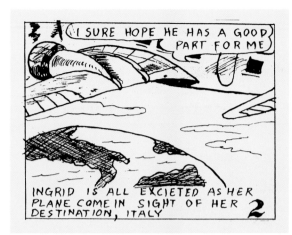

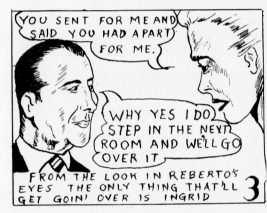

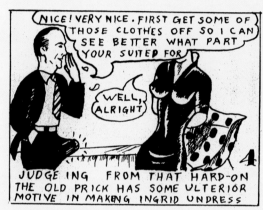

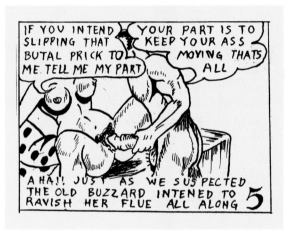

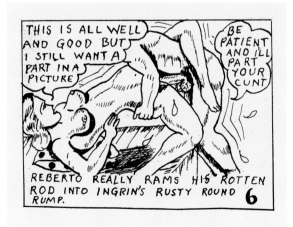

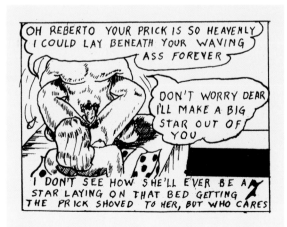

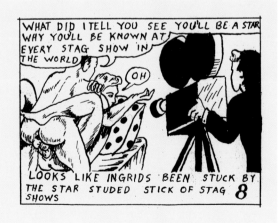

In the late forties, the glamorous Ingrid Bergman, married and already a great star, began a love affair with the Italian director Roberto Rossellini, then the beau of the fiery Italian actress Anna Magnani. For the tabloid mind of Mr.

Dyslexic, the affair was inspiration enough. Today the late Ms. Bergman is still known for her portrayal of Elsa in Casablanca, and the Rossellini scandal is forgotten.

Gun Molls, Heavyweights, and Assorted Tyrants

If the funny papers and then the endless Hollywood parade led the pack as inspiration for the Tijuana Bible artists, then Celebrities of Note, the pungent repertory company gathered from the tabloids of the day, came in a close show. For the Great Depression, the American thirties, was an era when outlaws were as urgently news-worthy as prime ministers (or maybe more so), and anyone who made the evening news might also have the makings of folk myth. In getaway cars or classic squared circles like Madison Square Garden (then still on Fiftieth and Eighth, of course) the gun molls and pugs suggested sex and, hence, Tijuana Bibles.

The cartoonist now known as Mr. Prolific, in honor of both his ubiquity and his output during the middle thirties, had a field day with gangsters and occasionally dealt with political figures as well (Gandhi and Hitler). He did a superb series based upon the public enemies of the day, immortalizing Al Capone, "Pretty Boy" Floyd, "Baby Face" Nelson, "Machine-Gun" Kelly, and the cigar-smoking, curvaceous gun moll of legend, Bonnie Parker, who was more than likely far more lethal in her eight-pager than she ever was in her sad and short life. The *Public Enemies* suite was beautifully drawn, witty, and intelligently constructed, like most all of Mr. Prolific's work. His range of interest was broad and occasionally included rather eccentric subjects like Jesse James, who falls into the outer limits of the public-enemies range.

Tijuana Bible artists often became territorial. Many of the eight-pagers that dealt with political themes, both national and international, were the work of an artist whose drawings were bold, overtly flawed, and extremely disturbing in both narrative content and graphic distortion. Where the drawings of Mr. Prolific are graceful and lightly incisive, the cartoons of "Mr. Dyslexic" (as Speigelman names him in his introduction)

are ominous and foreboding, even malevolent. The heads are often hidden behind talk balloons, suggesting decapitation, and there is a sadistic streak that is palpable. Despite this he did a great many books, almost always on figures like Stalin or Churchill or Chiang Kai-shek. His skills were limited and his vision disturbing, but there is an intensity about his perceptions that is undeniable and, furthermore, memorable.

There are very few Tijuana Bibles concerning baseball, which is curious, in a way, considering its immense popularity during the period. Moreover, there are none on Babe Ruth—who was, like Mae West, born for the Tijuana Bible. By the early thirties, though, Ruth was already a holdover figure from the "good, gone times." There are two Bibles on Lou Gehrig and Joe DiMaggio; in the Gehrig story, Larrupin' Lou has the good fortune of meeting Mae West, as one might expect.

Owing, perhaps, to their physical allure and the odd glamour of the Sweet Science, boxers were popular with Tijuana Bible artists from the start. In the late thirties, another cartoonist, whose particular gifts were nearly as well defined as Mr. Prolific's, undertook a series of booklets that included former ring heroes from John L. Sullivan to Max Schmeling and Max Baer, and ended with Joe Louis, then heavyweight champion. The Louis treatment includes a full menu of the racial stereotypes prevalent at the time, but at the same time, one is aware of the awe in which the Brown Bomber was held. Like most of the boxing booklets, the Max Baer one can be seen as a cautionary tale, painfully proving the adage of the great Boston Tar-Baby, Sam Langford, held by many to be the greatest heavyweight never to hold the title: "You can sweat out the food and you can sweat out the booze, but you can't sweat out the women!"

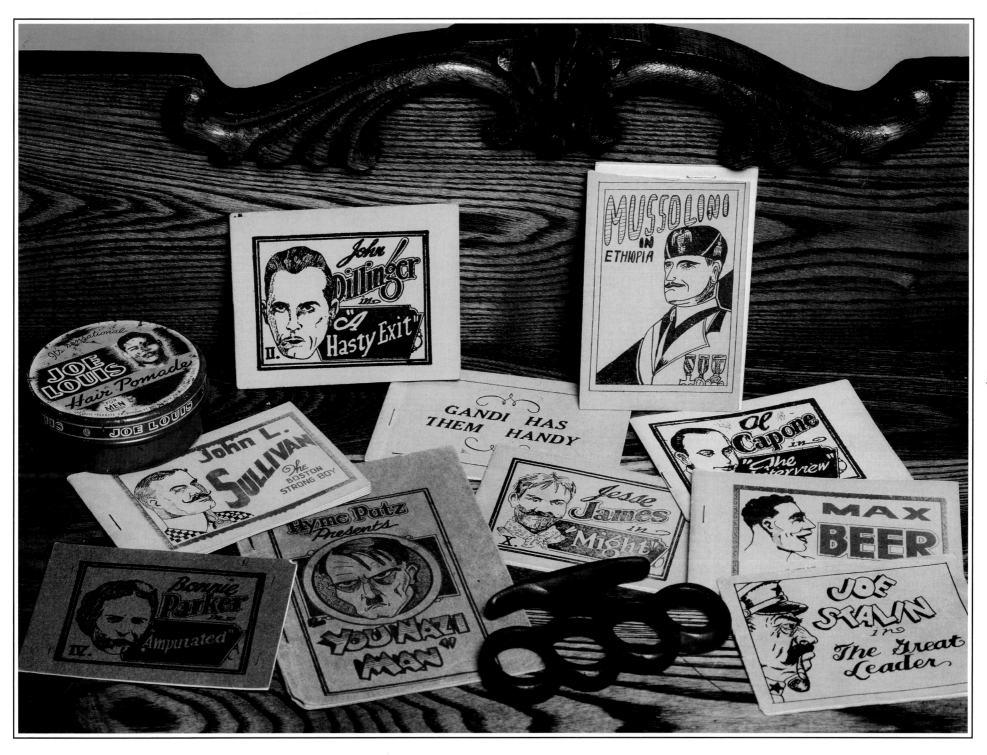

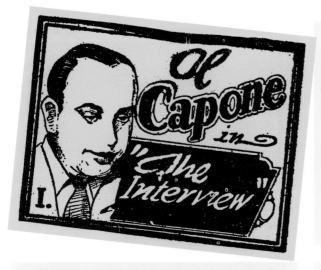

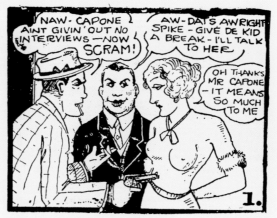

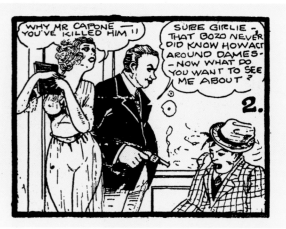

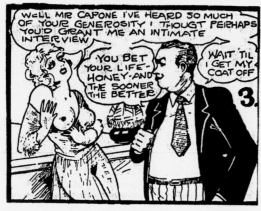

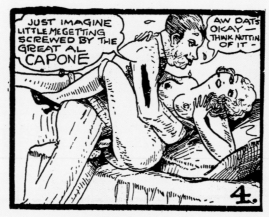

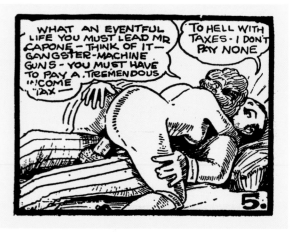

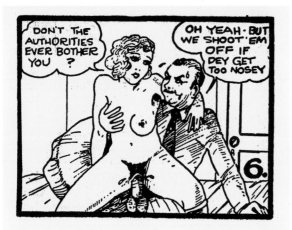

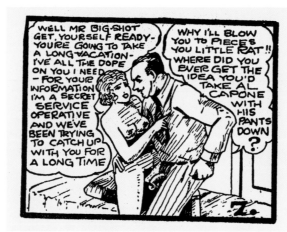

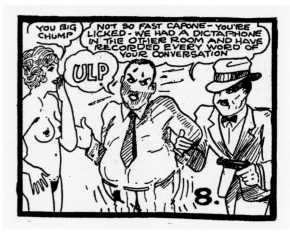

Al Capone was the boss of the Chicago underworld during the Roaring Twenties, and since then he has passed into legend—and through an endless stream of books, magazines, and films. He almost seems still to be with us. Capone was the original Scarface (a role played by Paul Muni in the film of the same name), and the public never tired of hearing about him, even after his relatively early demise from syphilis. In the earlier part of the decade, he was interviewed by a woman of the fourth estate. "They talk about me not being on the legitimate," he said. "Why, lady, nobody's on the legit when it comes down to cases; you know that."

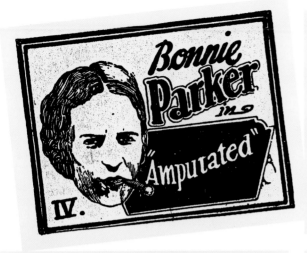

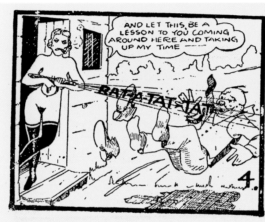

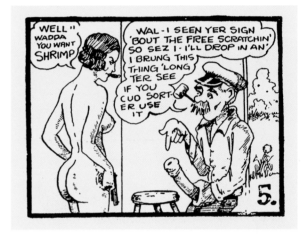

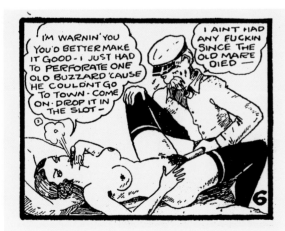

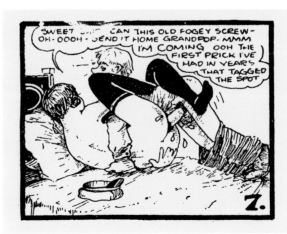

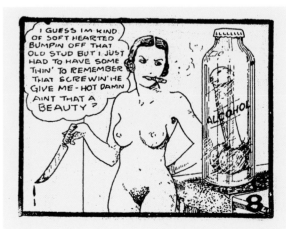

Like so many of the mid-country gangsters of the Depression, Bonnie Parker had a short career but good press coverage. She ran off with Clyde Barrow in 1932 and, after a series of exploits, primarily inept bank robberies, was killed with him in 1934 by Texas Rangers in a remote section of Louisiana. For over three decades the saga lay dormant, until the 1967 film Bonnie and Clyde *recreated the legend for keeps. Chances are that the Bonnie Parker in* Amputated *is closer to the raw-boned gun moll than the silky Faye Dunaway ever was, especially since the booklet was done while the real Bonnie Parker was very much in business.*

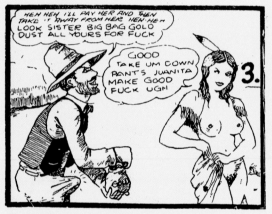

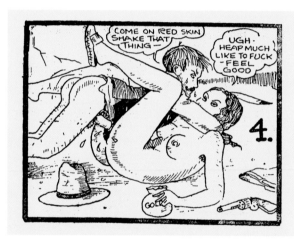

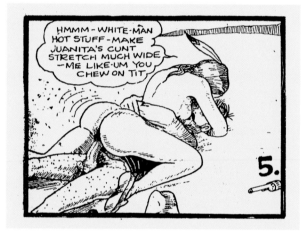

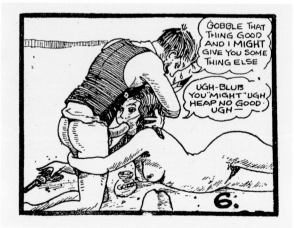

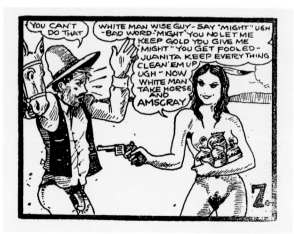

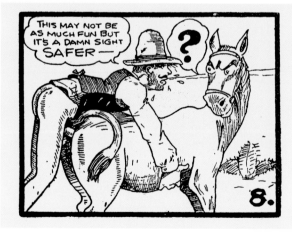

The Tijuana Bible artists usually preferred current events, so it's unusual to find a genuinely historical character portrayed. (Jesse James was, of course, a desperado who died in 1882.) This is one of a series of booklets by Mr. Prolific featuring gangsters and public enemies; as is often the case with his work, the tale is a cautionary one, with the devil getting his due in the end. The inclusion of a Native American is also not standard fare, although it surely occurred in the lampoons of some of the cowboy strips, like Red Ryder or The Lone Ranger.

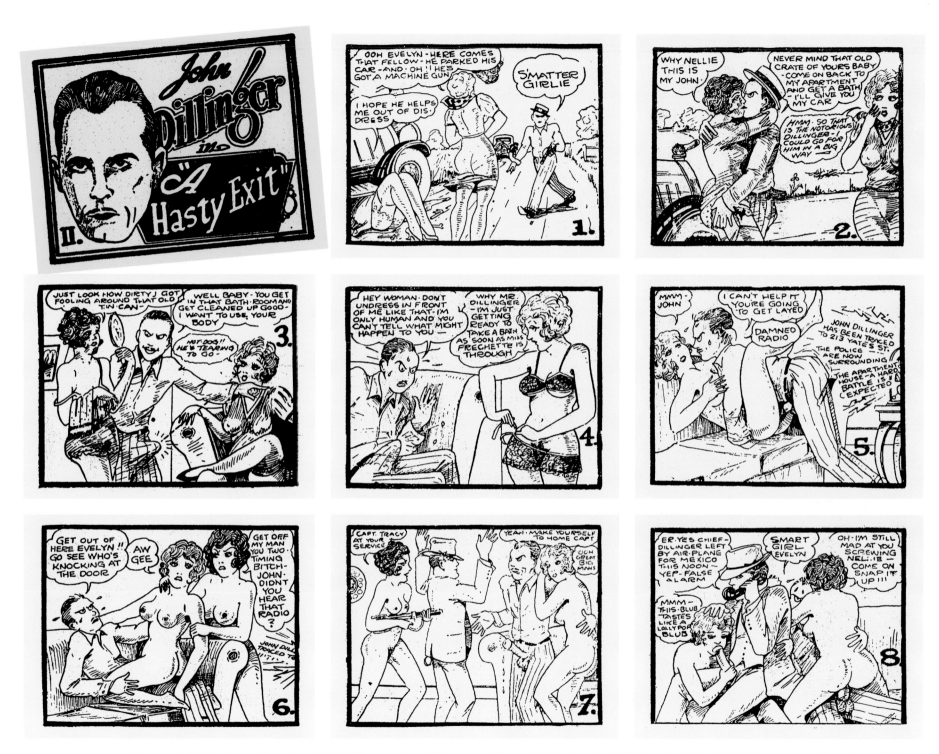

No gangster cut a wider swath in the Depression than John Dillinger, whose life and exploits have stimulated endless books and films. Dillinger's actual career as a bank robber and public enemy lasted a scant fourteen months—he was ambushed by Melvin Purvis and the FBI in Chicago on July 21, 1934, as he emerged from the Biograph Theater—but within a short time he had become nothing short of a legend. Rumor had it that he was astonishingly hung, and for years small traveling carnivals would feature, as an exhibit, the pickled member of the baddest of American desperadoes.

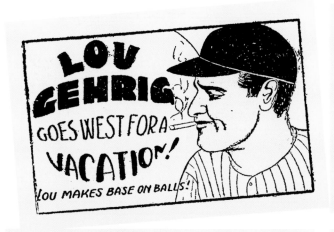

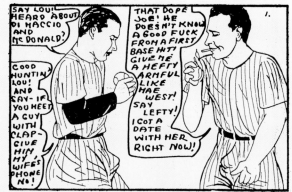

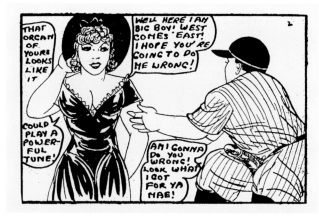

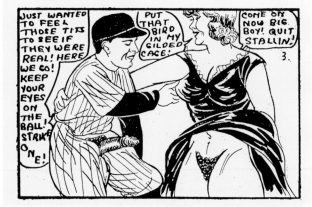

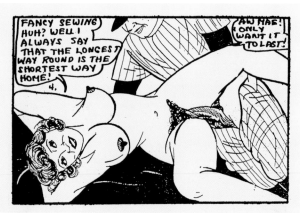

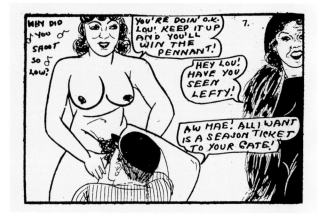

118

Few Tijuana Bibles were allotted to baseball players, but Lou Gehrig—a homebody who would be the least likely—was so honored with this eight-pager from the mid-thirties. His partner is none other than the ubiquitous Mae West, whose amorous choices, in these little books, usually ran to other movie stars. The artist was a baseball fan is clear: who else would have known that June O'Dea was married to Lefty Gomez? (Also note the Joe DiMaggio look-alike in the first panel.)

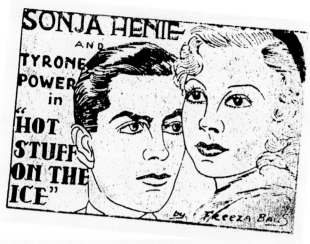

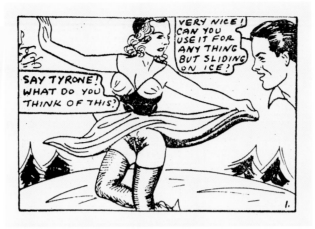

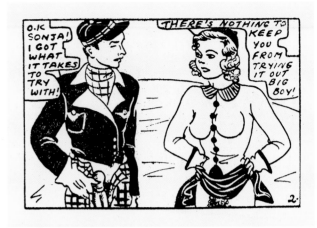

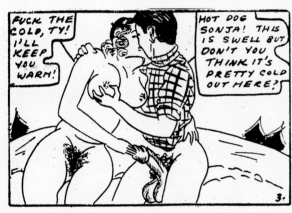

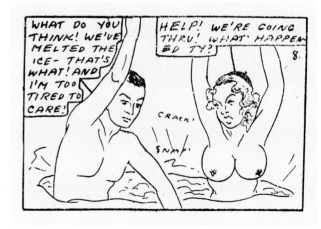

Sonja Henie was a rather chubby Norwegian blonde who parlayed Olympic success into a surprisingly extended Hollywood career. Her films always contained a figure-skating complication, thank heaven, and she became a perennial. Tyrone Power, who made a couple of films with her, was a heart-throb of the forties and fifties who was lamentably typecast in swashbuckling roles. A troubled soul, he was capable of more.

Max Baer was heavyweight champion in 1934–35. He greatly
preferred carousing to training, and women to carousing.
Built like an Atlas and packing a powerful punch, he had
the capabilities to become one of the greatest heavyweights
of all time, but he couldn't seem to keep his mind on his
work. He held the crown for just one year, then lost it to
James Braddock—quite likely for reasons best described
in this little booklet.

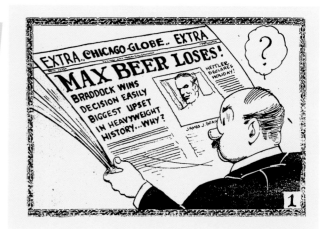

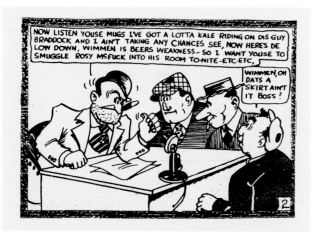

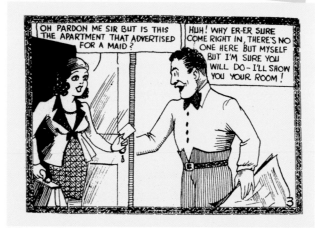

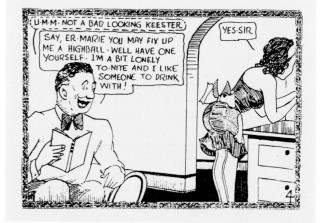

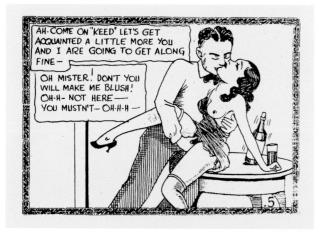

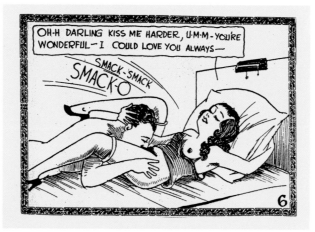

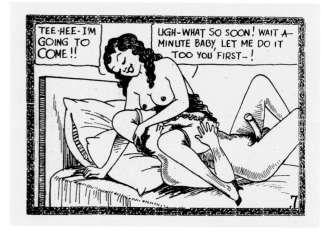

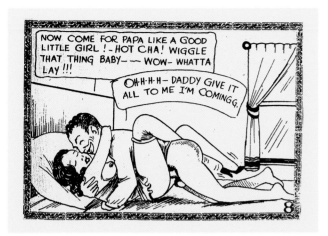

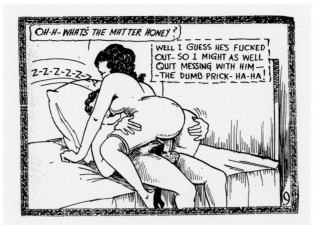

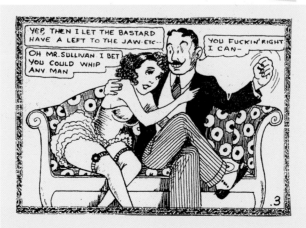

John L. Sullivan, heavyweight champion from 1882 to 1892, was effectively the beginning of big-time boxing in America. Known as the Boston Strong-Boy, he was the stuff that legends are made of, the last bare-knuckle fighter in America. He boasted, "I can lick any man in the house!" but eventually lost his championship to "Gentleman Jim" Corbett, a different sort altogether. Sullivan was a boozer and brawler for most of his career, but in middle age he saw the light and preached for the temperance movement.

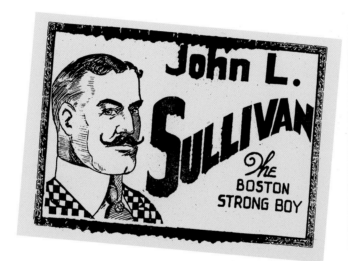

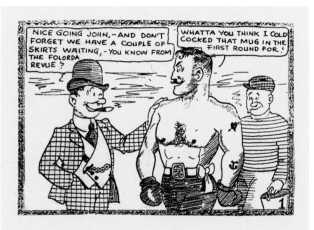

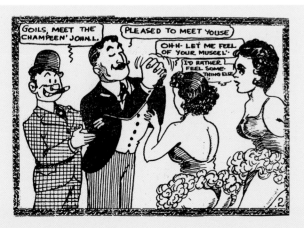

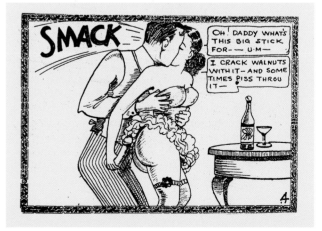

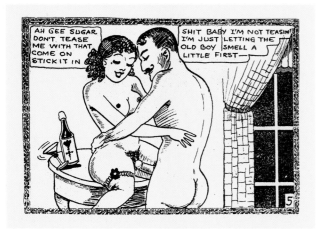

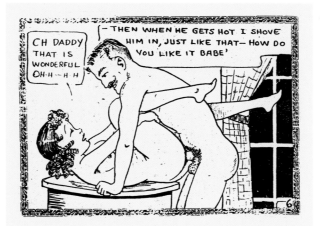

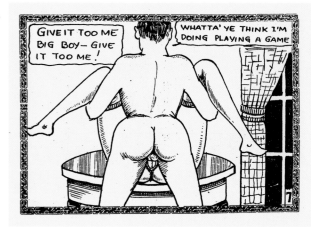

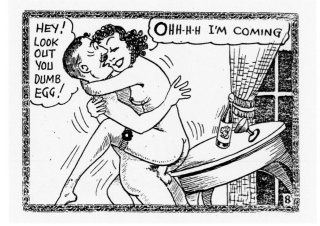

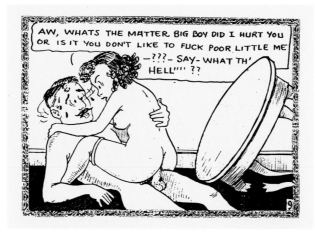

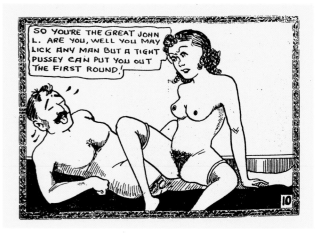

This booklet, obviously done in the early part of Joe Louis's career (he was heavyweight champ from 1937 to 1949), is important for several reasons: first, it is the only known eight-pager of the great Brown Bomber, and, second, it is another of the stylized Amos 'n' Andy-type interpretations, employing all the standardized techniques for depicting cartoon blacks. Rumor has it that Louis did indeed get around, and did bed any number of noted celebrity ladies. The resemblance to Louis is off, but the flavor is authentic.

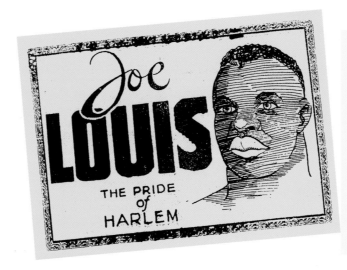

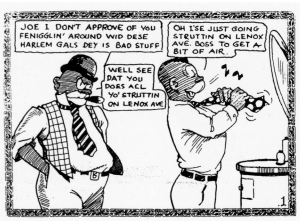

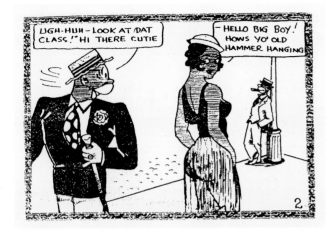

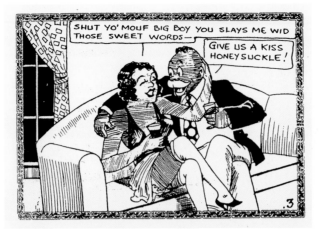

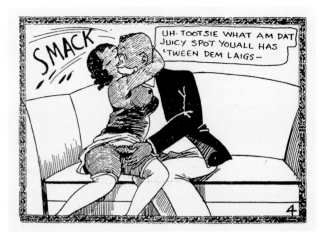

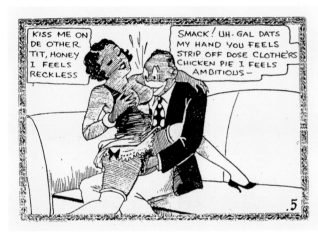

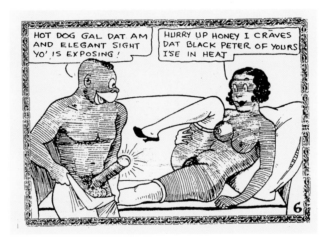

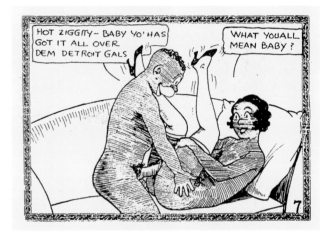

123

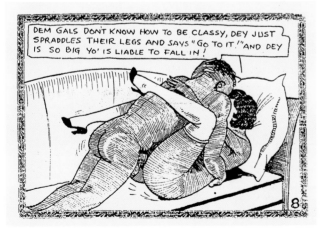

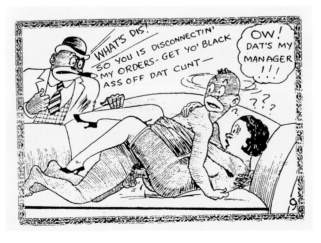

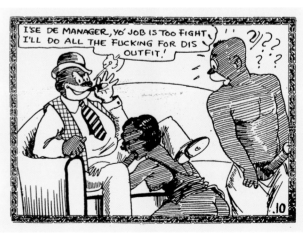

The artist responsible for the *Mussolini eight-pager was certainly not prolific—only two booklets can be definitely linked to him. The drawing ability is woeful, but there is a sort of raw, primitive quality about the line and the form that truly helps to define the subject, which is Il Duce in Ethiopia. (The spelling is equally inept, but this is often true in the genre.) In all, there is an eccentric blend of form and content that is not always found in the Tijuana Bibles — even with more gifted artists.*

124

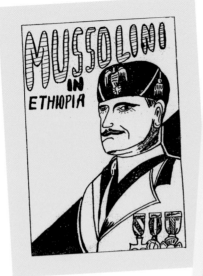

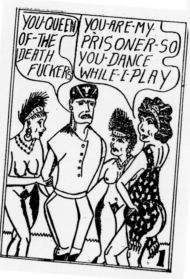

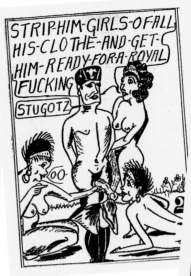

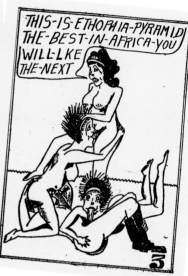

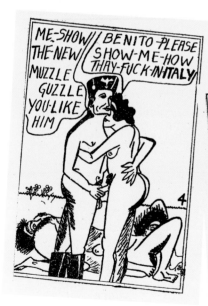

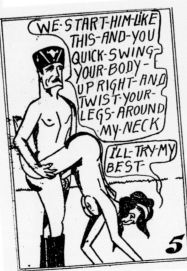

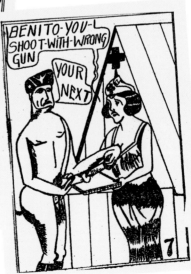

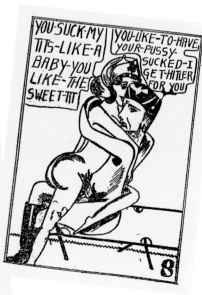

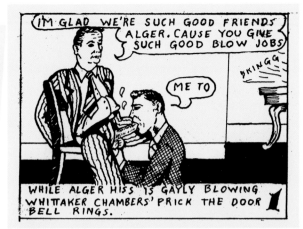

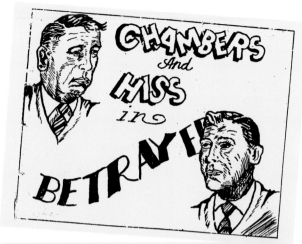

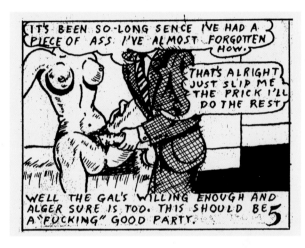

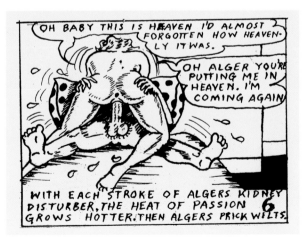

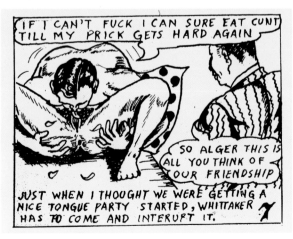

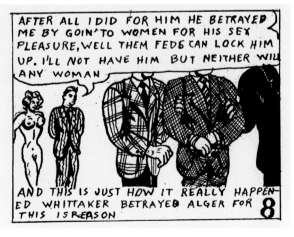

125

The long-running debate and mystery surrounding the Red spy case of Alger Hiss and Whittaker Chambers lend this book a disarming charm. Mr. Dyslexic, as Art Spiegelman has recently dubbed him, had an astounding ability to splice world leaders and events with raw and even disturbing depictions of sex. He latched onto the Rashomon-like enigma of the case and invited the conclusion that a recent biography indicates—that the love that dare not speak its name animated the mystery.

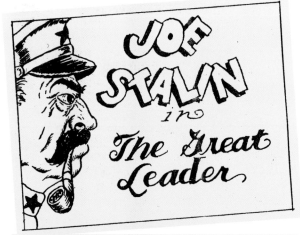

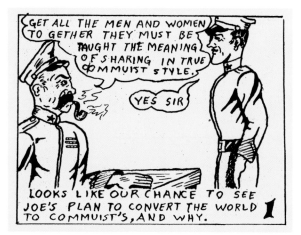

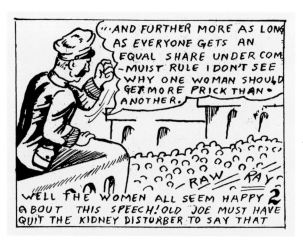

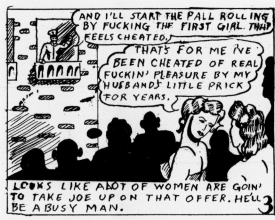

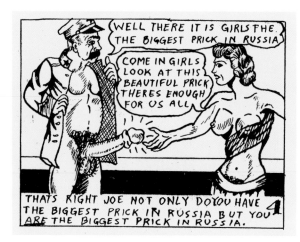

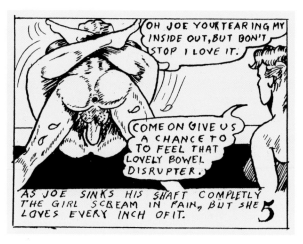

126

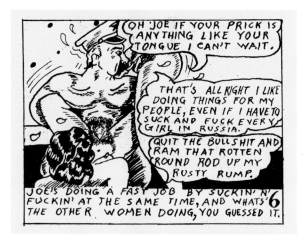

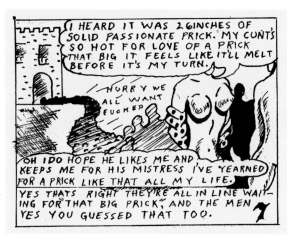

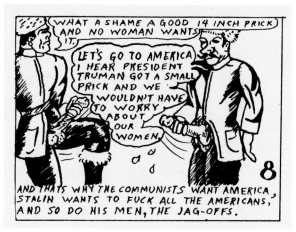

Political coverage in the Tijuana Bibles was never overly profound. Usually a world figure is latched onto, many times by this artist. But the topical pertinence is virtually nil. Instead, a sort of broad sexual burlesque is substituted, and we are off to the races. Here the races are those of the Cold War, as perceived by a sexual obsessive (or maybe worse). But the drawings have an ominous quality about them that, curiously, does suggest that period and its paranoiac mood. Here Joe Stalin and Chiang Kai-shek evoke lousy memories and, in that sense, may well be more meaningful now than they were when created.

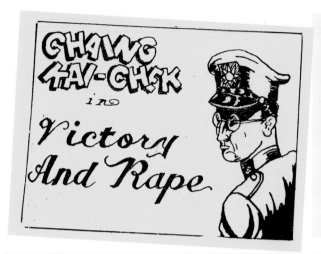

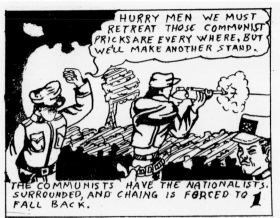

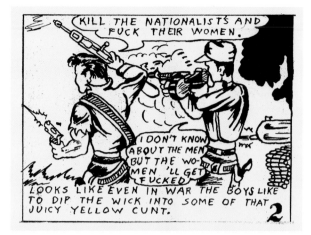

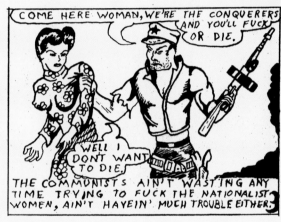

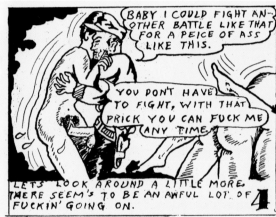

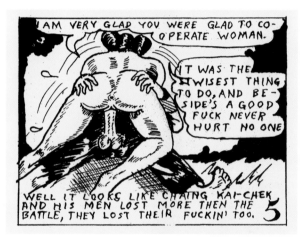

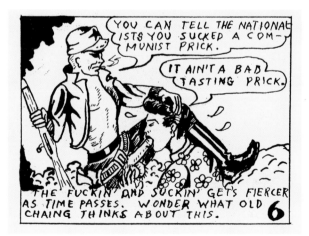

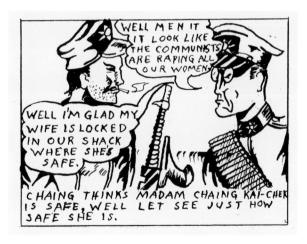

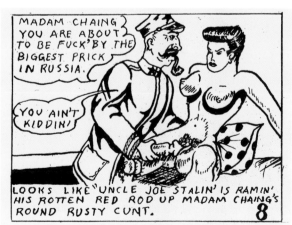

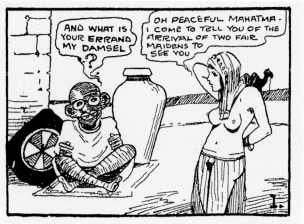

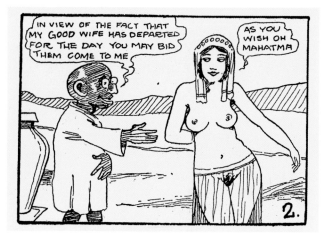

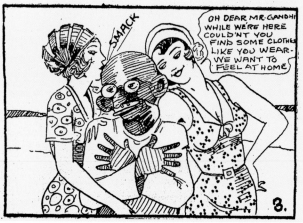

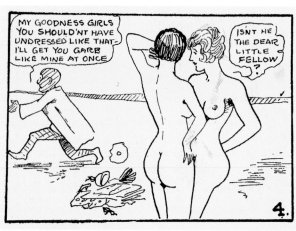

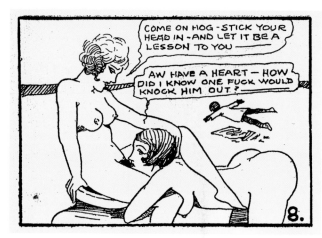

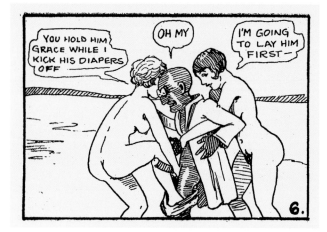

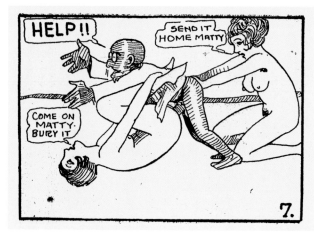

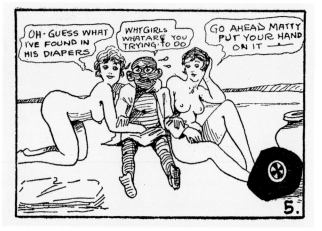

128

Though eight-pagers largely depended on the funnies for inspiration, they attempted to cover other bases as well. This Gandhi episode (the only one that's known to deal with the Mahatma) takes off on his practice of sleeping with young virgins for warmth and to test his virtue. Imagining his celibacy to fail allowed the Tijuana boys to poke fun at pious puritanism.

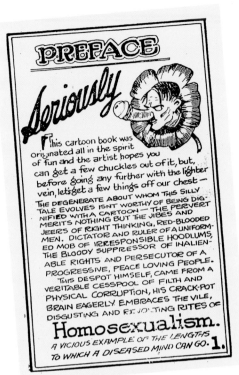

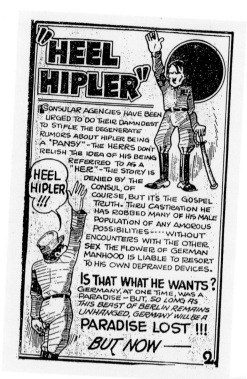

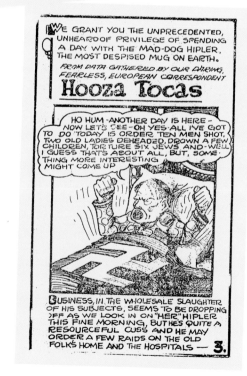

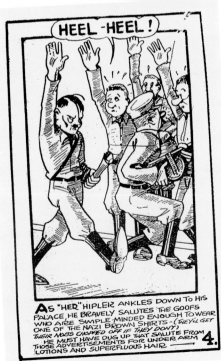

This is one of the few Tijuana Bibles that deals with Adolf Hitler. The primary theme of Der Führer's homosexuality was not a new supposition, but the cannibalism lends an air of true ghastliness. Although the booklet was drawn by the competent Mr. Prolific, it is surely not one of his best. But it is revealing: the final statements regarding Jews, plus the use of Yiddish, suggest (1) that Mr. Prolific may well have been a Jew, and (2) that the Holocaust was not a closely guarded secret even in the late thirties.

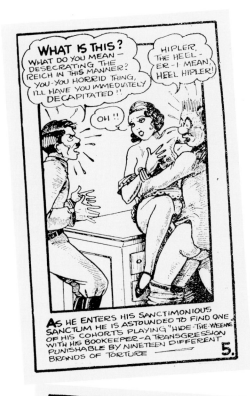

WHAT IS THIS? WHAT DO YOU MEAN — DESECRATING THE REICH IN THIS MANNER? YOU-YOU HORRID THING, I'LL HAVE YOU IMMEDIATELY DECAPITATED!!

OH!!

HIPLER, THE HEEL- ER-I MEAN HEEL HIPLER!

AS HE ENTERS HIS SANCTIMONIOUS SANCTUM HE IS ASTOUNDED TO FIND ONE OF HIS COHORTS PLAYING "HIDE-THE-WEENIE" WITH HIS BOOKEEPER—A TRANSGRESSION PUNISHABLE BY NINETEEN DIFFERENT BRANDS OF TORTURE— 5.

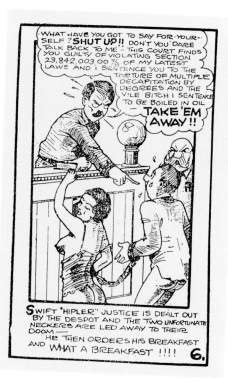

WHAT HAVE YOU GOT TO SAY FOR-YOUR-SELF? SHUT UP!! DON'T YOU DARE TALK BACK TO ME.- THIS COURT FINDS YOU GUILTY OF VIOLATING SECTION 23,842,003.00% OF MY LATEST LAWS AND I SENTENCE YOU TO THE TORTURE OF MULTIPLE DECAPITATION BY DEGREES AND THE VILE BITCH I SENTENCE TO BE BOILED IN OIL — TAKE 'EM AWAY!!

SWIFT "HIPLER" JUSTICE IS DEALT OUT BY THE DESPOT AND THE TWO UNFORTUNATE NECKERS ARE LED AWAY TO THEIR DOOM. HE THEN ORDERS HIS BREAKFAST AND WHAT A BREAKFAST!!!! 6.

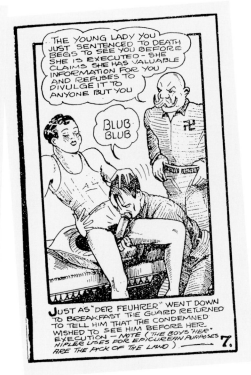

THE YOUNG LADY YOU JUST SENTENCED TO DEATH BEGS TO SEE YOU BEFORE SHE IS EXECUTED-SHE CLAIMS SHE HAS VALUABLE INFORMATION FOR YOU AND REFUSES TO DIVULGE IT TO ANYONE BUT YOU

BLUB BLUB

JUST AS "DER FEUHRER" WENT DOWN TO BREAKFAST THE GUARD RETURNED TO TELL HIM THAT THE CONDEMNED SHE WISHED TO SEE HIM BEFORE HER EXECUTION — NOTE (THE BOYS HER HIPLER USES FOR EPICUREAN PURPOSES ARE THE PICK OF THE LAND) ——→ 7.

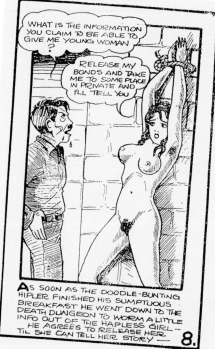

WHAT IS THE INFORMATION YOU CLAIM TO BE ABLE TO GIVE ME YOUNG WOMAN?

RELEASE MY BONDS AND TAKE ME TO SOME PLACE IN PRIVATE AND I'LL TELL YOU

AS SOON AS THE DOODLE-BUNTING HIPLER FINISHED HIS SUMPTUOUS BREAKFAST HE WENT DOWN TO THE DEATH DUNGEON TO WORM A LITTLE INFO OUT OF THE HAPLESS GIRL — HE AGREES TO RELEASE HER TIL SHE CAN TELL HER STORY — 8.

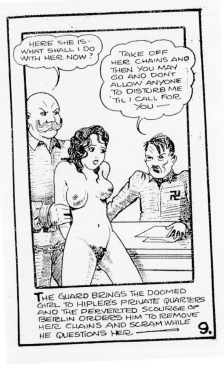

HERE SHE IS - WHAT SHALL I DO WITH HER NOW?

TAKE OFF HER CHAINS AND THEN YOU MAY GO AND DON'T ALLOW ANYONE TO DISTURB ME 'TIL I CALL FOR YOU —

THE GUARD BRINGS THE DOOMED GIRL TO HIPLER'S PRIVATE QUARTERS AND THE PERVERTED SCOURGE OF BERLIN ORDERS HIM TO REMOVE HER CHAINS AND SCRAM WHILE HE QUESTIONS HER — 9.

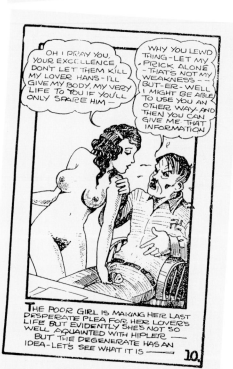

OH I PRAY YOU, YOUR EXCELLENCE, DON'T LET THEM KILL MY LOVER HANS-I'LL GIVE MY BODY, MY VERY LIFE TO YOU IF YOU'LL ONLY SPARE HIM —

WHY YOU LEWD THING-LET MY PRICK ALONE -THAT'S NOT MY WEAKNESS — BUT-ER-WELL I MIGHT BE ABLE TO USE YOU AN OTHER WAY-AND THEN YOU CAN GIVE ME THAT INFORMATION

THE POOR GIRL IS MAKING HER LAST DESPERATE PLEA FOR HER LOVER'S LIFE BUT EVIDENTLY SHE'S NOT SO WELL ACQUAINTED WITH HIPLER — BUT THE DEGENERATE HAS AN IDEA-LET'S SEE WHAT IT IS — 10.

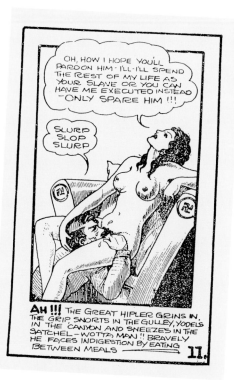

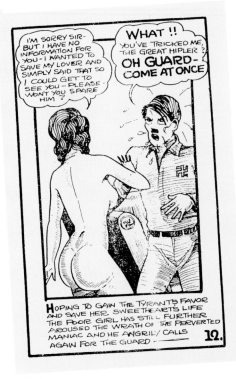

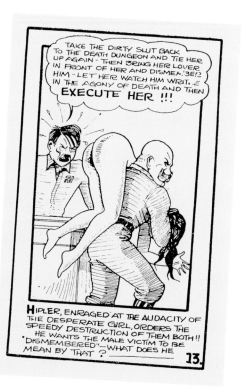

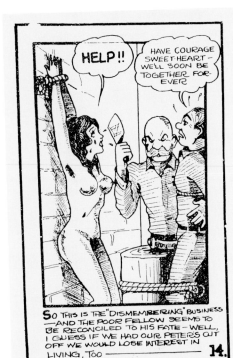

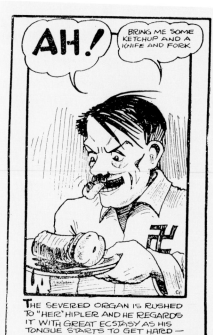

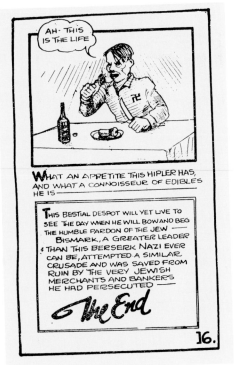

Odds 'n' Ends; or, Hot Nuts and Wild Gooses

Owing to their relaxed, to say the very least, attitude toward the graphic depiction of erotic happenstance, the cartoonists of the Tijuana Bible have occasionally been cast as precursors of our own much-vaunted sexual revolution, early chefs of today's varied erotic menu. Nothing could be further from the truth.

While they might well be seen as social anarchists with a rather spicy program—not far removed from, say, vintage Marx Brothers—they were not condoning the activities but rather reporting on them with the pornographer's relish. The context was one of zany journalism and, within this context, no possible sex act remained immune to their daft, and sometimes deft, line. This included penetration of any possible stripe; homosexual relations within both genders; bestiality, particularly with dogs or horses (the ongoing camaraderie between Barney Google and his hapless nag, Sparkplug, was a kind of field day in itself); and multi-partner orgies with as few as three or four men and a woman (depending upon Zeppo's mood, I guess) and as many as the crowd in a sixteen-pager titled *Hiya Boys!* In that single truly hilarious get-together, Popeye, Moon Mullins, Tillie and Mac, Jiggs and Maggie, Major Hoople (a curmudgeonly windbag), Toots and Casper, and Pete the Tramp were directed by Mae West (who else?), and anything sexual that could go on did, along with a few things that simply couldn't, in real life.

Despite their crudity, the mundaneness of their premise, and the often blatantly amateur quality of both their execution and certainly, production, these caricaturists generally exhibited a buoyant exuberance in their attitude toward what goes on between men and women behind closed doors, and in other places as well. Plots and punch lines abound in this petite theater of erotic tableaux, but in most cases, anyhow, a passionate bonhomie prevails. A few feathers may get ruffled (sometimes literally), but real violence is truly rare. Here, in the middle of a highly troubled time, these pool sharks and printers and hack greeting-card artists tried to create a sexual Eden for the Republic. As the young woman at the top of the quartet on the couch exclaims, "Hot ziggity! Is this some idea? What's life without lots of fuckin', anyway?"

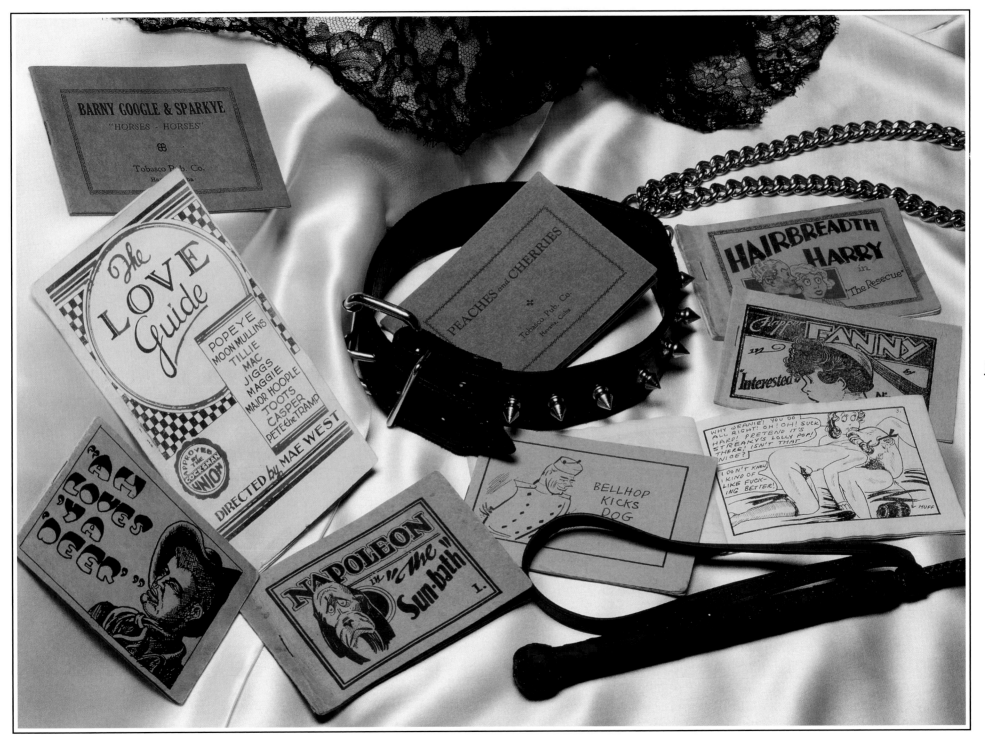

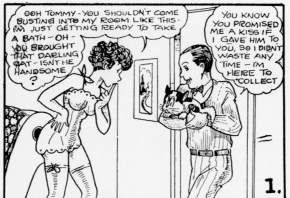

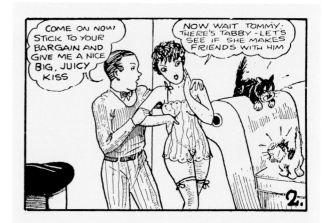

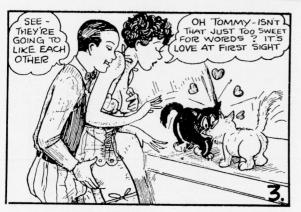

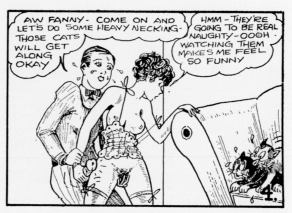

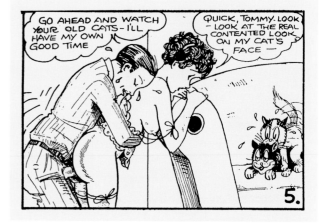

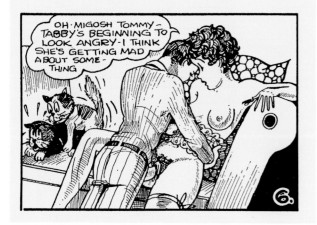

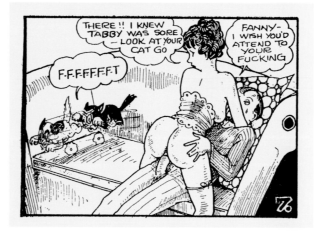

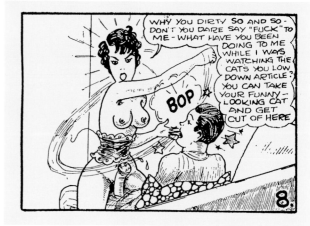

Flapper Fanny is another comic-strip character in the Clara Bow mold. The Tijuana Bible artists never tired of these soubrettes, and in this petite parable, Mr. Prolific is at his best. The pussycat touch is typical of his powers of invention.

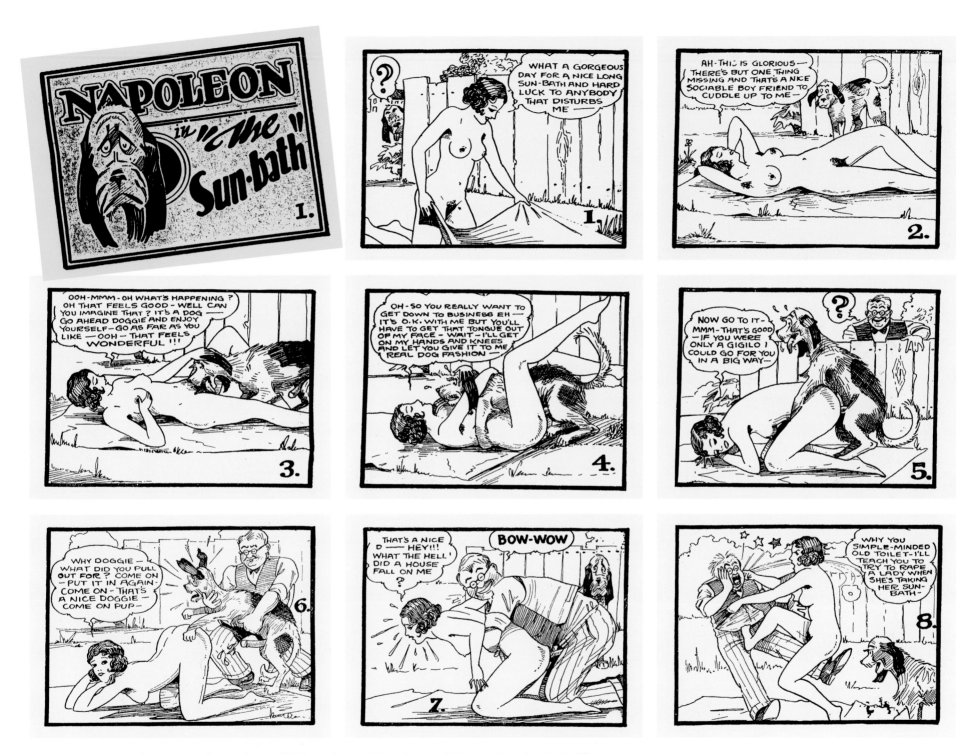

Napoleon *was a comic strip that featured a soulful hound named Napoleon and his squat master, Uncle Elby.*
The strip ran from the thirties to the fifties, drawn by cartoonist Cliff McBride, who named his dog Napoleon II.

135

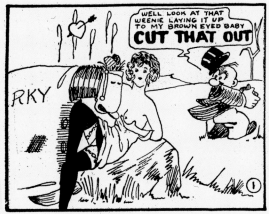

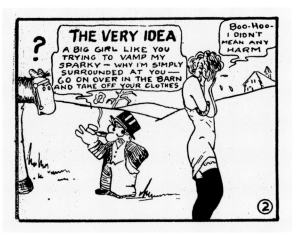

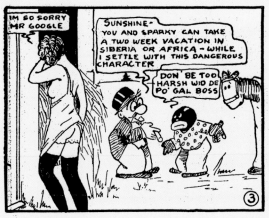

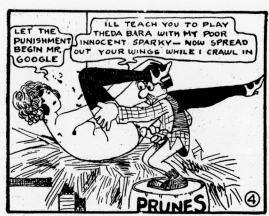

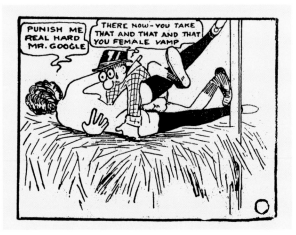

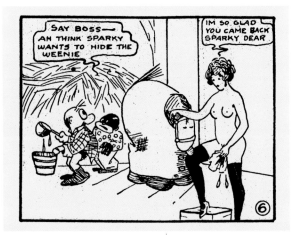

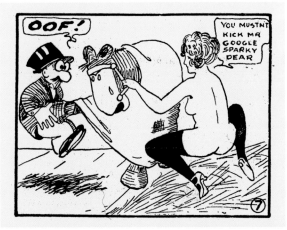

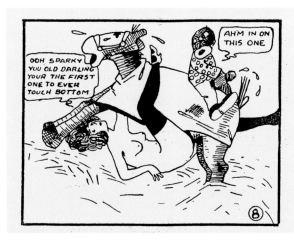

Barney Google, *drawn by Billy DeBeck, was so terribly popular that it inspired a song that ran, "Barney Google, with the goo, goo, googly eyes." Barney himself was an outrageous entrepreneur who owned, and at times lived with, a hopeless nag called Sparkplug. The strip ran for years and eventually evolved into another strip* called Snuffy Smith. *If I had to pick one single, solitary moment that best exemplifies the spirit of the Tijuana Bible, it would be panel five of this episode, which features our hero, hard at work, collar askew, while the black-stockinged damsel encourages him: "Punish me real hard, Mr. Google!" It doesn't get much better than that.*

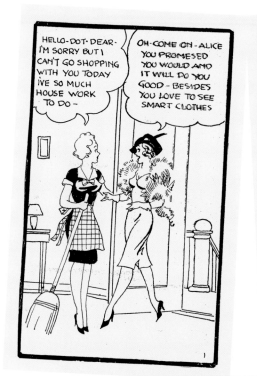

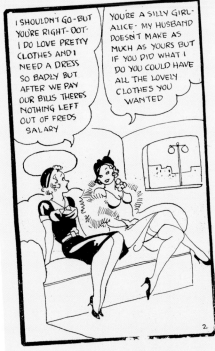

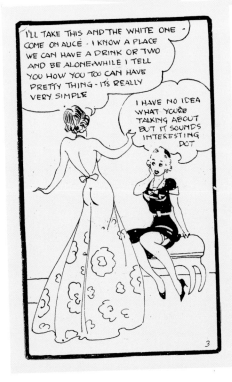

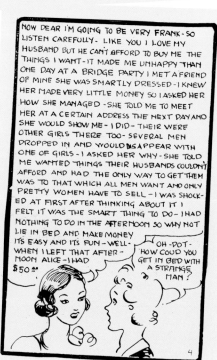

No one had enough cash during the Depression, so advice on stretching, and earning, dollars abounded— most more serious than How One Wife Made It Pay. This is one of many eight-pagers done by an artist now identified as Wesley Morse. Artistically, the work is of high quality; the line is crisp and deft, and the whole concept has a sophisticated, modern air about it. The dialogue, in particular, is chic and knowing, and an obvious intelligence informs the affair. The artist worked at the end of the thirties; there are a number of references in his booklets to the 1939 New York World's Fair.

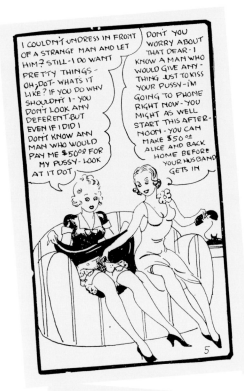

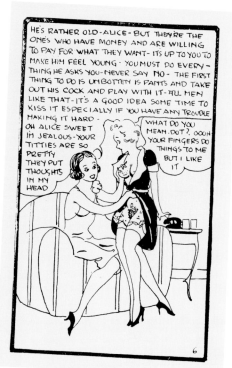

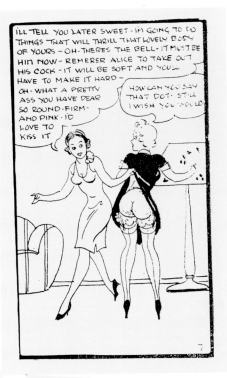

138

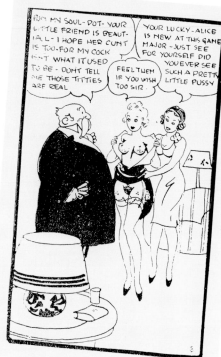

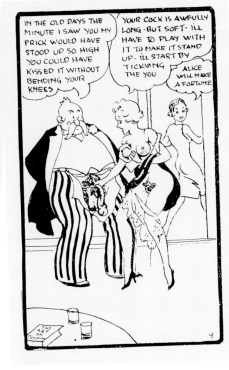

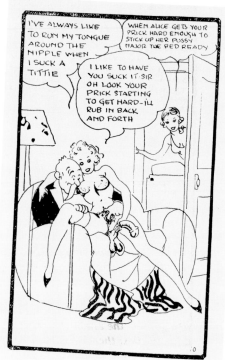

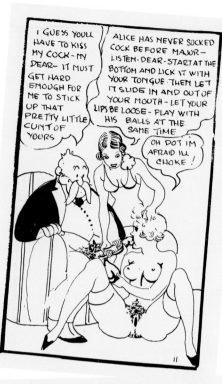

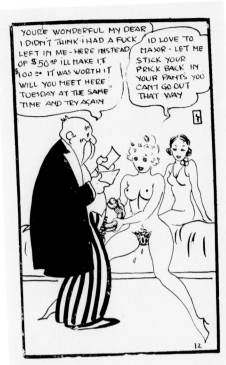

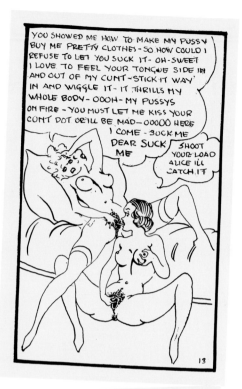

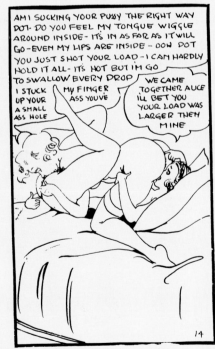

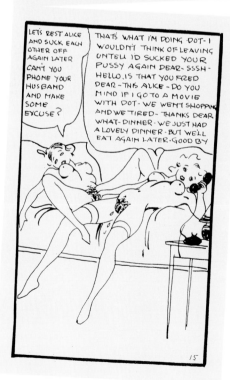

When Peaches married Daddy Browning in 1926, the New York Evening Graphic *had a blast. "Peaches" was Frances Heenan, a plump much younger lady; her husband, Edward Browning, was a wealthy eccentric of fifty-one. The* Graphic *satirized the pair and published outrageous collages called "composographs," thereby advancing, if not inventing, tabloid journalism in the Republic.*

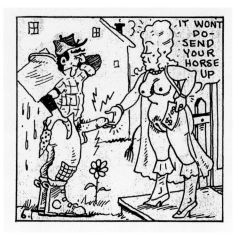

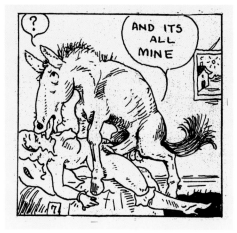

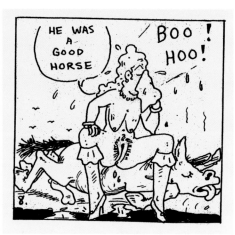

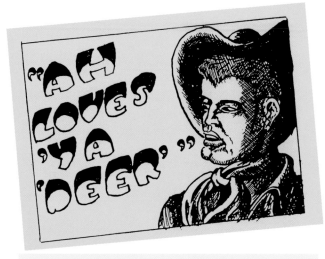

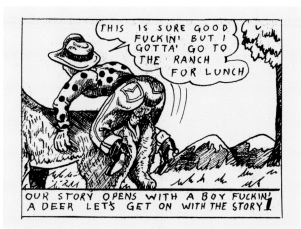

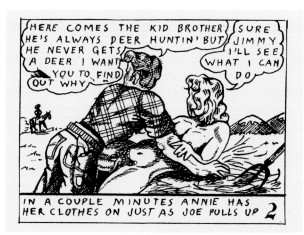

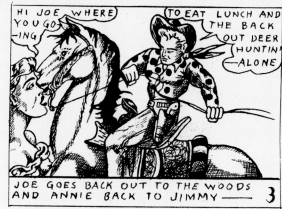

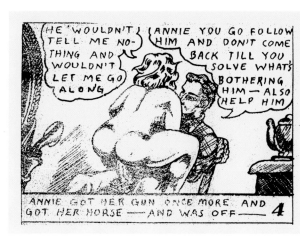

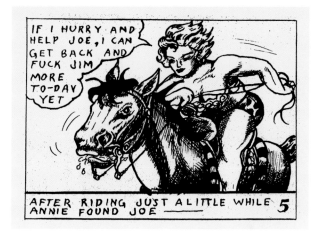

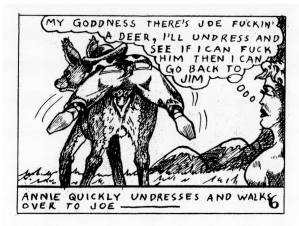

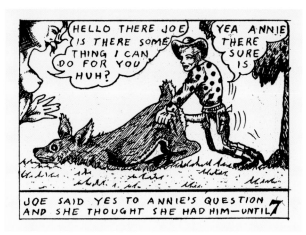

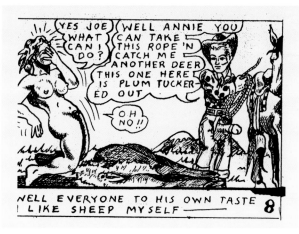

The artist Mr. Dyslexic was himself prolific and produced some of the most bizarre and even disturbing of all the little books. His material of choice was movie stars and political figures, but when he went off on a tangent he could, and did, come up with a doozie. Ah Loves 'Ya, 'Deer' features a standard cowpoke whose taste runs to venison on the hoof (or off). Mr. Dyslexic was hardly a polished draftsman, but his distortions almost always furthered the ghastly slant of his tales.

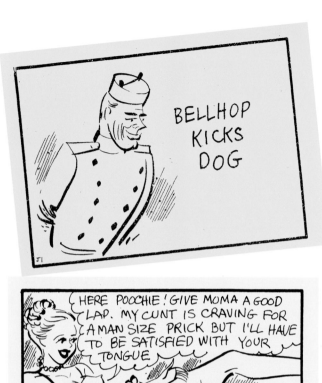
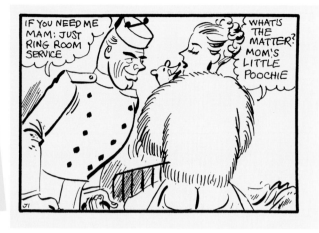
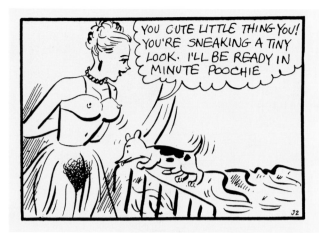
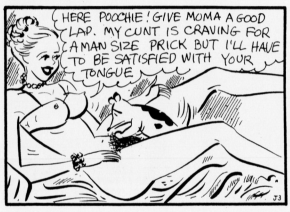

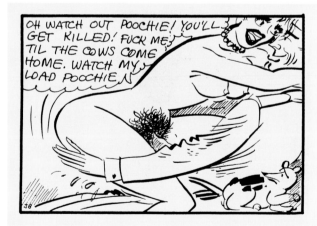

142

Bellhop Kicks Dog *is another charming and graphically stylish eight-pager by the artist who did the phone-booth lovers (page 53). There is a brisk elegance to the line, and while some of the booklets seem like they could have been done in Peoria, the sensibility here suggests a swanky hotel in a big city like New York or Chicago in the early fifties.*

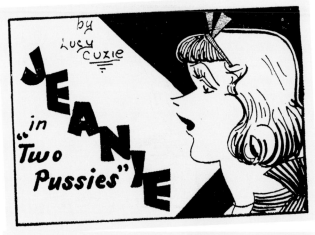 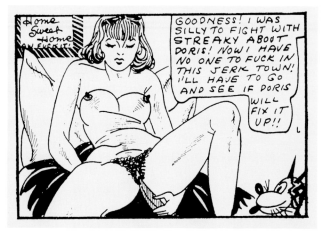 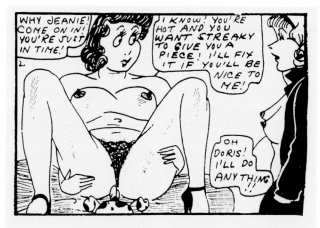

 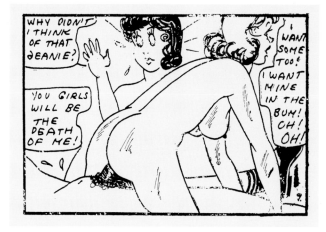 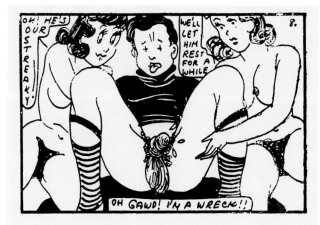

The original Jeanie was, more than likely, a short-lived comic strip from the late thirties or early forties. The art work is heavy-handed, even for the genre, and the locale is particularly poorly rendered. Lesbian activity was not a common theme, however, so the little booklet does offer something rather out of the ordinary.

This may be the ultimate sixteen-pager: an all-star game of favorites from the eight-pager league. Just about every major cartoon figure of the mid-thirties is there, and if the drawing is sometimes a tad suspect, the energy simply never quits.

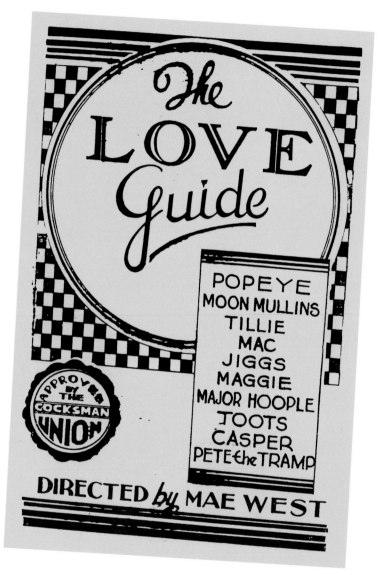

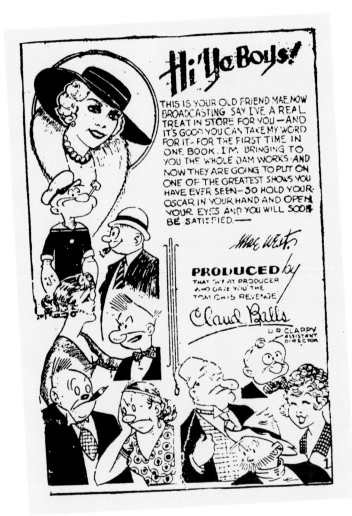

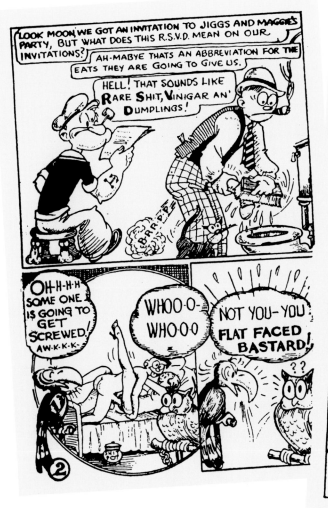

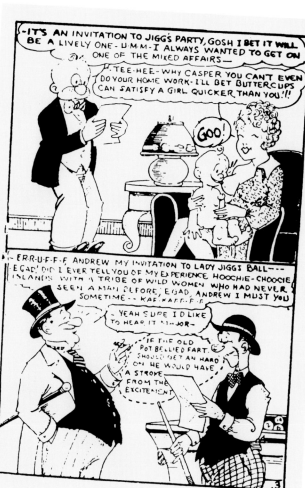

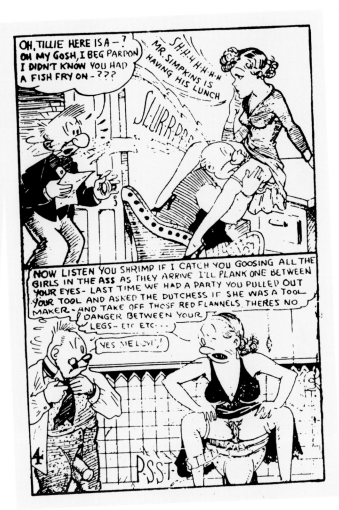

145

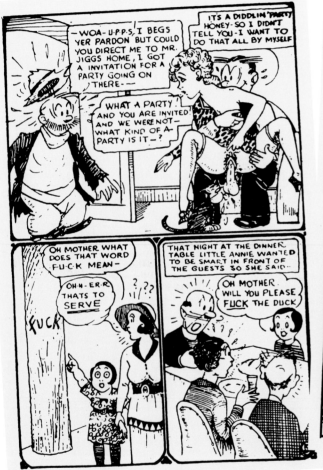

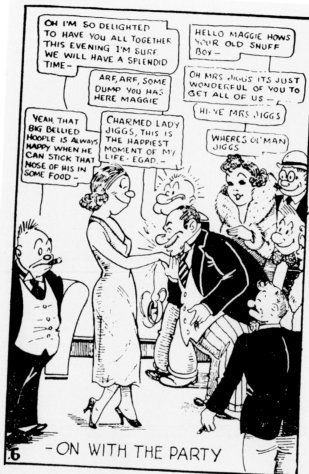

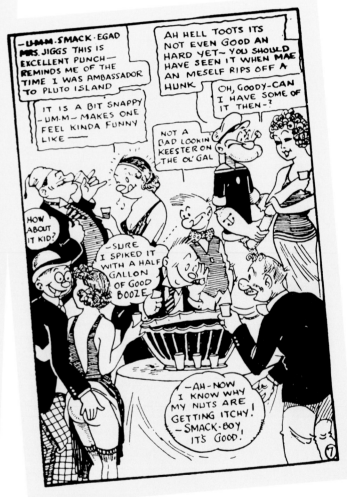

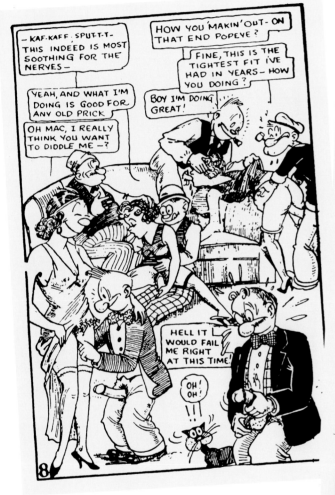

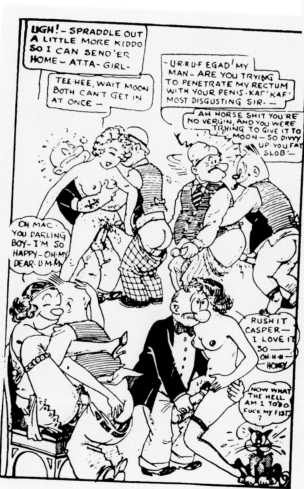

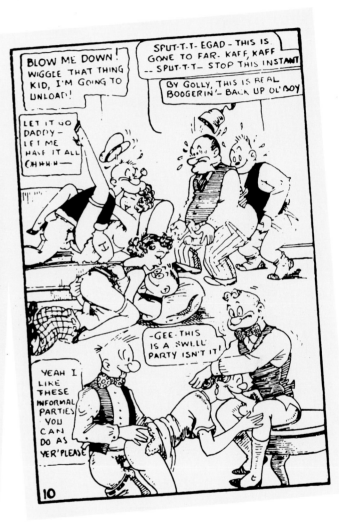

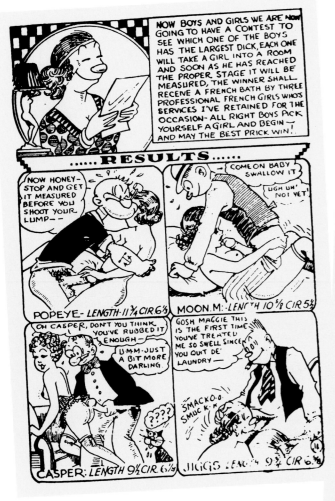

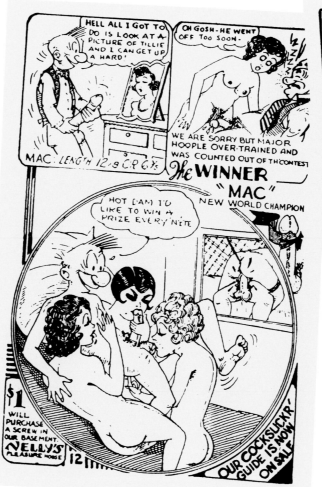

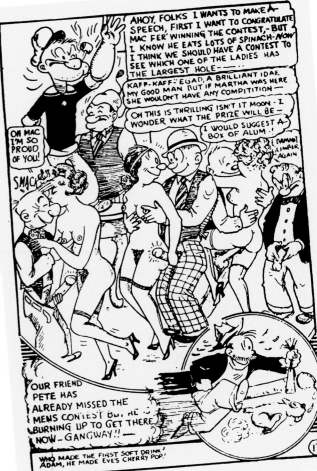

148

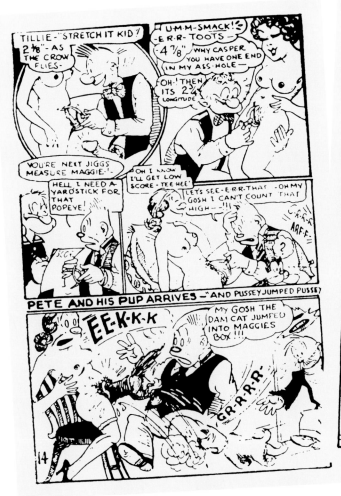

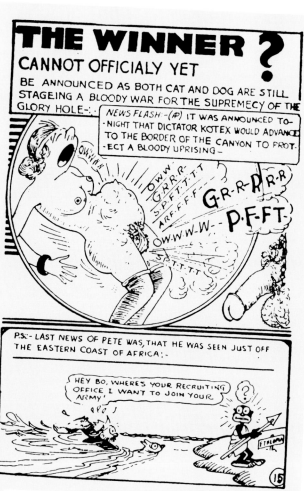

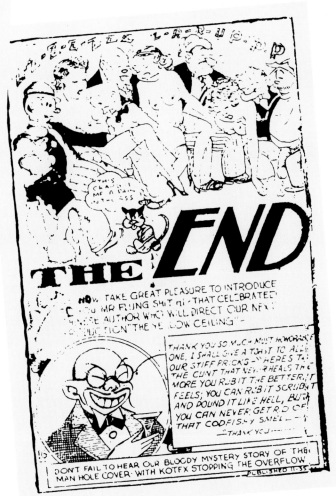

The Wide Stylistic Range of the Tijuana Bibles

Owing to their outlaw status and utterly primitive mode of both production and distribution, the artistic quality of the Tijuana Bibles was all over the lot, to say the least. Certainly much of the illustration and narrative was mediocre, though sufficient to the task at hand—that is to say, it got the job done, and expeditiously at that. A small percentage of the little books were deft, inspired, and very funny; many of them were crude and inept.

The high-water mark was surely the work of the artist who has come to be known as Mr. Prolific, a superb cartoonist who worked tirelessly, it seems, during the middle years of the Depression. His books were intelligently plotted and dramatized, and his cartoons were rendered in a graceful, articulate, Deco style—not unlike the best work of Cliff Sterrett, who drew the oft-times brilliant *Polly and Her Pals* at roughly the

same time. Unlike so many of his woeful peers, Mr. Prolific could really draw, especially in the graphic vernacular of the day. His pictures were the work of a real, intelligent pro, and they were informed by an awareness of what makes a comic strip tick.

Still, Mr. Prolific was not the only artist of quality nor the only one deserving of our interest. Another Tijuana Bible artist drew in a style that was similar in many ways, though lacking that special grace and nuance. He worked in very much the same milieu and was proficient enough to do a number of sixteen-pagers, a task left only to the most talented. Lamentably, he will in all likelihood remain anonymous. Later on, at the end of the thirties, the artist now identified as Wesley Morse (he of *Bazooka Joe* fame) did a series of eight-pagers, quite a few concerning the New York World's Fair of 1939–40, that have a wonderful graphic flair and a narrative that is inventive and highly playful. And sexy, to be sure.

Morse's contributions seem to end with the beginning of the new decade, and most of the Tijuana Bibles done during the war and directly after were poor to hopeless in quality. Once again, however, in the late forties a cartoonist of quality entered the field. His subjects were more or less generic, as in *Bellhop Kicks Dog*, but his line was assured and brisk, and its almost shorthand quality linked him with prevailing graphic style. His tableaux had a peppy insouciance that implied *Vogue* and hi-fis and martinis. They were at one with the moment.

The artists of lesser skills and even cruder intent are not without interest, for, like much "outsider art," their work suggests not only the substitute theater but the curiosity of the vision as well. The artist dubbed "Mr. Dyslexic" in the

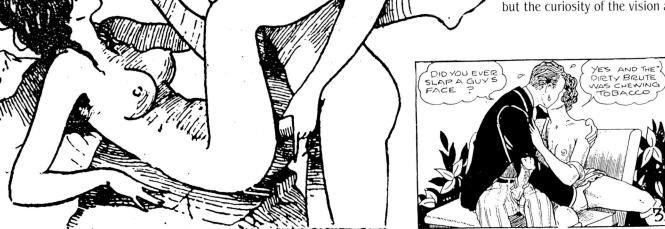

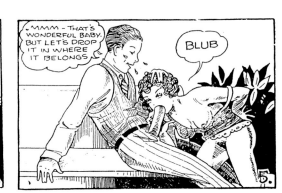

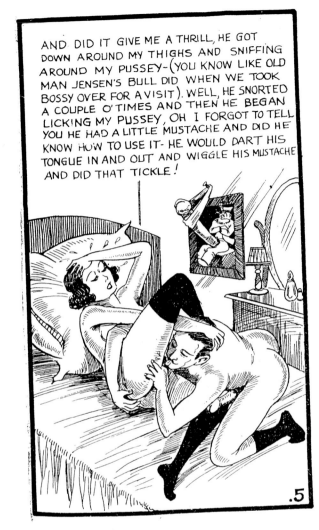

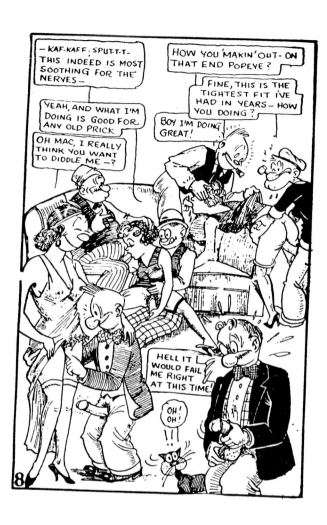

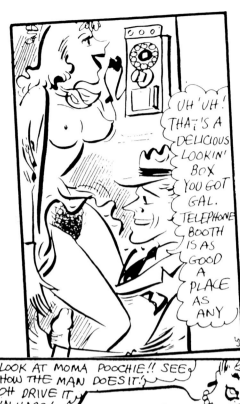

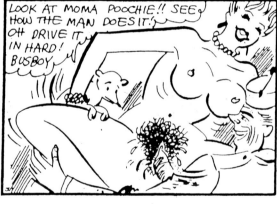

151

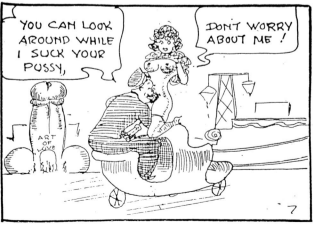

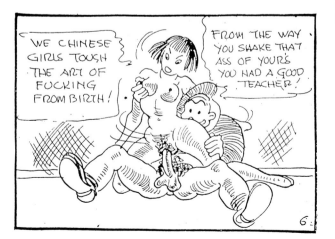

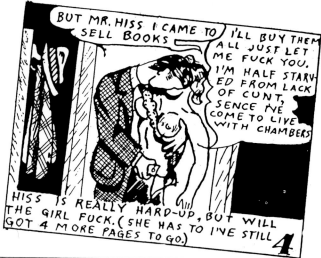

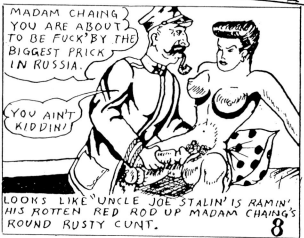

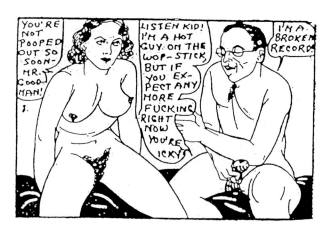

introduction worked for a substantial period of time, almost always dealing with noted personalities, from movie starlets (Rita Hayworth) to Cold War spies (Alger Hiss). And although *Mussolini in Ethiopia* was done by an artist of severely limited skills, its pathetic inadequacy seems to heighten the horror. In short, a triumphant merger of subject and style could emerge, no matter how primitive the talent. This phenomenon accounts for much, I think, of the enduring vivacity of this subterranean genre.

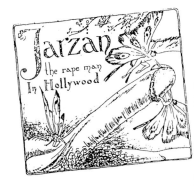

Although most of the important Tijuana Bible production was done by a few key players, there was more than a smattering of other artistic voices and styles. Some were truly deft and accomplished, others plodded earnestly along the same weary paths, but all contributed to a unique species (perhaps subspecies) that had both audacity and fun. **Tarzan: The Rape Man in Hollywood** *features both Lupe Velez and Johnny Weissmuller. Large in format, it is decorative and dainty in execution, so much so that it almost seems influenced by Aubrey Beardsley or DuLac or Rackham. For a subterranean expression, the Bible was often both inspired and informed.*

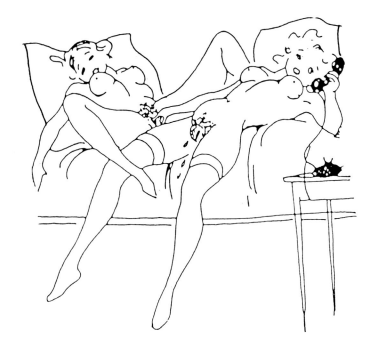

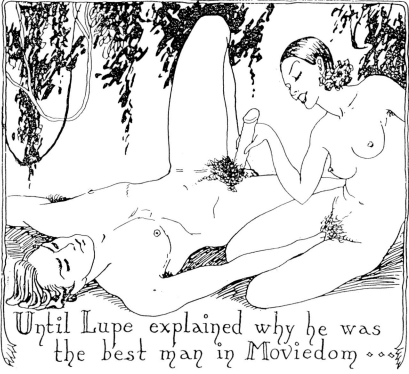

Until Lupe explained why he was the best man in Moviedom...

152

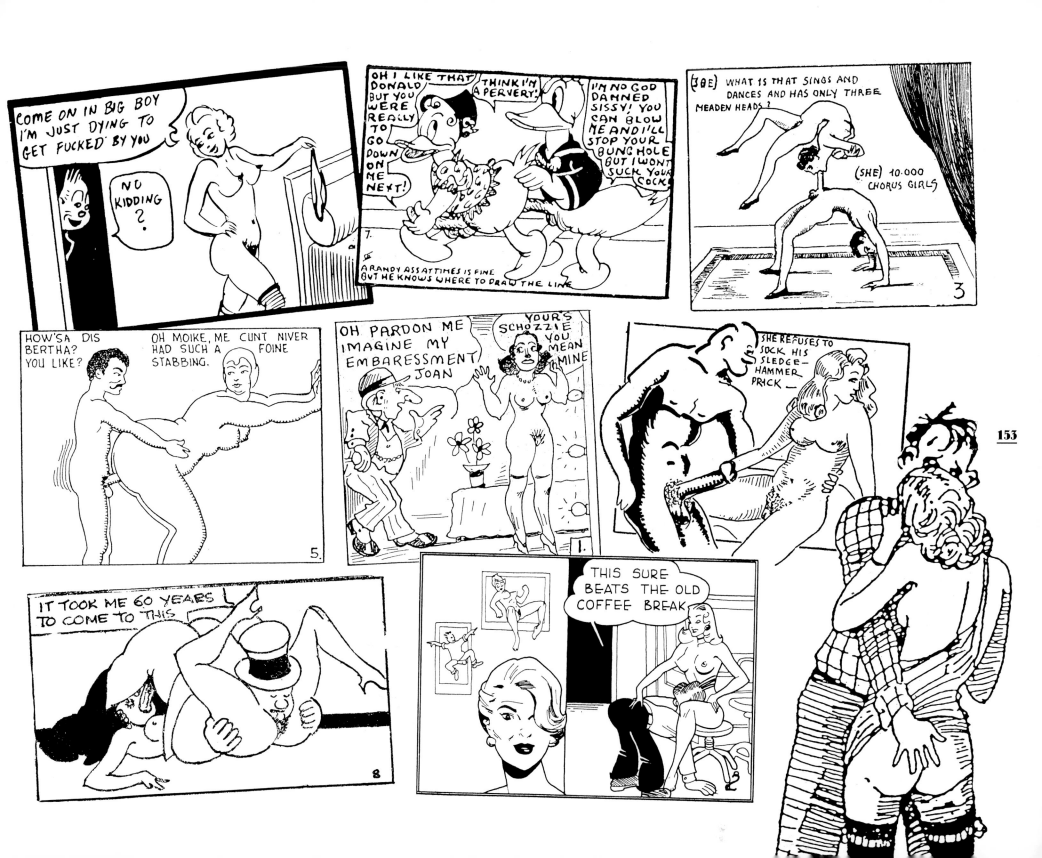

The Demise of the Tijuana Bibles

Historically speaking, the Tijuana Bible was born in the waning days of Prohibition, achieved its robust manhood in the middle of the Great Depression, slipped into middle age during World War II, became geriatric in the late fifties, and then died in the early Kennedy years. To some degree, the little outlaw booklet's demise was hastened on by the new television sensibility but, more important, I think, was the fact that the average Joe in the pool room or barber shop found the girl in the centerfold of *Playboy* (or *Rogue* or *Nugget*) far more appealing than a cartoon of Blondie (and sometimes a woeful one) playing hide-the-salami with Mr. Dithers. Simply speaking, what played in the thirties did not always play a quarter of a century later. Most efforts to revive the eight-pager, in the waning years, were doomed to

failure. A good example of this, the Tijuana Bible at its most decadent, is *Oh Elvis*, surely done in the very late fifties. Despite the surface dexterity, the graphic style of the episode does not fit the format and the requisites of the narrative. It is, at once, too lush and slick, deriving as it does from romance comic books, not strips, or the highly mannered drawings of S & M illustrators like Eric Stanton or Gene Bilbrew (but not, alas, John Willie, who understood comic strips far better). The classic eight-pager took pride in a joyful and utterly accessible outrageousness; *Oh Elvis* seems far more arch and malevolent than joyous or even erotic. Finally, the eight-pager artist caricatured his subjects through zany exaggeration, but how in the world could one caricature Elvis Presley, the emperor of excess himself?

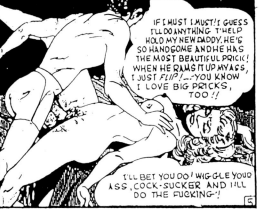

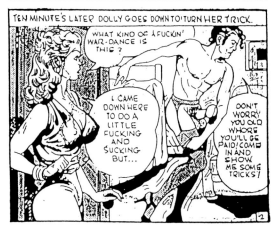

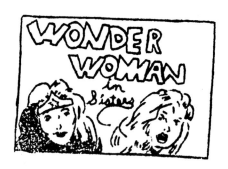

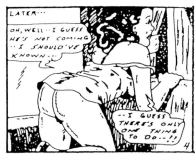

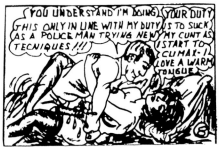

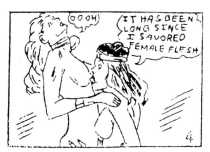

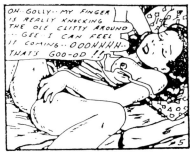

Talking Dirty: The Vocabulary of the Tijuana Bibles

Madeline Kripke

Much of the language in the Tijuana Bibles is directly sexual and quite colorful. In a generous sampling of the books (more than 300), I found the following expressions relating to sex and private bodily functions.

ass: The buttocks are called *ass, can, fanny, kiester, rosta beef* (by an Italian character), and *rumble seat*; they provide the locale for an *asshole, a-hole, bumhole, bunghole,* or *crack*.

balls: Testicles are most commonly *nuts,* often *balls* or *cods,* occasionally *the family jewels,* rarely *testicules.* Collectively with the cock, they're a *basket* or a *three-piece set*.

blow job: A partner might *blow* someone or *blow his nuts* or *give a blow job, suck cock* or *cocksuck, eat dick,* or *French.*

breasts: Breasts are almost always *tits* or *titties*. In one rare instance they are *a baby's restaurant*. A partner may *chew on* (a woman's) *milk route* or *nibble the rosebud* (but never just caress her breasts).

buggery: Anal intercourse is *buggering* or *boogerin'* or *brown* (as in "the boys enjoyed their brown"); one can *Greek* one's partner or go *up the back door, up the dirt road,* or *up the kiester.*

cock: The most common terms are *cock, prick, prong,* and *joy prong;* also *prod, kidney prodder* (or *mover* or *disturber*) and *bowel disrupter* (or *disturber* or *oiler*); *jock, root, shaft,* and *tool; rod, joy rod, ramrod,* and *pile driver; peter, roger,* and *joy dispenser.* Less common are *nubbin, Johnson bar, iron,* and *lightning rod.* Occasional variants are *barber pole, ding-dong, hammer, cherry buster, lollipop* or *popsicle, middle leg, monkey, old pisser, hose, pea pipe, thing, whang,* and *yardstick.* An aroused man gets a *hard on* or a *bone on,* or less often a *stiff up* or simply a *bone* or *boner.* After the act, his cock is *done in, limber as a rag, limp as a dishrag,* or *plumb tuckered out.*

come (noun): The substance has many names: *come, jizz, joy juice, pep, spunk,* or *the works,* sometimes *cherry juice, cream,* or *hot fat* (or *gravy* or *load*).

come (verb): Both men and women can *come, throw a lump,* or *pop.* A man can also *blow* (or *drop* or *shoot*) *his load* (or *lump* or *nuts*) or *the works,* or *drop* (or *blow*) *his load of red hot lava;* or he can simply *spurt.* He can *fill* (his partner) *with a pint of cream,* give her some *cherry juice* or a *faceful of starch, pour* (her) *some*

hot (or *red-hot*) *gravy,* have his *lump blown,* or *shoot his lump* (or *the works* or a *load that makes her teeth rattle*).

cunt: Most often it's a *cunt, box* (sometimes a *hot* or *snuff* or *giggle box*), *snatch, pussy, hole, cherry, crack, quim, nookie,* or *piece.* Two common terms that appear only in phrases are *home* ("I'm going home," "ramming that old baloney home," "pounding that old Roger home") and *slot* ("in the slot," "drop it in the slot"). A bit less common are *cooze, flue, gash, groove, jelly roll, rumble seat,* and *twat.* A few rarities are *fish barrel, flood gates, piece of peter grease, piece of raw meat, big sweet ham, red-hot gravy, watzis,* and *wet deck.*

cunt-lapping: The most common terms for this form of oral sex are to *cunt-lap, French, muff-dive,* and *suck off.* An enthusiast will commonly *yodel* or go *yodeling* (sometimes *in the canyon* or *valley*) or *whistle in* (her) *whiskers* (or, again, *in the canyon*). He's less likely to *go down on* her. Rarely, he might *muzzle-guzzle,* become a *pearl fisher,* get a *mouthful of cherry juice,* swallow a *mouthful of come* (or *of hair*), or have a *tongue party.*

dildo: Often seen but only once named, it's a *phony prick.*

fart: It's not uncommon for these people to *fart;* in one case a sly fellow *lets a sneaker.* In imitation of the usual telltale sound, one hapless group of characters is named the Poot family.

foreplay: It's nonexistent or at best a minimal exhortation: "Hurry up and get your wings spread" or "Spread it nice, baby"; a solicitous partner might *grease* (a girl's) *asshole.*

fuck: The denizens of the Tijuana Bibles are most likely to *fuck* (plain, or *most proper* or *ragged*), or to *jazz, frig, shag, scratch, diddle* (or *doodle*), *lay* or *give a lay,* or (least common of the front-runners) *screw.* They're a bit less likely to *get* (or *shoot*) *the works,* to *give a good hump* or a *piece* (or sometimes *an injection*), or to *get their ashes hauled* or to *vamp* or *go to town* or go *boom-boom;* similarly, a man might *slip the prick to* his partner, *pick her cherry, rip* or *knock off a chunk,* or just *knock one off.* Roughly, a suitor may *jump* his partner and *stick in* his *prong,*

stick it in, drive it in hard, ram it in, ram the old baloney home, or *plug her ass, dislodge her kidneys, dispossess her bowels, disturb her insides,* or *send it up her gizzard.* He may *ravish* her *flue, plumb* her *hole, snatch a piece of plunder,* and *pound that old Roger home.* More gently, a woman may *bounce on it,* or *camp* (or *sit*) *on the peg,* and a man can *dip the wick, drop it in* (or *into the slot*), *get in the slot,* or *ride in* (or *get* or *crawl into*) *the saddle,* or *creep into her bloomers,* or *go home;* he can both *get some meat* and *put* (or *pack*) *some meat into* his partner. And he can *grease the flagpole* or *oil* (or *tickle*) *her tonsils.* He can be exhorted to *do your stuff;* she, to *shake it up* or *hoist your ass.* In a few rare instances; the partners may *belly-whack* or *scrowge;* he may *sling a fuck* into her, *tickle* her *ovaries, blowa da tune on da meat whistle, feed her his pipe loaded with cream,* or *knock off a couple of corners;* and she may plead with him to "put that bird in my gilded cage" (Mae West to Lou Gehrig).

horny: Men who are aroused are *hot* or have a *hard on;* a woman may have *a cunt craving some action* or *burning* for sex; perhaps her *pussy is sizzling,* or she's *getting a hot box.* Both genders may be *in heat, rarin' hot, all hot and bothered,* or simply (and less commonly) *horny.*

jerking off: A man without a partner might *jerk* (or *jack*) *off,* or *fuck* (his own) *fist.*

orgies: Sex for more than two is overwhelmingly popular in these comics, but it's not usually given a distinct name, though *daisy chain* appears once.

period: A menstruating woman is simply *on the rag;* no other expressions are given.

piss: The usual *piss, pee,* and *take a leak* appear throughout; rarely, when a sex partner is the target, it's referred to as *showers.*

rubber: Usually a *rubber* or *rubber goods;* sometimes a *condrum, cundrum, inner tube,* or *raincoat.*

same-sex partners: The rare male homosexuals in the Tijuana Bibles are called *faggot, fag,* or *pansy;* though lesbians (or lesbian acts) are far more common here, no special terms for them are given.

shit: The usual *shit, crap,* and *turd* appear often enough, but without relevance to the erotic except, occasionally, as a damper.

whore: A prostitute is a *whore, hooker,* or *jade;* she works in a *whorehouse, cathouse,* or, occasionally, a *hookshop.* In one instance a woman enjoys a fine life as a *keptee.*

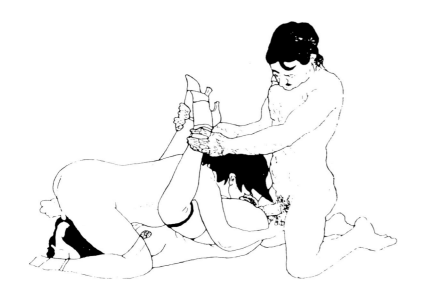

Those Naughty End Pages

Adorning the back covers of many eight-pagers were black-and-white drawings, uneven in artistic quality but all sharing that same ghastly printing quality. Most of these pictures were borrowed from thirty-two-page (or longer) pornographic booklets called "readers," for obvious reasons. Readers were usually square in format, though some were oblong, and they contained longer pornographic texts, which were either original, and decidedly inferior, or pirated from some classic source like Henry Miller. The readers were usually illustrated, either by photographs, explicit but often grainy and indistinct, or line drawings depicting some pornographic melodrama. The drawings varied drastically in quality, but the best were done by the ubiquitous "Mr. Prolific" or some other master, or mistress, of the eight-pager. Occasionally the illustrations were actually taken from some artist of real quality like Mahlon Blaine, Emil Ganso, or Clara Tice. Within the readers themselves, the illustrations were relevant, but by the time they were lifted from this source their literary affiliation became nonexistent. Nevertheless, these back covers were decorative, sprightly, zany, and occasionally deftly rendered, and they lent to the poor little eight-pager a curious collagistic charm. From our vantage point, moreover, they have a surreal link that is truly modern.

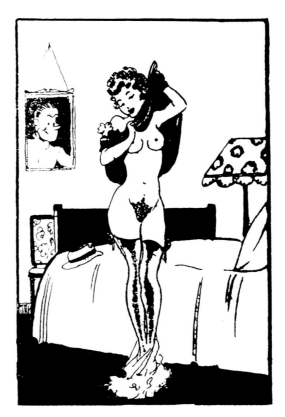

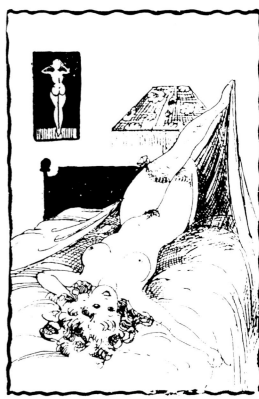

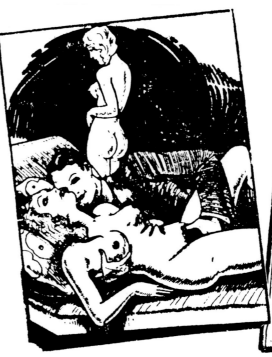

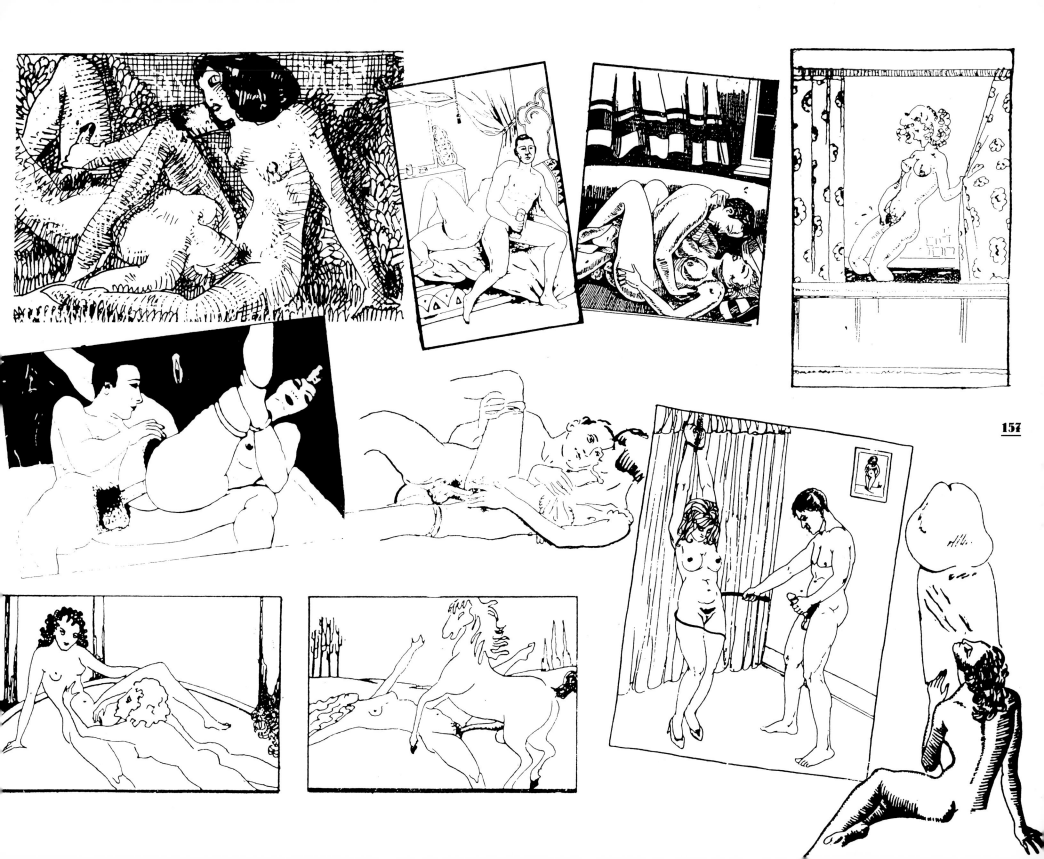

Annotated Bibliography

Madeline Kripke

What follows is a partial listing of books and articles containing information about the Tijuana Bibles (TJBs). Many (but not all) that are out of print, difficult to find, and unavailable in libraries have been excluded.

Anonymous. "Sex in the Comics," *Playboy*, March 1985, pp. 108–113.

Atkinson, Terrence (ed.). *More Little "Dirty" Comics*. Reseda, Calif.: Socio Library (#9615), 1971, 214 pp. Introduction by R. G. Holt, pp. 9–15. Short notes and informative essays, including a discussion of sexual humor in literature.

Baisden, Greg. "All Off-Color for a Time," introductory essay in Michael Dowers and Greg Baisden (eds.), *The Tijuana Bible*, book 1. Seattle, Wash.: Starhead Comix, 1991, pp. 2–3. The role played by TJBs in going against repressive social codes.

Brackman, Jacob. "The International Comix Conspiracy," *Playboy*, December 1980, pp. 195–99 and 328–34. An exemplary, concise history of the "underground comics" movement inspired by the TJB genre.

Brooks, Lou. "Oooo Mama! Comic Strip Porn Was Always Good for a Laff," *Penthouse Hot Talk* #8, pp. 31–39. New York, 1984. A short, nostalgic overview of the genre, written with cheek and sparkle.

Carl, C. H. "The Fornicating Funnies," *The Swinger*, April 1972, pp. 14–16. A very brief history of the TJB phenomenon, from its emergence to its fadeout. The article touches on matters of advertising and production.

Clinch, Toby A. "The Great Comic Book Controversy," in *Sexuality Today and Tomorrow: Contemporary Issues in Human Sexuality*, North Scituate, Mass.: Duxbury, n.d. (ca. 1976).

Daniels, Les. *Comix: A History of Comic Books in America*. New York: Outerbridge & Dienstfrey (distributed by E. P. Dutton), 1971.

Dowers, Michael (ed.). *The Tijuana Bibles: America's Forgotten Comic Strips*, vol. 1. Seattle, Wash.: Eros Comix, 1996. Reproduces 15 TJBs, all enlarged. Contains a 2-page introductory essay by R. C. Harvey (see).

———, and Greg Baisden (eds.). *The Tijuana Bible*, books 1–9. Seattle, Wash.: Starhead Comix, 1991–94. Together, a valuable repository.

Eisner, Will. *The Dreamer*. Northampton, Mass.: Kitchen Sink Press (The Will Eisner Library), 1986. 46 pp. A graphic novel in which a Depression-era cartoonist is offered a job drawing TJBs. (See Spiegelman's introduction to the present volume.)

Ellison, Harlan. "Hot Damn! The Kind Men Like," *The Staff*, September 10, 1971. Los Angeles.

Estren, Mark James. *A History of Underground Comics*. Berkeley, Calif.: Ronin Publishing Co., 1987. A sweeping survey of the "undergrounds." Densely illustrated and packed with information, it gives a quick nod to the role of TJBs in the counterculture.

"Flooglehorn, A." (ed.). *The Tiajuana [sic] Bible Revival*, vol. 1, *Hot Nuts*; vol. 2, *Under the Stars in Hollywood*, each 96 pages. Blueballs, Pa.: Penetrating Pubs, Inc., 1977. An anthology of TJBs with an engaging, humoresque presentation.

Geerdes, Clay. "Part One: The Origin of the Eight-Pager," *Comics F/X*, #11, August 1989, p. 4.

———. "The New Dirty Comics," *Hustler*, April 1976.

Gilbey, Jack. *Dirty Little Sex Cartoons: A Fully Illustrated Report on the Contraband Comics of the Thirties: Which Helped Stir the Blood of a Nation Economically Depressed and Sexually Repressed.* Los Angeles: Argyle Books, n.d. (ca. 1972). 192 pp.

Gilmore, Donald H. *Sex in Comics: A History of the Eight Pagers*, vol. 1, *The Early Years, 1930–1937* (GP602), 192 pp.; vol. 2, *Mr. Prolific — King of the Comics* (GP603), 192 pp.; vol. 3, *The World's Fair* (GP604), 208 pp.; vol. 4, *An Attempt to Expand* (GP605), 144 pp. San Diego: Greenleaf Classics, 1971. A pioneering study as well as a major anthology of TJBs.

Goodrick, Susan. *The Apex Treasury of Underground Comics*. New York: Links Books (distributed by Quick Fox), 1974. 192 pp.

Gluckson, Robert. "Sex Comics from the Thirties to the Fifties: The Tijuana Bible Story," 3-part introductory essay in Dowers, Michael (ed.), *The Tijuana Bibles*: book 1, pp. 4–5, 8–9, and inside back cover; book 2, pp. 8–11 and inside back cover; and book 3, pp. 8–13 and inside back cover. Seattle, Wash.: Starhead Comix, 1991–92. A scholarly, detailed, and entertaining text; a wealth of factual information, rich in historical and social perspective. Includes a valuable, extensive bibliography.

———. "World's Fair Comics and Stories," introductory essay in Michael Dowers (ed.), *The Tijuana Bible*, book 5, *Blusie Toons II: It Happened at the World's Fair*, inside front and back covers. Seattle, Wash.: Starhead Comix, 1993. A brief and fond evocation of the time and place.

Harvey, R. C. "Getting Our Pornograph Fixed," introductory essay in Michael Dowers (ed.), *The Tijuana Bibles: America's Forgotten Comic Strips*, vol. 1, pp. 4–6. Seattle, Wash.: Eros Comix, 1996. An affectionate and sophisticated musing on the genre.

Harvilecz, Helena. "Women and Tijuana Bibles," introductory essay in Michael Dowers (ed.), *The Tijuana Bible*, book 3, pp. 2–5. Seattle, Wash.: Starhead Comix, 1992. A quirky, satirical piece, written in an exaggerated academic style.

Holt, R. G. (editorial commentary). *Little "Dirty" Comics*. Reseda, Calif.: Socio Library, 1971. The editor provides an introduction, short notes, and 40 pages of commentary, including discussions of TJB sales figures and censorship issues; bibliography.

Horn, Maurice. *Sex in the Comics*. New York: Chelsea House, 1985. 215 pages.

Klotman, Phyllis R. "Racial Stereotypes in Hard Core Pornography," *The Journal of American Popular Culture*, vol. 5, no. 1 (Summer 1971), pp. 220–35. A careful and sadly illuminating examination of methods used to preserve racial stereotypes, in this case within the TJB genre.

Kurtzman, Harvey. "@ &%$!! or Takin' the Lid Off the Id," *Esquire*, June 1971, pp. 128–132. Contains an 8-page pulp section sketching the history of American comics. Kurtzman, the creator of *Mad*, says, "The obvious repression of sexual fantasy in (the straight comics) brought its release in the little dirty books. . . . The distribution system was mysterious, but it worked."

Olson, James. *Sex, Humor, & the Comics: An Illustrated Study*. (No place given): Pendulum Psychomed Study, n.d., 112 pages.

Palmer, C. Eddie. "Pornographic Comics: A Content Analysis," *Journal of Sex Research*, vol. xv, no. 4 (November 1979), pp. 285–98.

———. "Filthy funnies, blue comics, and raunchy records. . . ," in Clifton Bryant (ed.). *Sexual Deviancy in Social Context*, pp. 82–98. New York: New Viewpoints, 1977.

Parkinson, Robert E. "Carnal Comics," *Sexscope Magazine*, vol. 1, nos. 3 and 4.

Raymond, Otis. *An Illustrated History of Sex Comic Classics*, vols. 1 and 2. New York: Comic Classics, 1972. 224 and 222 pages, respectively; each contains a bibliography.

Reynolds, John J. *Famous Sex Comics*. Reseda, Calif.: Socio Library (#9621), 1971. 216 pages. An anthology of TJBs. Contains a 6-page foreword by C. Leslie Lucas, commentary, and a bibliography.

Rymarkiewicza, Wenzel. *A Scientific Study of Hot Little Comics*, vol. 2. Redondo Beach, Calif.: Monogram Books (M-107), 1972. 224 pages. Reproduces 18 TJBs, a 12-pager, and some later comics. Contains a 4-page foreword plus a 40-page essay that categorizes the comics by the types of characters and the sexual activities portrayed. An original, somewhat eccentric, but substantial piece of scholarship.

Side'n, H. "The Amazing Art of the Kinky Comic," *Mayfair*, vol. 9, no. 1, pp. 40–41.

Stewart, Bhob. "Bubbling Over," *Blab!* no. 3 (September 1981), pp. 30–31. Princeton, Wis: Kitchen Sink Press.

Trench, William (Bill Blackbeard). "The Kind Men Like," chapter 7 in *Kiss, Screw, Pleasure and Sex*, pp. 121–40. San Diego, Calif.: Greenleaf, 1969. 189 pp.

Wolfe, Bernard. *Memoirs of a Not Altogether Shy Pornographer*. New York: Doubleday, 1972. Includes the author's reminiscences of writing dialogue balloons for TJBs.

Woods, Anthony. *Comic Strip-Tease*, vols. 1 and 2, 191 pages each. N.p., n.d. (ca. early 1970s). Anthologies of TJBs, each with a 12-page introduction and 12 pages of commentary. Vol. 2 contains a discussion of the TJB artists known as "Zilch."

———. *Yesterday & Today's Classic Comics*, vol. 4. N.p., n.d. (ca. early 1970s). Reproduces 13 TJBs and some other comics. Contains a 4-page introduction and a useful 32-page history of American comics, especially the "undergrounds."

Wyndham, Ryder. "Thy Cartoon Neighbor's Wife," introductory essay in Michael Dowers (ed.), *The Tijuana Bible*, book 2, pp. 2–5. Seattle, Wash.: Starhead Comix, 1991. A thoughtful, well-written editorial on corporate repression of the erotic in contemporary comics.

TITLES

159

INDEX OF SUBJECTS PARODIED